WILD THING

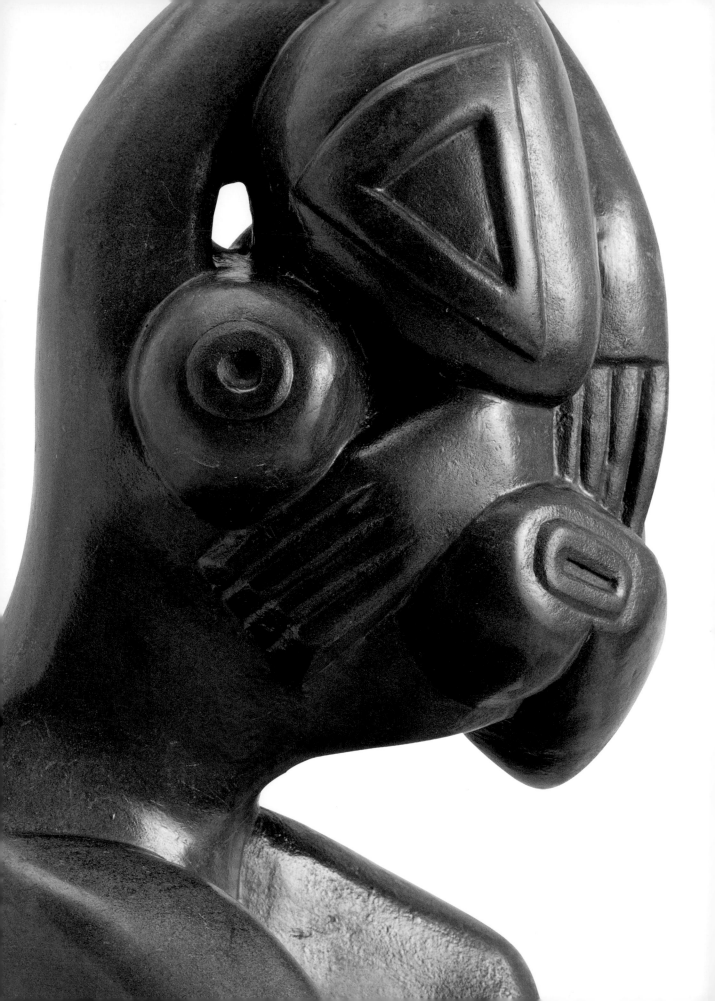

RICHARD CORK

WILD THING

Epstein, Gaudier-Brzeska, Gill

ROYAL ACADEMY OF ARTS

First published on the occasion of the exhibition
'Wild Thing: Epstein, Gaudier-Brzeska, Gill'

Royal Academy of Arts, London
24 October 2009 – 24 January 2010

2009–2013 Season supported by

Sponsored by

The bank for a changing world

With additional support from

The Henry Moore
Foundation

The Royal Academy of Arts is grateful to Her Majesty's
Government for agreeing to indemnify this exhibition
under the National Heritage Act 1980, and to
Resource, The Council for Museums, Archives and
Libraries, for its help in arranging the indemnity.

EXHIBITION CURATORS
Richard Cork
Adrian Locke
assisted by Sarah Lea

EXHIBITION ORGANISERS
Idoya Beitia
Caroline McCarthy

PHOTOGRAPHIC AND COPYRIGHT CO-ORDINATOR
Trine Hougaard

CATALOGUE
Royal Academy Publications
Lucy Bennett
David Breuer
Carola Krueger
Sophie Oliver
Peter Sawbridge
Nick Tite

Copy-editor and proofreader: Kate Bell
Designer: Maggi Smith
Colour origination: DawkinsColour, London
Printed in Verona by Graphicom

EDITOR'S NOTE
All dimensions are given in centimetres,
height before width before depth.

FRONTISPIECE
Detail of cat. 62
Henri Gaudier-Brzeska, *Redstone Dancer*, c. 1913
Red Mansfield stone, 35 × 60 × 40 cm
Tate. Presented by C. Frank Stoop through
the Contemporary Arts Society 1930

British Library Cataloguing-in-Publication Data
A catalogue record for this book is available from the
British Library

ISBN 978-1-905711-46-8 (hardback)
ISBN 978-1-905711-47-5 (paperback)

Distributed outside the United States and Canada
by Thames & Hudson Ltd, London

Distributed in the United States and Canada
by Harry N. Abrams, Inc., New York

ACKNOWLEDGEMENTS
My fascination with this momentous period in the
history of sculpture was ignited by Jim Ede. He
welcomed undergraduates to Kettle's Yard, his
luminous home in Cambridge, where I first
encountered Gaudier-Brzeska's work on a revelatory
day in 1965. Soon afterwards, researching my book
on Vorticism, I benefited from invaluable visits to Lilian
Bomberg, Kathleen Epstein, Frederick Etchells, Duncan
Grant, Kate Lechmere, Lydia Lopokova (an event kindly
arranged by Geoffrey Keynes), Helen Peppin, Sarah
Roberts, Barbara Wadsworth, Rebecca West and R. H.
Wilenski. Lady Epstein was also kind enough to show
me the collection that now excites visitors to the New
Art Gallery, Walsall, and the late Freddie Gore RA
proved exemplary when I researched the Cave of the
Golden Calf for my book *Art Beyond the Gallery* (1985).
Anthony d'Offay invited me to write catalogue essays
for three pioneering exhibitions at his gallery:
Jacob Epstein: The Rock Drill Period (1973), *Henri
Gaudier and Ezra Pound: A Friendship* (1982) and
Eric Gill: Drawings and Carvings (1982).

 Henry Moore and Ben Nicholson shared with me
their memories of Epstein and Gaudier respectively.
Then, while curating an exhibition on 'Vorticism and
Its Allies' at the Hayward Gallery in 1974, I discovered
that Holman Brothers in Cornwall would allow their
machine to be incorporated in a full-scale
reconstruction of *Rock Drill*. Ann Christopher RA and
her husband Ken Cook bravely assured me that they
could make this reconstruction, and the magnificent
result is now returning to London for this exhibition.

 The Royal Academy and I have been immensely
fortunate to be helped in so many ways during the
preparation of 'Wild Thing'. Particular thanks are due
to Debra Armstrong, Victor and Gretha Arwas, John
Austin, Sebastiano Barassi, James Beechey, John
Bernasconi, Lewis Biggs, Jonathan Black, Ivor Braka,
Richard Childs, Jonathan Clark, Celia Coke-Steel,
Roger Cole, Judith Collins, Michael Craig-Martin, Ruth
Cribb, Stephen Deuchar, Jo Digger, Anthony d'Offay,
Ann Dumas, Tim Egan, Eliza Frecon, Peter Gorschlüter,
Antony Griffiths, Michael Harrison, Michael Houlihan,
Godfrey Howard, Graham Howes, Neil Hyman, Gillian
Jason, Jen Kaines, Susan Kent, Anne and Richard
Keynes, Simon Keynes, Stephen Keynes, Doïna Lemny,
Denise McCann, Jean-Michel Massing, Varshali Patel,
Alastair Penfold, Susannah Pollen, Timothy Prus, Mary
de Rachewiltz, Gillian Raffles, Alicia Robinson, Evelyn
Silber, Sarah Skinner, Peyton Skipwith, Thyrza Smith,
Stephen Snoddy, Colin Still, Reena Suleman, Phillippa
Wood and Douglas Woolf.

 Kate Bell and Ivor Heal have been a delight to
work with on the catalogue and the exhibition design
respectively. Finally, the outstanding staff of the Royal
Academy deserve special thanks for all they have done.
Richard Cork

Contents

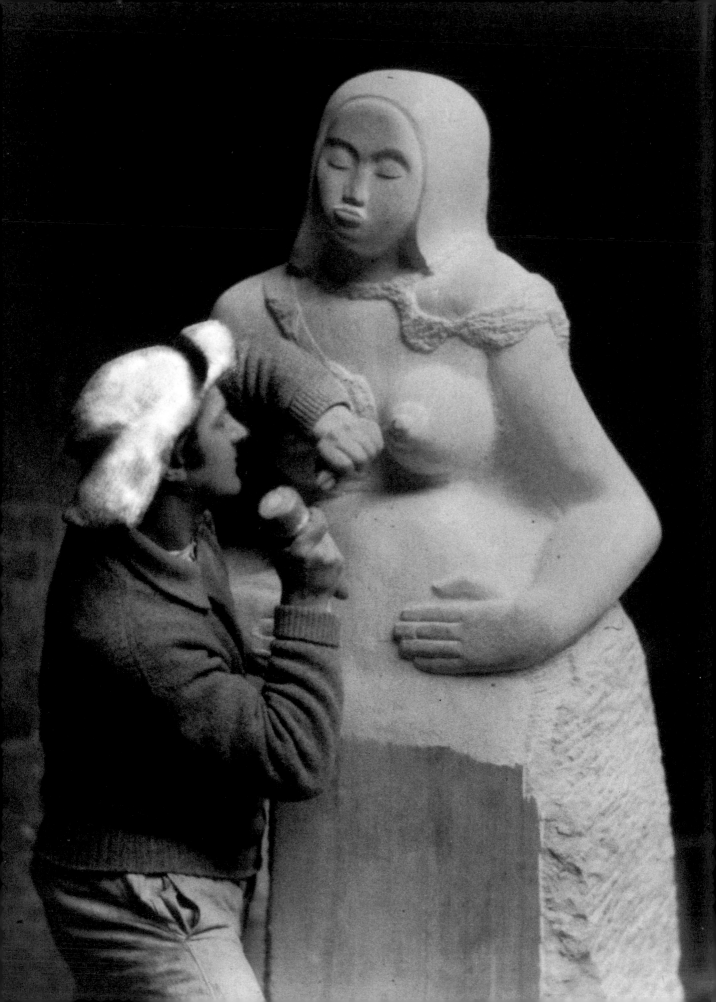

President's Foreword

In the ten short years between 1906 and 1916, Jacob Epstein, Henri Gaudier-Brzeska and Eric Gill transformed the face of British sculpture. It seems remarkable that until now the work of these artists has never been exhibited together for the purpose of examining this artistic revolution. Perhaps no single work emphasises their achievements more than Epstein's *Rock Drill*: man and machine come together in the most radical and dynamic manner, presaging the horrors of modern warfare that were about to be unleashed across Europe and which would claim the life of Gaudier.

Although Epstein and Gill worked together at Ditchling, and Epstein and Gaudier knew each other well, they worked autonomously, driven by a need to return to the essence of sculpture as they saw it: carving direct. The relationship between the sculptor and the raw material was key. In part a return to the 'lost' craftsmanship of the past and led by a desire to be true to artistic expression, this preoccupation also reflected the influence of the ethnographic collections of the British Museum.

'Wild Thing' has been curated by Dr Richard Cork, whose knowledge of and deep passion for the subject knows no bounds, with Dr Adrian Locke. A number of the works lent from private collections, particularly by Gill, have never been exhibited in public before, and in some cases are shown together here for the first time. Museums have also lent outstanding works rarely seen in Britain, including Gaudier's final masterpiece *Birds Erect*, and Epstein's fascinating *Venus – second version*, last exhibited in London in 1917.

The Royal Academy would like to thank the numerous lenders to this exhibition, many of whom prefer to remain anonymous. We are especially grateful to Tate, Kettle's Yard and the University of Texas at Austin for agreeing to lend so many key pieces, and to the Museum of Modern Art, New York, and Yale University Art Gallery for lending such significant works from their collections. The generosity of all the lenders underlines the importance of the exhibition. This in turn stands as testament to the significance of the three artists and the extraordinary impact that they exerted.

This exhibition has been made possible by the extremely generous support of JTI, our 2009–2013 Season supporter of exhibitions in the Sackler Wing of Galleries, and our sponsor BNP Paribas. Their generosity is particularly appreciated in these financially difficult times. I would also like to thank The Henry Moore Foundation and the individuals listed on page 8 for their additional support.

Sir Nicholas Grimshaw CBE
President, Royal Academy of Arts

Supporters of the Exhibition

Jacob Epstein, Henri Gaudier-Brzeska and Eric Gill are widely acknowledged as bringing about the birth of modern sculpture in Britain. As the long-term Season Supporter of the Sackler Wing of Galleries, JTI is honoured to be associated with this remarkable exhibition, which celebrates an era of dramatic transformation in British art. We are delighted to play a part in bringing these extraordinary artists to your attention.

Daniel Torras
General Manager, UK, JTI

BNP Paribas is proud to sponsor 'Wild Thing', an exhibition of works by a group of young, revolutionary artists whose original and audacious style changed British sculpture at the start of the twentieth century. This is the second exhibition that BNP Paribas has sponsored at the Royal Academy and through our support we hope to inspire visitors, clients and colleagues alike with the same pioneering ethos and visionary spirit that defined these artists.

Ludovic de Montille
UK Chief Executive, BNP Paribas

Detail of cat. 13
Eric Gill, *Madonna and Child 1 – feet crossed*, 1909–10
Portland stone, 62.2 × 20.3 × 17.1 cm
Leeds Museums and Galleries, City Art Gallery

With additional support from

The Henry Moore Foundation

Anne Baldock
Guy and Margaret Beringer
Robert Bowman
Mark and Clare Brailsford
Jonathan and Debbie Brayne
Däna Burstow
Mr and Mrs Geoffrey Fuller

Soo and Jonathan Hitchin
Colleen Keck
Patrick Mears and Rachel Anderson
Mervyn Parry
Berni and Chris Rushton
Mark and Vanessa Welling
Mr and Mrs Boyan Wells
Mark and Emma Wippell
Mr and Mrs David Wootton

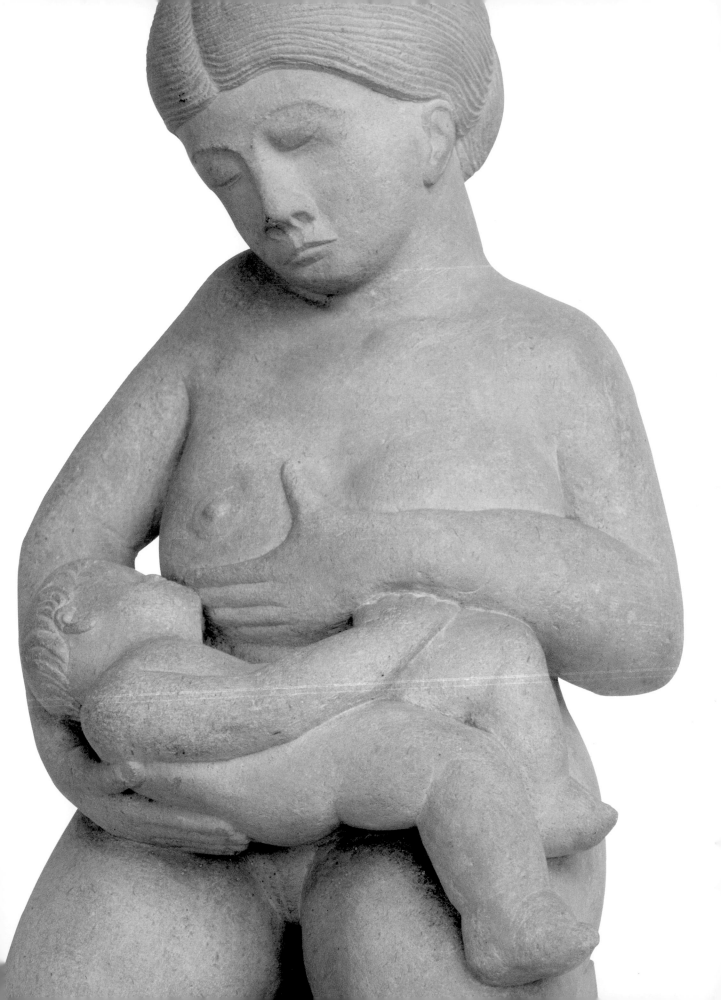

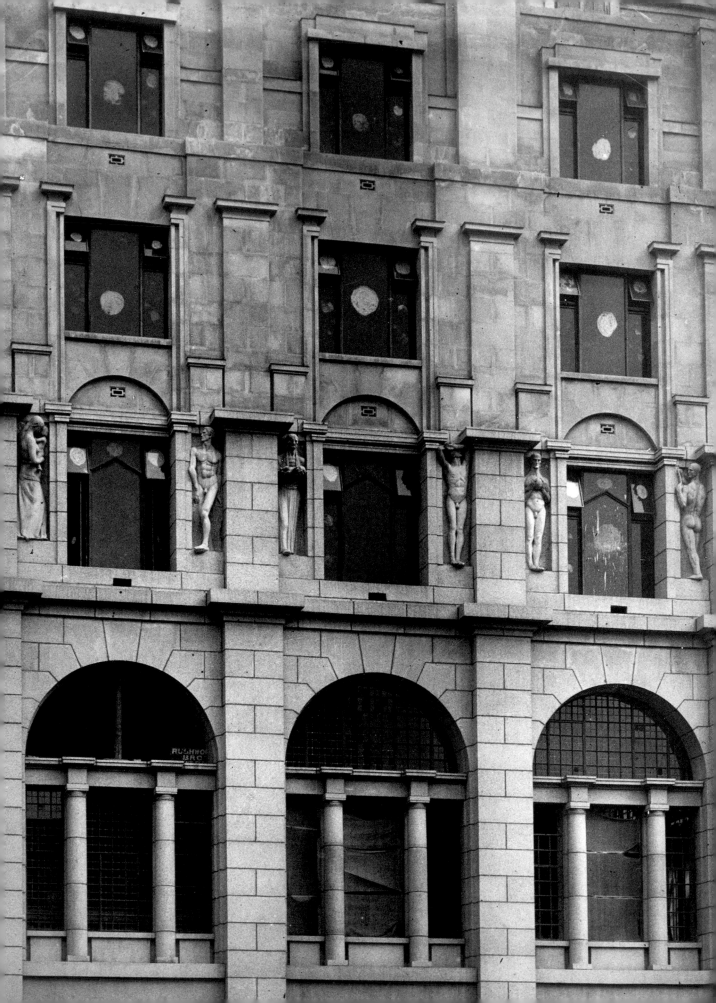

Scandal on the Strand

Fig. 2
British Medical Association, Strand, London, showing Jacob Epstein's sculptures. Photographed in 1908. From left to right: *Maternity, Man, New-Born, Youth, Mentality, Academic Research.*

When Ezra Pound encountered Henri Gaudier-Brzeska for the first time in 1913, he was immediately impressed and likened the young Frenchman to 'a well-made young wolf or some soft-moving, bright-eyed wild thing'.[1] But those last two words, which later became the name of an iconic rock song, also sum up the feisty and provocative spirit of rebellion driving the young Jacob Epstein and Eric Gill. The origins of these three men could hardly have been more disparate. Epstein was a Jew from New York, Gaudier the son of an Orleans joiner, and Gill's father a Brighton clergyman. Yet they shared a bold dissatisfaction with hallowed academic ideals, looking far beyond the classical tradition to gain stimulus from what Gaudier excitedly called 'the barbaric peoples of the earth (for whom we have sympathy and admiration)'.[2] By 1912, the *Pall Mall Gazette* decided that Epstein should be described as 'a Sculptor in Revolt, who is in deadly conflict with the ideas of current sculpture.'[3] So, too, were Gaudier and Gill. Between them, in a sustained burst of fecund and audacious inventiveness before the First World War, they brought about the birth of modern sculpture in Britain.

In 1905, when Epstein came to London, an awareness of the need for radical renewal of many kinds was beginning to spread across the nation. The historian H. A. L. Fisher caught its emergent spirit with appropriate vigour when he described how 'an extraordinary political effervescence prevailed in England during the period which lay between the Boer War and the fateful opening years of Armageddon. A spirit of fanaticism invaded a luxurious world which no longer felt itself secure. Pious dissenters broke the law rather than pay the education rate. Well-bred and delicate women smashed windows, scuffled with the police, and by one means and another got themselves sent to prison as a protest against a government which refused them votes. Party spirit ran so high in London over the House of Lords and Ireland that social relations were ruptured. To some imperialism and tariff reform constituted a religious faith, pressed with sectarian fervour. By others these causes were denounced as synonymous with the exploitation of oppressed peoples by unscrupulous profiteers and the corruption of

Fig. 3
Mutilated figures of Jacob Epstein's *Maternity* (left) and
Man (right) on the former British Medical Association
Building, Strand, London.

legislatures by sinister vested interests. The country was full of industrial unrest, the striking habit extending from the mines, the railways, and the factories to the schools.'[4]

British sculpture was likewise ripe for a thoroughgoing overhaul. Towards the end of the previous century, the so-called New Sculpture movement had set out to revitalise sculptors' relationship with architecture, the public monument and the concept of a unique art object. But as the movement's historian Susan Beattie pointed out, 'the four years from 1898 to 1901 may be shown, with unnerving ease, to have contained not only the greatest achievements of the New Sculpture movement but the forces and events which contributed most insidiously to its decline.'[5] So Epstein was justified in striving for an alternative direction when he left Paris and crossed the English Channel.

At the Académie Julian, where he had studied, his teacher called him 'ce sauvage Américain'.[6] And Epstein did not take long to attract notoriety in his newly adopted homeland. His early series of stone figures, carved for the façade of the British Medical Association in London at 429 the Strand, may now look respectful of tradition (figs 2–7). He later admitted that 'at first I was somewhat held back by the admonitions of the architects, who, although they had given me a big commission, yet felt that I might do something rash. I already had a reputation for wildness; why, I don't know. It is quite possible my appearance at this time was that of the traditional anarchist. However, later gathering strength, as the architects gathered faith, I managed to impose my own ideas.'[7]

But by an extraordinary coincidence, the statues happened to be directly opposite the headquarters of the censorious National Vigilance Association. Its prudish staff were infuriated when they looked out of their windows and saw the full-breasted, amply proportioned young woman in Epstein's *Maternity* carving (fig. 2). Their outraged complaints alerted outrage-hungry journalists on the *Evening Standard*, who declared in a front-page denunciation that the carvings were 'a form of statuary which no careful father would wish his daughter, or no discriminating young man, his fiancée, to see'.[8] The figures quickly became a nationwide scandal, and the *British Medical Journal* was aghast to discover in the summer of 1908 that 'the whole Strand opposite was packed with people, most of them girls and young men, all staring up at the statues.'[9]

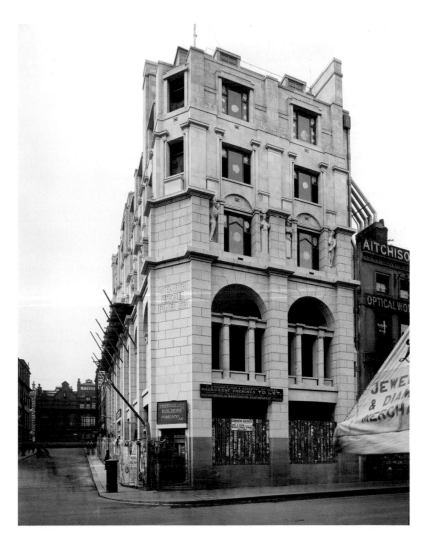

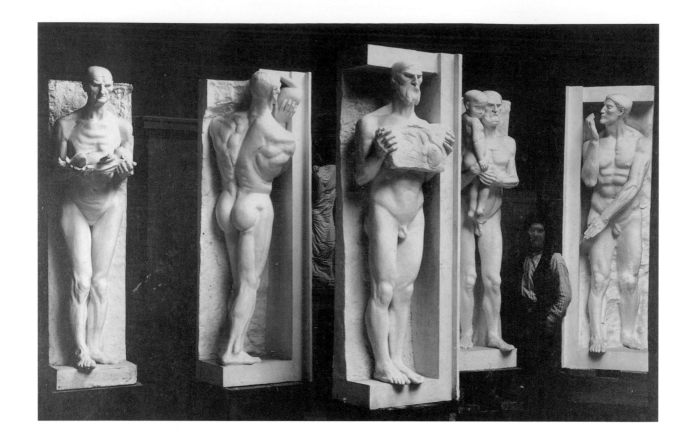

Fig. 5
Jacob Epstein with original plaster versions of the
BMA statues prior to installation, *c.* 1907. From left
to right: *New-Born*, *Chemical Research*, *Matter*,
unknown statue, *Primal Energy*.

Epstein felt unabashed. His wife Peggy, a fervent left-wing Scottish
Nationalist whom he had married in 1906, bolstered him with devoted
support. He was, however, shaken by the acrimony his work aroused, and
doubtless wondered if he had been right to settle in a country where philis-
tine anger was so easily triggered. When chosen to execute this major com-
mission by the building's architect Charles Holden, Epstein was exhilarated
by the thought of working with a man who shared his own enthusiasm for
Walt Whitman. The American poet had been among Epstein's favourite
authors while still in New York, when he escaped from his crowded
Hester Street neighbourhood to spend the day reading in the seclusion of
Central Park. The adolescent Holden had likewise read Whitman's *Leaves
of Grass* in his native Bolton, and in an unfettered 1905 article called
'Thoughts for the Strong' he concluded that 'we are ashamed of our naked-
ness – and yet it is in the frank confession of our nakedness that our
regeneration lies.'[10] Epstein would have agreed, for he declared towards the
end of his British Medical Association project: 'I have wished to create
noble and heroic forms to express in sculpture the great primal facts of man
and woman.'[11]

Suddenly, however, those same 'great primal facts' caused so much
national perturbation that Epstein's name became, overnight, a by-word
for scandal. He found himself visited by the police on-site in the Strand,
and the cowardly Chairman of the BMA Council opined after a quick,
embarrassed tour of the carvings that 'they ought never to have been put

there'.[12] He added that an emergency meeting of the BMA's buildings committee would be held to debate the statues' fate. Meanwhile, the Church mounted an assault of ecclesiastical indignation when Father Bernard Vaughan, a vociferous Roman Catholic priest, accused Epstein of attempting to 'convert London into a Fiji island'. The enraged prelate even declared that the carvings were provoking 'vulgarity and unwholesome talk, calculated to lead to practices of which there are more than enough in the purlieus of the Strand already'.[13]

By this time the accusations had grown patently absurd, and the perplexed Epstein must have felt very relieved when an impressive array of artists, critics and museum directors came to his aid. The sculptors ranged from F. W. Pomeroy of the older generation to Eric Gill, who was only twenty-six and about to become Epstein's closest collaborator. Walter Crane, Roger Fry, Augustus John and Sir Charles Holroyd, Director of the nearby National Gallery, also joined the chorus for the defence. They stressed the dignified restraint and severity of the figures. At this crucial stage, another member of the religious establishment made a decisive intervention. Dr Cosmo Gordon Lang, Bishop of Stepney and later Archbishop of Canterbury, took the trouble to climb the ladders up Epstein's scaffolding and absolve the statues of all immoral intent. Then, after the enlightened Home Secretary refused to echo general condemnation when a question was tabled in the House of Commons, the BMA finally decided on 1 July 1908 that Epstein should be permitted to complete his original commission.

It was a victory both for sound aesthetic judgement and for common sense, but the furore undoubtedly contributed to the eventual, tragic downfall of Epstein's statues. In 1935 the Southern Rhodesian government purchased the BMA building, and soon afterwards the High Commissioner announced that all the carvings would be taken down. Although his official reason was that 'they are not perhaps within the austerity usually appertaining to Government buildings',[14] the truth is that beneath the diplomatic camouflage lay the same objection that had been expressed by the National Vigilance Association in 1908. And by this time Epstein was synonymous with everything the British found absurd in modern art, as a popular lampoon made clear:

I don't like the family Stein.
There is Gert, there is Ep, there is Ein
Gert's writings are punk,
Ep's statues are junk,
Nor can anyone understand Ein.[15]

1
Jacob Epstein
Study for 'Maternity', 1907
Pencil and ink, 50 × 30.5 cm
The New Art Gallery, Walsall

After a fragment from one of the figures crashed onto the pavement, Epstein could do nothing to prevent a group of callous inspectors from examining each statue and hacking away any section considered to be dangerous.[16] No attempt was made to repair the butchered carvings, and their terrible mutilations are still exposed in all their rawness on the façade of Zimbabwe House today.

The destruction was inexplicably savage, ruining a scheme which can now be ranked among the most impressive sculptural sequences ever made for a London building. Epstein was not a fully mature artist when he car-

Fig. 6
Jacob Epstein, *New-Born*, 1907–08

ried it out, and surviving photographs reveal an eclectic range of sources at work. Some of the figures, like *Hygieia* (fig. 4), are profoundly indebted to classical precedent, and show how the Greek collections at the British Museum exerted their hold over Epstein's imagination. Others, most notably *Youth* (fig. 2), demonstrate his respect for Michelangelo and Rodin, the latter of whom had written him a 'commendatory letter'[17] when he left Paris for London. But the uncompromising realism deployed in the head of the old woman in *New-Born* (fig. 6) shows how important Donatello's example had become, while an undulating ink and pencil study for *Maternity* (cat. 1) – the most admirable as well as the most notorious figure in the series – indicates that Epstein was already beginning to look with avidity at the voluptuousness of Indian carvings.

All these heady sources of inspiration ensure that the BMA scheme is marked by unusual diversity. The venture as a whole offers a fascinating insight into the early flowering of Epstein's inventive resources. Rather than feeling overwhelmed by the sheer scale of this monumental commission, the young sculptor was immensely stimulated by the opportunity it presented. Holden gave him the chance to create 'large figures on which I could let myself go'. Epstein explained later that 'I had been like a hound on a leash, and now I was suddenly set free.'[18] Carvings as tender and heartfelt as *Maternity* (fig. 2) prove that he did manage to assert his own individuality on the BMA project. The bulbous-nosed, haggard features of the old woman in *New-Born* (fig. 6) demonstrate how eagerly he had scrutinised a wide variety of physiognomic types ever since his New York days. Growing up in streets he described as 'the most densely populated of any city on earth',[19] Epstein had been mesmerised by the racial richness of a district teeming with immigrants from many diverse parts of the world. They prompted him to draw, and instilled in him a readiness to roam far beyond the restricted ethnic range explored by most sculptors of the period. As early as 1904, he had been delighted to use as models a black boy from Martinique and a Sikh youth from India.[20] But his achievement in the BMA scheme rested, fundamentally, on his ability to fuse the curative side of the commission with his own most deeply felt preoccupations: erotic delight, mortality, birth, virility and above all a celebration of men and women in their unashamed nakedness.

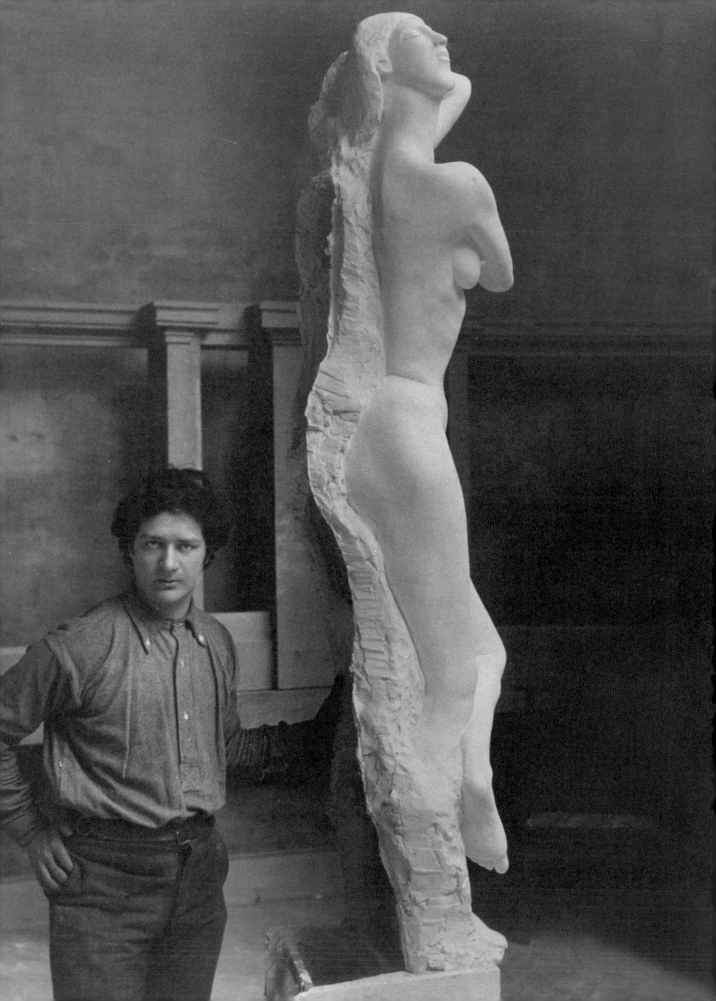

Epstein Befriends Gill

Fig. 7
Jacob Epstein in his studio with the plaster version
of the twelfth BMA statue, 1907

After the BMA venture, sculpture in Britain was never the same again. In July 1908 the young Eric Gill, who had recently befriended Epstein, wrote an impassioned letter to the *British Medical Journal* supporting the endangered statues. Describing them as 'most admirable sculpture', Gill argued that 'when we compare Mr Epstein's work with the florid and ostentatious sculpture on such a building as Messrs Waring's on the one hand, or with the mass of deadly dull work that "graces" the new Government offices on the other hand, we can have nothing but praise for the man who, like Mr Epstein, has attempted to rescue sculpture from the grave to which ignorance and indifference had consigned it.'[1] Such a resounding claim could only be made by someone with a profound belief in the rightness of Epstein's cause, so Gill must already have felt convinced that his new friend would purge British sculpture of its manifold weaknesses.

The two men had first met socially in April 1908, and they were in some respects unlikely allies. Epstein was the son of refugee Polish immigrants deeply attached to the Orthodox Jewish faith. Gill, by extreme contrast, had been born in Brighton, where his father was a clergyman of 'The Countess of Huntingdon's Connection' – an idiosyncratic eighteenth-century sect of Calvinist Methodists. Born in the South Seas, Gill's father belonged to a family of missionaries who travelled far beyond familiar western boundaries. His forebears' example broadened Gill's outlook as a child, introducing him to non-European cultures at an unusually early age. Even so, the Christian religion remained of cardinal importance throughout Gill's childhood. The eldest son of thirteen children produced by his tireless parents, he owed his first name to the hero of Dean Farrar's moral school story *Eric, or Little by Little* (1858). Gill's father never allowed the family to forget the holy presence. He even went so far as to install in the breakfast room a large card depicting a very realistic image of a great eye, accompanied by the ominous text 'Thou God seest me.'[2]

The young Eric therefore had every reason to regard with puritanical mistrust the growth of his prodigious sexual appetite in adolescence. Like Epstein, however, the adult Gill always fought against such an attitude.

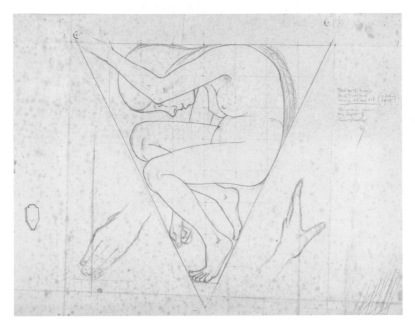

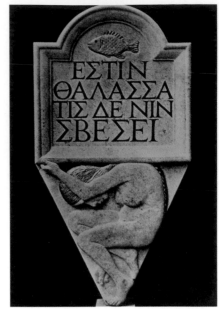

Indeed, he remained preoccupied with the delight and wonder which sexual desire generated within him. 'How shall I ever forget the strange, inexplicable rapture of my first experience?' he wrote in his *Autobiography*, asking: 'What marvellous thing was this that suddenly transformed a mere water tap into a pillar of fire – and water into an elixir of life?'[3]

The erotic side of his nature would eventually become instrumental in developing his interest in sculpture, but when he first moved to London in 1900 Gill was set on an architectural career. Although he enrolled as a pupil in an architect's office, and always regarded the art of building as the mother of all the fine arts, the growth of other interests diverted him from this profession. He began to see himself as a maker and workman rather than a prosperous commercial architect, and his friendship with the great Arts and Crafts calligrapher Edward Johnston proved decisive. 'The first time I saw him writing, and saw the writing that came as he wrote,' Gill recalled, 'I had that thrill and tremble of the heart which otherwise I can only remember having had when I first touched her body or saw her hair down for the first time.'[4] As if to stress the interrelationship between erotic delight and religious conviction, he went on to describe how, watching Johnston write, 'it was as though a secret of heaven were being revealed.'[5] But his willingness to equate the onset of his calligraphic obsession with sexual gratification is enormously significant. The delight he experienced when making love to his fiancée Ethel for the first time, in a Fleet Street hotel room booked for the purpose, became intertwined in his mind with the joy of discovering and extending his creative abilities.

Nowhere does this equation become clearer than in the momentous period, late in 1909, when he executed his first carving (cats 2–3, fig. 8). Gill explained frankly in later life that 'comparative continence'[6] forced him to

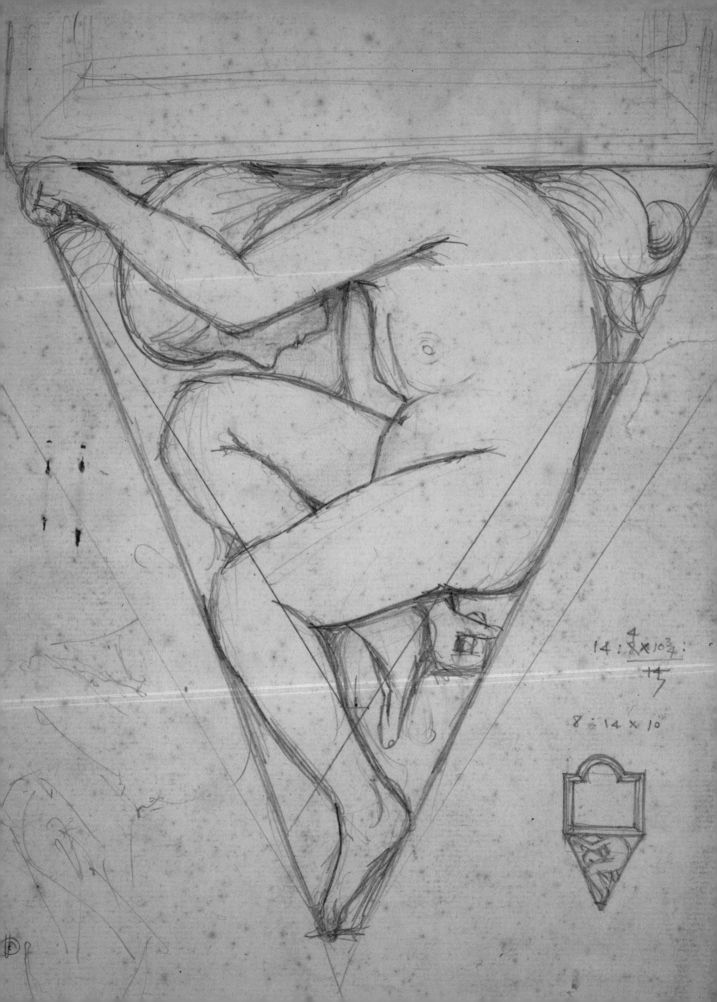

14 : $\frac{4}{8} \times 10\frac{3}{4}$:

8 : 14 × 10

take on the challenge of sculpture: since Ethel's pregnancy often made her sexually unavailable, he turned instead to the making of a stone woman. Far from offering her body to the viewer, though, the naked figure in his carving is burdened with the caryatid-like task of supporting a tablet inscribed in Greek. Commencing with the words 'Estin Thalassa' ('there is the sea'), the quotation is taken from Aeschylus' play *Agamemnon*. Gill never explained why he singled out Clytemnestra's reply to her husband; but the other words on the tablet, 'and who shall drain her dry', may well have possessed an erotic significance for him.

He certainly looked back on the act of carving his first woman with a sense of possessive exhilaration, declaring that 'I was responsible for her very existence and her every form came straight out of my heart.'[7] Indeed, Gill's discovery of his ability as a sculptor may have been bound up in his mind with the excitement of setting out on a maritime voyage of exploration. When he exhibited *Estin Thalassa* at the Whitechapel Art Gallery a year later – the first occasion that he had displayed a carving in an exhibition – the work was described as 'Tablet for the wall of a seaside house'.[8] Perhaps he liked to envisage this small, eccentrically shaped relief facing the epic immensity of the water, where the fish carved at the top of his tablet would find a natural home.

There is a fascinating parallel here with the origins of Epstein's commitment to sculpture. From the outset it was allied with the sense of release that he discovered in tough, manual exertion among surroundings alive with the most untamed aspects of the world. However attached he felt as a young man to drawing the 'moving mass'[9] of humanity, observable from the ramshackle wooden building which afforded him an inexhaustible daily view of street-market life in New York, it was a claustrophobic activity. 'I had been drawing and reading to excess, sometimes in dim light, and my eyes had suffered from the strain,' he remembered, describing how his first attempts at sculpture 'gave me relief'.[10]

Epstein associated this above all with 'a delight in outdoors'[11] engendered by a Whitmanesque expedition he undertook with his artist friend, Bernard Gussow. The adventure remained vividly in his mind for the rest of his life, and decades later he recalled how they had 'hired a small cabin on the shores of Greenwood Lake, in the State of New Jersey. In this mountain country I spent a winter doing little but tramping through snow-clad forests, cutting firewood, cooking meals and reading. To earn a little money we both helped to cut ice on the lake.'[12]

This was, perhaps, Epstein's first experience of carving into natural substances of outsize dimensions, and his work at the lake may well have encouraged him to regard the act of cutting as a large-scale endeavour. He

afterwards described the fortnight's labour on the ice as 'very hard but congenial work', explaining that 'we were taken to the ice-fields by sledges drawn by a team of horses in the early morning' and returned in the evening when 'we saw wonderful snow views of mountainsides ablaze with sunset colours. It was a physical life full of exhilaration.'[13] It might also, according to Epstein's recent biographer June Rose, have been the moment when he and Gussow became lovers.[14] The intimacy of their winter in the cabin may well be reflected in Epstein's frankly homoerotic ink and wash drawing *We Two Boys Together Clinging* (fig. 9), its title inspired by Whitman's celebrated poem about adolescent love.[15]

The consequences of this adventure were profound, for after returning from Greenwood Lake Epstein decided to become a sculptor. He would always believe that the challenge of carving was an activity as demanding, vigorous and close to nature as the ice cutting had once been. It is significant that his most productive and audacious early period as a carver occurred in a remote part of coastal Sussex, where he rented a bungalow intriguingly similar in setting to the 'seaside house' that Gill had envisaged as a setting for *Estin Thalassa*. But several years were to elapse before Epstein found this retreat, which enabled him to 'look out to sea and carve away to my heart's content'.[16] Following the completion of the Strand commission, he reverted to modelling for a while and executed some surprisingly conventional work based on the gypsy Nan Condron. 'After so much that was large and elemental,' he explained later, 'I had the desire to train myself in a more intensive method of working; and, with that in view, I began a series of studies from the model … as exact as I could make them.'[17]

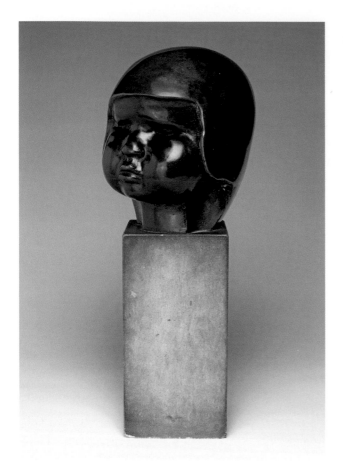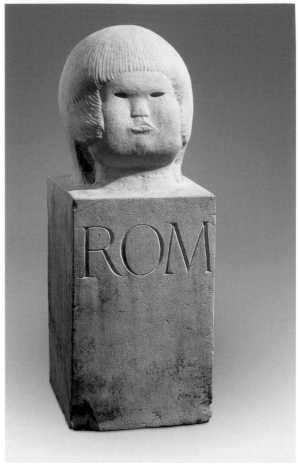

Such a limited aim indicates that Epstein did not yet regard his sculptural training as complete. The results inevitably lack the robust sense of emergent individuality that he began once again to demonstrate in 1910, turning back to his earlier and more powerful bronze head of Augustus John's young son Romilly (cat. 4). Although this melancholy portrait had been commissioned in 1907, its arresting contrast between the naturalistic face and the smooth, helmet-like cap of hair seems prophetic. The disturbingly machine-like simplicity of the boy's burnished hair is the first sign of Epstein's involvement with the form-language that reached its climax in *Rock Drill*. And in the limestone carving he now proceeded to make of the same child (cat. 5), Romilly's head seems to grow like a majestic deity from the block retained in all its cubic simplicity below. Looking at this sculpture close-to, we become intensely aware of its hand-chiselled vigour. Epstein now has no intention of refining the head into a bland smoothness. On the contrary: he wants to declare his own defiant physical involvement with the stone. The base, far from being a subordinate plinth, is left in a proud state of minimal bareness so that nothing detracts from the child's shortened name 'ROM' which Gill incised there with such confident prowess.

above left
4
Jacob Epstein
Romilly John, 1907
Bronze, 42.9 × 16.1 × 19.6 cm
Lent by the Syndics of the Fitzwilliam Museum, Cambridge

above right
5
Jacob Epstein
Rom – second version, 1910
Limestone, 85.4 × 32.6 × 33.1 cm
National Museum Wales, Cardiff. Purchased 1979

By this time, Epstein was moving decisively away from the classical tradition still revered by older and more established sculptors. *Rom*, along with another impressive carving called *Sun Goddess, Crouching* (cat. 6) and a tantalisingly unfinished relief known as *Sun-Worshipper* (fig. 11), announced his readiness to learn from oriental and Egyptian art. Epstein's peers could not understand why he was espousing such heretical sources of stimulus. Nor could they sympathise with his new-found determination to take into account the intrinsic character of the stone itself during the carving process. 'It was at this period', he remembered wryly, 'that I was proposed for membership of the Royal Society of British Sculptors, by Havard Thomas. I was rejected.'[18]

Epstein had embarked on a radical path, and he told C. Lewis Hind that *Rom* was planned as 'one of the flanking figures of a group apotheosising Man and Woman, around a central shrine, that the sculptor destines in his dreams for a great temple'.[19] The project centred on visionary plans hatched by Epstein and Gill for an immense sculptural megalith set in six acres of the Sussex countryside around Asheham House near Lewes.[20] Gill, who unhesitatingly described his friend as 'quite mad about sex',[21] reported in the autumn of 1910 that 'Epstein and I have got a great scheme of doing some colossal figures together (as a contribution to the world), a sort of twentieth-century Stonehenge.'[22]

It was a stirring ambition, and for a while the two young men refused to let these untrammelled hopes be crushed by their chronic lack of financial resources. They interviewed the owner of Asheham, visited Stonehenge for first-hand inspiration and travelled to quarries at Portland and Wirksworth for appropriate stone. They also managed to excite Augustus John with their hopes for the site. He announced, with typical impulsiveness, that 'the Temple must be built. People will take to their heels at the sight of so stupendous a thing walking about in daylight, but they must be overtaken with giant strides. Some sacrifice will be necessary at the foundation – all great buildings begin with the accompaniment of the shedding of blood.'[23]

John's theatrical rhetoric was not, however, backed up by any financial assistance. Without success, Epstein and Gill asked wealthy friends to contribute to the cost either of renting the land on a fourteen-year lease or buying it for £3,500. Gill's frustration is clear enough in a letter he wrote to the painter William Rothenstein, exclaiming: 'But oh! if only we could buy the place outright! Then we should be free to do all we wanted without the fear of hurting anybody's feelings or the risk of being turned out at the end of the 14 years and our figures smashed up by some damned fools who didn't choose to like them.'[24]

overleaf

6

Jacob Epstein
Sun Goddess, Crouching, c. 1910
Limestone, 37.5 × 13 × 10.8 cm
Nottingham Castle Museums and Galleries

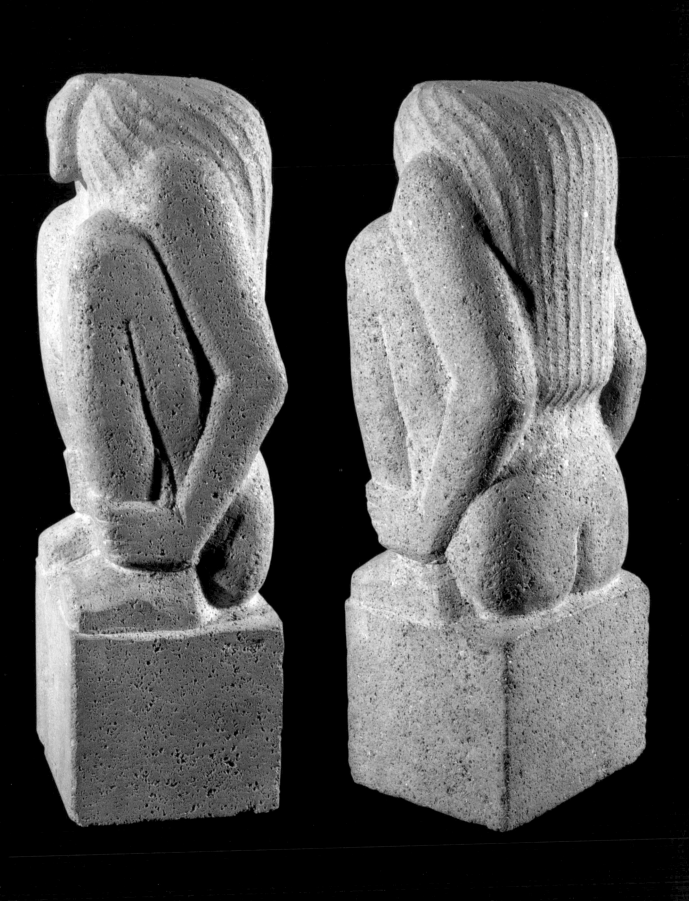

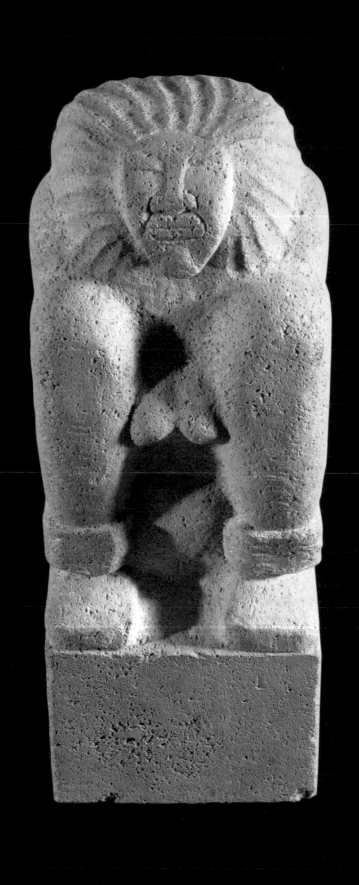

For the moment, though, Epstein and Gill remained bent on convincing themselves that their titanic scheme for a Sussex Stonehenge could somehow be realised. 'I do feel that this is the grandest opportunity,' Gill insisted, 'and it is increasingly evident that it is no use relying on architects & patrons and dealers.'[25] The two sculptors were out on their own. And judging by a drawing inscribed with the words 'One of the hundred pillars of the Secret Temple', Epstein set no limits on the size of the building they envisaged. The intertwined figures defined by his pencil (cat. 7) are frankly erotic, and suggest a new awareness of Indian art. He may well have been alerted to the uninhibited allure of Indian temple carvings by Gill, who announced in 1911 that he and Epstein were united in their agreement that 'the best route to Heaven is via Elephanta, and Elura [*sic*] & Ajanta.'[26]

The power of the sun may have played a major role in Epstein's thinking about the Temple scheme. He carved an imperious *Sun God* in relief, and this commanding figure appears to grow out of the immense Hop-

Fig. 10
Jacob Epstein, *Sun God*, 1910. Hoptonwood stone relief, 213.4 × 198 × 35.5 cm. The Metropolitan Museum of Art, New York. Gift of Kathleen Epstein and Sally Ryan, in memory of Jacob Epstein, 1970. Photographed *c*. 1910

opposite
7
Jacob Epstein
Study for 'One of the Hundred Pillars of the Secret Temple', *c*. 1910
Pencil, 37 × 25.5 cm
Private collection

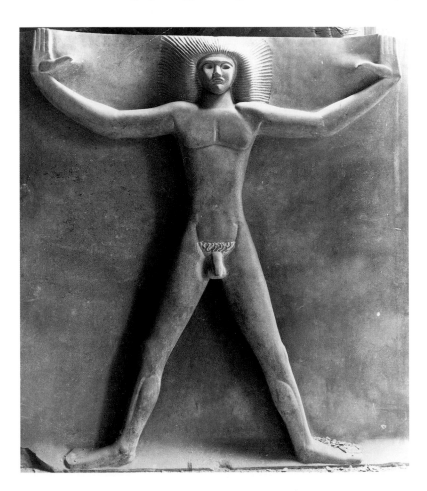

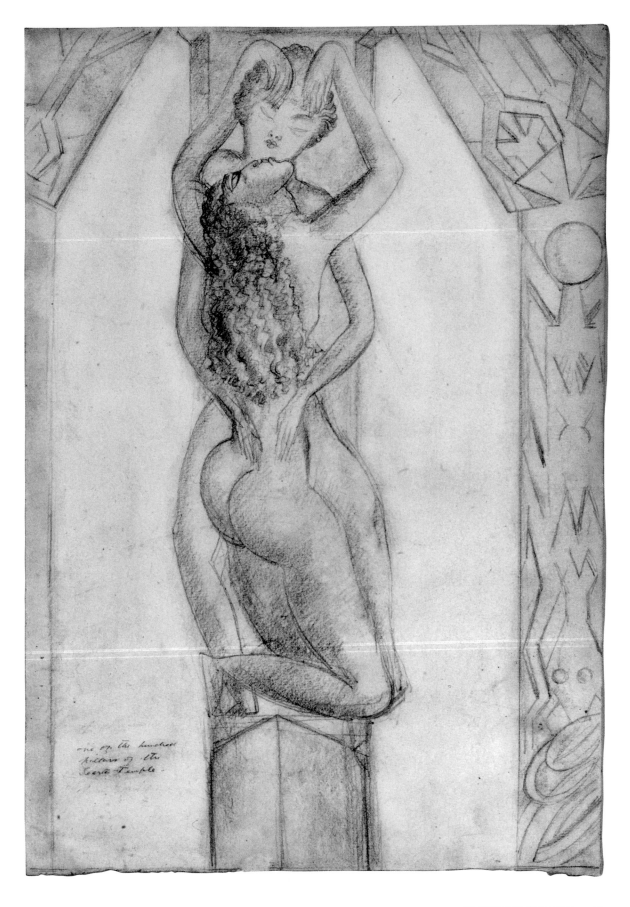

one of the hundred
pillars of the
Secret Temple.

tonwood stone block. The deity stretches out his arms in an authoritative gesture, as if bestowing light and life on the world. His protruding thumbs have a phallic insistence, while Epstein ensures that the god spreads his legs wide enough to expose his genitals with pride. Judging by a photograph taken around 1910 (fig. 10), when the carving was unaffected by the changes and weathering it later suffered, Epstein also gave this virile figure some crisply defined pubic hair.[27] Its surging force is echoed and extended further up, in the dramatic mane exploding outwards from the god's haughty face.

While the *Sun God* exudes the authority of an Egyptian deity, a related carving called *Maternity* (figs 12–13) is closer in spirit to the voluptuous abundance of Indian sculpture. The National Vigilance Association would have been horrified by the amplitude of the pregnant woman's breasts. They jut out towards us, proclaiming both her prodigious sensuality and, at the same time, her readiness to feed the baby flourishing within her ample womb. Epstein was later to explore the theme of imminent maternity in two of his 'flenite' carvings, but this stone figure is conceived on a far larger scale. Reliant on the same type of stone as *Sun God*, she may well have been intended as a major presence in the Sussex Temple. Epstein, clearly believing that her back view was equally important, devoted an immense amount of thought to the palpable pigtail plummeting down towards her provocative, globular buttocks. But he first exhibited her in an unfinished form,[28] and may even have relished leaving the lower half of her figure in a rough state to signify his respect for the innate identity of the stone from which she was hewn.

All the evidence suggests that the works Epstein initially intended for the Stonehenge venture benefited from his momentous decision to liberate his carving procedure from its previous dependence on copying. His BMA figures had, after all, been modelled in the studio, cast in plaster and only then copied in Portland stone with the help of highly professional assistants. Now, however, Epstein was fired by a determination to stake all on the act of cutting straight into the stone. So much is clear when we examine the unfinished *Sun-Worshipper* (fig. 11). Probably related to the Temple project, this little-known carving reveals the raw, rough energy with which the impetuous Epstein attacked his tall slab. Eschewing the more svelte approach adopted by Gill, he makes the naked figure resemble a diver preparing to leap off a cliff edge. The large, circular, unseeing eyes suggest a near-suicidal impulse, and the amount of harshly hacked stone surrounding him accentuates the alarming sense of a man *in extremis*.

This involvement with 'carving direct' would have an enormous influence on the future development of modern sculpture in Britain. And

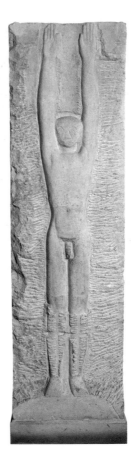

Fig. 11
Jacob Epstein, *Sun-Worshipper, c.* 1910.
Limestone relief, 190 × 54 cm. Leighton House
Museum, London

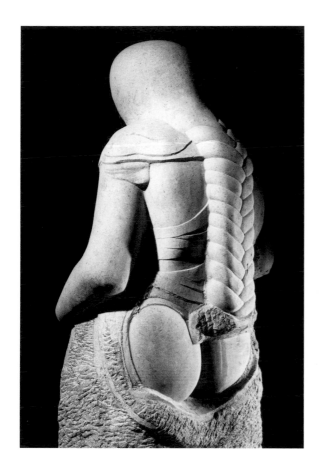

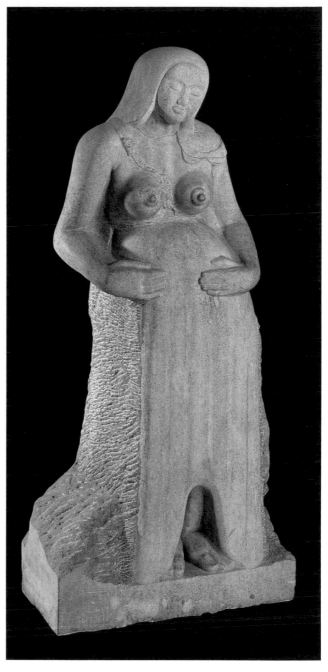

Figs 12 and 13
Jacob Epstein, *Maternity*, 1910–12. Hoptonwood stone,
height 203 cm. Leeds Museums and Galleries,
City Art Gallery

Gill, for his part, was even more committed to the same approach. 'I shall assume', he wrote a few years later, 'that the word sculpture is the name given to that craft and art by which things are cut out of a solid material, whether in relief or in the round. I shall not use the word as applying to the craft and art of modelling. I oppose the word "cut" to the word "model" and assume that a sculptor is one who shapes his material by cutting and not by pressing. The cutting of stone is the type of craft of the sculptor and the modelling of clay, if he practises it at all, is, for him, merely a means of making preliminary sketches.'[29]

Even at the height of his involvement with carving, Epstein would never have been ruthless enough to exclude modelling from the sculptural canon. His later success as a maker of portrait busts commenced during this early period, most notably with a bronze head of the Irish dramatist Lady Gregory (fig. 14) so unyielding in expression that it caused her nephew, the art collector Sir Hugh Lane, to exclaim: 'Poor Aunt Augusta. She looks as if she could eat her own children.'[30] And *Rock Drill*, the most revolutionary product of Epstein's early period, relied on radical ideas far removed from the notion of cutting into stone. Nevertheless, at the time of the Sussex Temple, Gill's passionate belief in the importance of 'carving direct' helped to convince Epstein that it was an activity well worth exploring. During the course of 1910, a key year for both men, Epstein grew more in accord with Gill's insistence on the value of retaining full manual responsibility for every blow of the chisel, and allowing the intrinsic character of the stone to affect the sculpture's fundamental identity. 'Stone carving properly speaking isn't just doing things in stone or turning things into stone, a sort of petrifying process,' Gill explained, 'stone carving is conceiving things in stone and conceiving them as made by carving. They are not only born but conceived in stone, they are stone in their innermost being as well as their outermost existence.'[31] The importance of such a credo, for the course taken by early twentieth-century sculpture in Britain, can hardly be overstated.

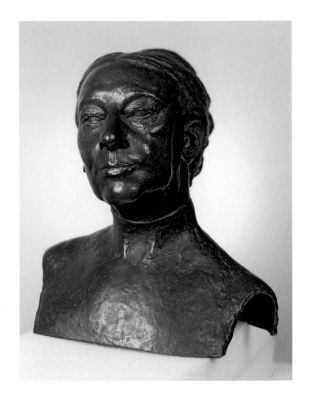

Fig. 14
Jacob Epstein, *Bust of Lady Gregory*, 1910. Bronze, height 38 cm. Leeds Museums and Galleries, City Art Gallery

Both Gill and Epstein learned how to shape their images with the ardency of a lover. But Gill, after settling into his new Sussex home at Ditchling and hoping it would become a craft community inspired by the radical libertarian ideas of the poet and philosopher Edward Carpenter, decided that he would adopt a cotton smock as the apparel of the stonemason.[32] Not only did he feel that men should dress according to their work. He also published an angry attack on the 'commercialism' which forced the male organ – 'the most precious ornament' – to be tucked away in trousers.[33] Throughout his career Gill made drawings of his own genitals as well as other people's, finally deciding to offer 130 'studies of parts' to the Royal College of Surgeons because 'in my opinion anatomy books are not well illustrated in respect of the male organ.'[34] The offer was rejected by the surgeons, who gravely decreed that Gill's drawings were 'not showing any pathological condition'.[35]

Epstein never shared his friend's obsessive need to draw so many genitals. And even at the closest stage of their relationship in 1910, the two men's

commitment to an unmediated engagement with wood and stone origi-
nated in very different underlying concerns. Although religion remained
important to Epstein throughout his life, he would not have agreed with
Gill's impassioned Christian belief that making sculpture was analogous to
the incarnation. Writing of his attempt to carve *Estin Thalassa* in 1909
(fig. 8), Gill likened the result to 'a new alphabet – the word was made
flesh.'[36] Those resounding last five words are a paraphrase of the celebrated
passage from the Gospel according to St John (John I, 14) and suggest that
Gill saw a parallel between the advent of Jesus and carving direct. Just as
Christ spoke to humanity without intermediaries, so the sculptor should
ideally hew his image from the block without help from hired technicians
or a preliminary maquette.

Nor did Epstein sympathise with Gill's desire to bridge the chasm
between artist and workman, ever widening since the onset of the Indus-
trial Revolution. In an age of increasing specialisation, Gill stubbornly
refused to confine his protean abilities. Without any sense of strain he
turned, during the course of a typically productive working week, from
decorative lettering and anatomical diagrams to drawing from life and
monumental carving. The infectious gusto with which he executed even the
most modest commission for an engraved bookplate or a Christmas card
shows how joyfully he attempted to demolish the distinction between 'fine'
and 'applied' art. There was nothing drily dogmatic about Gill's determi-
nation to recover the earlier meaning of the word 'artist' which, as Ray-
mond Williams pointed out, stood for 'skilled person' before the Industrial
Revolution brought about such profound social change.[37] The gulf sepa-
rating art and craft was deplorable to Gill, and he strove tirelessly to reunite
them in his own multi-faceted work.

Epstein, for his part, remained more than happy to rely on Gill's letter-
cutting prowess for inscriptions on works ranging from *Rom* to *The Tomb
of Oscar Wilde* at Père Lachaise Cemetery in Paris. For Epstein himself never
showed any interest in mastering such skills, and probably viewed with
impatience Gill's devotion to incorporating words in so many of his carv-
ings. The sculpture intended by Gill for the Sussex Temple relied signifi-
cantly on inscriptions, above all a stone relief with added colour called
Crucifixion (cat. 8). Its naked figure of Christ could not be more at variance
with the virile, muscular *Sun God* that Epstein carved for the same location.
Gill's crucified figure seems devoid of physical strength. His genitals are
minuscule, and his puny legs as helpless as a child's. No nails can be dis-
cerned either in his hands or feet, for Gill wanted to emphasise Christ's
own courageous willingness to place himself on the cross and die. On its
shaft, a vertical Latin inscription is taken from Psalm CXLVII, 10: 'He

overleaf left

8

Eric Gill

Crucifixion / Weltschmerz, 1909–10
Hoptonwood stone with added colour,
94.6 × 78.1 × 12.7 cm
Tate. Presented by the Contemporary
Art Society 1920

overleaf right

9

Eric Gill

A Roland for an Oliver / Joie de Vivre, 1910
Hoptonwood stone with added colour,
94.6 cm × 68 × 13.3 cm
University of Hull Art Collection

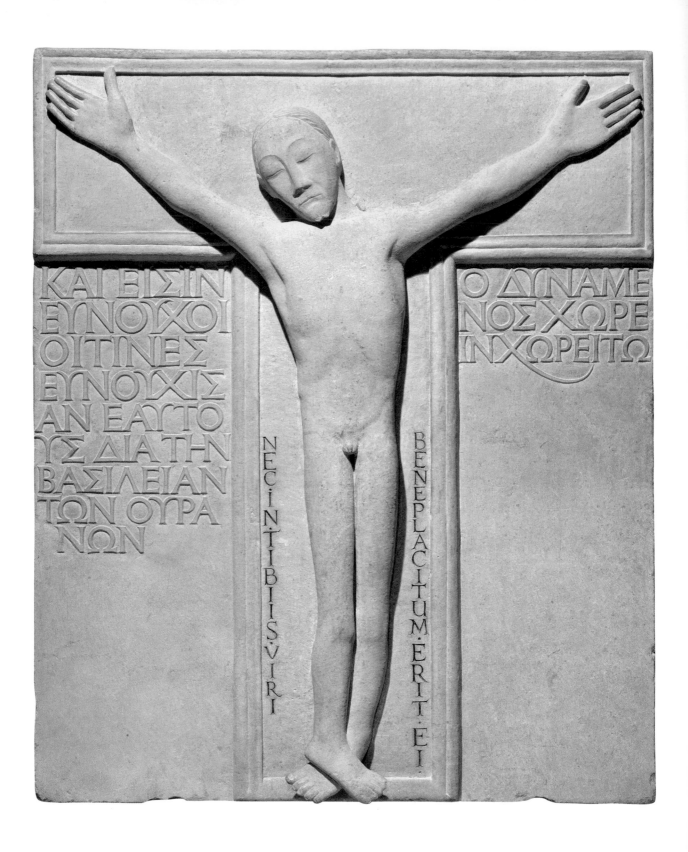

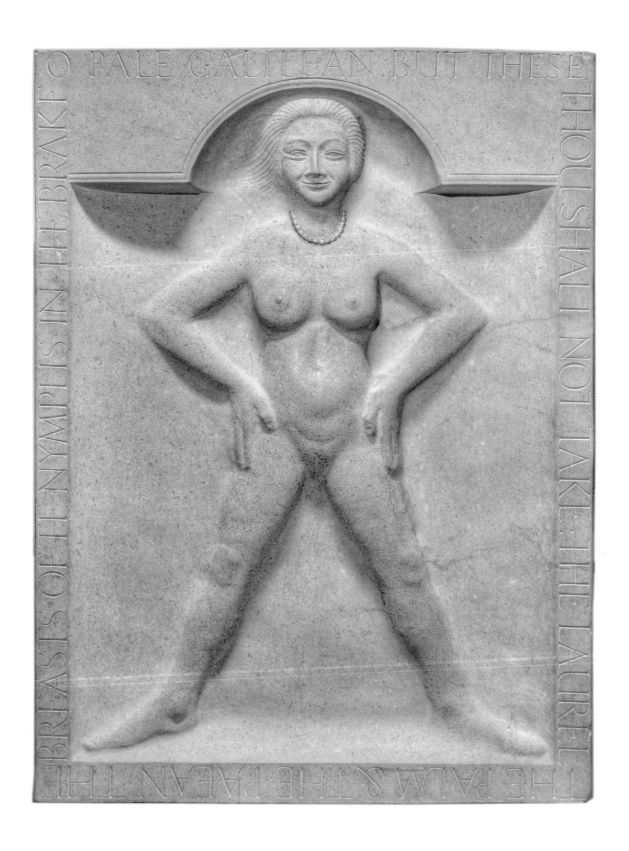

delighteth not in the strength of the horse: he taketh not pleasure in the legs of a man.' But the strangest inscription can be found in the raised, horizontal Greek letters flanking Christ's body. Quoting Matthew XIX, 12, they claim: 'for there are some eunuchs, which were born so from their mother's womb: and there are some eunuchs, which were made eunuchs of men: and there be eunuchs, which have made themselves eunuchs for the kingdom of heaven's sake.' In other words, Gill wanted to stress the power of sacrificial love and show how it makes bodily male strength shrink into insignificance.

Even so, he was equally determined to celebrate sensuality in the bold, startling relief carved as a companion for *Crucifixion*. Like Epstein's *Sun God*, Gill's naked woman in *A Roland for an Oliver* (cat. 9) parts her legs wide and flaunts her genitals. With hands placed jauntily on her hips, a flashing gilded necklace and a greedy smile, this *femme fatale* seems ready for anything. Unabashed, Gill initially painted her with red lips and nipples. He must have guessed that some critics would denounce him, and the influential Frank Rutter duly declared that 'the gold chain round the woman's neck produces an effect dangerously near that of the black stockings in some of Félicien Rops's pornographic etchings.'[38] Only in 1913 did Gill grant an embarrassed request from the prudish Contemporary Art Society, who had acquired the relief, to tone them down.[39] So this blatantly erotic woman was clearly intended as the absolute opposite of the self-sacrificial Christ. Gill's working title for the *Crucifixion* carving was 'Weltschmerz' (pain), whereas he originally referred to his sensual woman as 'Joie de Vivre'. The idea that they were in conflict was underlined by his subsequent adoption of the title *A Roland for an Oliver*, which, according to Gill's brother Evan, means 'tit-for-tat'.[40]

But Evan also revealed that Gill meant to 'imply an evenly matched combat'.[41] So it would be a mistake to assume that viewers were expected to ally themselves either with Christ or the painted lady. True, the lettered inscription running all the way round the frame of *A Roland for an Oliver* is a quotation from Algernon Swinburne, who notoriously rejected Christianity in his 1866 book *Poems and Ballads*. In 'Hymn to Proserpine', Swinburne supported the views of Julian the Apostate, a pagan Roman emperor of the fourth century who was determined to attack Christianity at every turn: 'O pale Galilean. But these / thou shalt not take: the laurel / the palm & the paean the / breasts of the nymphs in the brake.'[42] Swinburne undoubtedly intended to mount a full-scale assault on Christ and his believers, and yet Gill maintained that biblical faith could even be retained while he embraced the nymphs' breasts with enthusiasm. As Judith Collins has argued, 'Gill wanted to state his belief

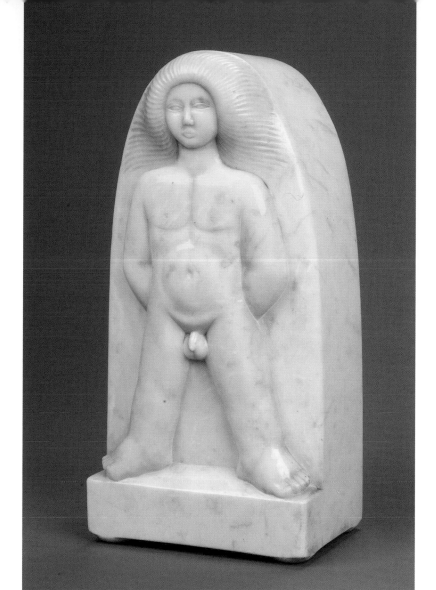

10
Eric Gill
Cupid / A Cocky Kid, 1910
White Sicilian marble, originally gilded,
28 × 13.6 × 9.5 cm
Art Collection, Harry Ransom Center,
The University of Texas at Austin

that it was possible to choose both paths simultaneously. One did not cancel the other out: on the contrary, they enhanced one another.'[43]

Gill's love of Indian art and Hindu belief played a decisive role in helping him to arrive at this duality. He admired in particular the writings of the Sri Lankan philosopher Ananda Coomaraswamy, who called for 'a frank recognition of the close analogy between amorous and religious ecstasy', pointing out that 'the imager, speaking always for the race, rather than of personal idiosyncrasies, set side by side on his cathedral walls the yogi and the apsara, the saint and the ideal courtesan.'[44] Hence Gill's decision to place *Crucifixion* and *A Roland for an Oliver* side by side when they were first exhibited. Virtually the same size and carved around the same time, they gain an immense amount in meaning when seen as a pair. It is a great pity that the Contemporary Art Society gave them to two separate public collections.[45] On the back of both reliefs Gill carved an eye in a hand, signifying that they were once intended for the Sussex

11
Eric Gill
One of forty-nine 'love drawings', man and woman
entwined (design for *Ecstasy*), *c.* 1910
Pencil on tracing paper, squared for transfer,
24.2 × 14 cm
British Museum, London

opposite
12
Eric Gill
Ecstasy, 1910–11
Portland stone, 137.2 × 45.7 × 22.8 cm
Tate. Purchased 1982

open-air Temple dedicated to love. And two of his other carvings are incised
with the same symbol. One of them is *Cupid / A Cocky Kid* (cat. 10), a
white marble relief resembling a mischievous miniature version of Epstein's
Sun God. We do not know how Gill wanted to display this cheeky little
figure in the Temple: the failure of the 'twentieth-century Stonehenge'
project meant that he sold *Cupid / A Cocky Kid* to his brother-in-law
Ernest Laughton for 'half a sovereign to get rid of it'.[46] But Gill's fourth
Temple carving, a taller work now called *Ecstasy* (cat. 12), found an eager
purchaser in Edward Warren, the wealthy and unashamedly lavish collec-
tor from nearby Lewes who commissioned Rodin's monumental marble
The Kiss in 1904.[47]

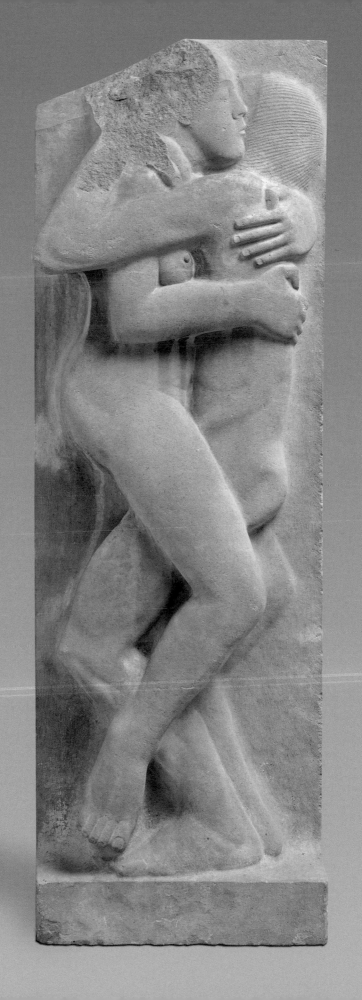

The young man and woman in Gill's *Ecstasy* have, however, gone far beyond kissing. Even more intertwined than the two naked figures in Epstein's drawing *Study for 'One of the Hundred Pillars of the Secret Temple'* (cat. 7), they are blatantly engaged in sexual intercourse. Gill, who probably never called this carving *Ecstasy* himself, referred to it with great directness in his diaries as 'They (big) group fucking'.[48] The man, whose face is hidden behind his partner's, lifts the woman and takes her standing up. In this respect, Gill wanted to celebrate a form of sexual union removed from conventional notions about horizontal copulation in bed. The carving goes further than his carefully squared-up preliminary pencil study (cat. 11), where both lovers hide their faces and the woman's feet are still touching the ground. In the carving, the man lifts his lover and she clings onto him far more tightly. Gill must have decided that his pencil study lacked animal passion. That is why the two figures are so convincingly locked together in the carving, and why the woman's facial features are now revealed with her eyes tight shut.

The 'fucking' sculpture seems even more daring once we realise that Gill habitually relied for his work on scrutinising live models. Moreover, Fiona MacCarthy made clear that 'he liked people close at hand, people he

Fig. 15
Eric Gill, *Votes for Women*, 1910 (lost). Stone relief, rubbing, 37 × 39 cm

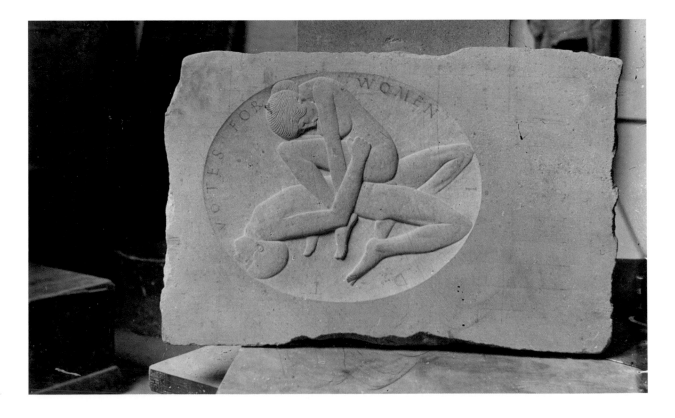

was used to; his friends and relations "or whoever was willing to take his or her clothes off". This came to be accepted as more or less a matter of course in the Gill households: the euphemism for it was "helping Mr Gill".[49] But the genesis of this particular carving becomes rather disconcerting when we discover that the models were his sister Gladys and her husband Ernest Laughton, who had bought *Cupid / A Cocky Kid* for 'half a sovereign'. They also posed for another, equally shocking stone relief of experimental sex called *Votes for Women* (fig. 15). Here, Gladys takes charge and sits astride the recumbent Ernest, who curves back in submissive delight. Reliant on more acrobatic poses than the other carving, *Votes for Women* may appear to be an unequivocal celebration of the suffragette movement then gaining ground across Britain. Even so, nothing is straightforward in Gill's work. Fiona MacCarthy believes that the three letters I.D.T. inscribed in the lower part of the relief stand for 'I don't think'.[50] Moreover, she points out that at the time Gill worked on these intercourse carvings he was 'embarking on the incestuous relationship with Gladys which lasted almost all his adult life'.[51]

Neither of these copulation pieces could possibly be displayed at Gill's first solo exhibition, held in January 1911 at the Chenil Gallery in Chelsea. But *Votes for Women* was at least shown to enquiring visitors in the back room, even if nobody bought it. Gill wrote to his admirer the economist John Maynard Keynes after the show and asked him if he would buy it for a fiver. Keynes sent the money by return of post, and *Votes for Women* was duly sent to his house in Cambridge. When his astonished brother asked: 'What does your staff think of it?', Keynes replied: 'My staff are trained not to believe their eyes.'[52] Unfortunately, at some point *Votes for Women* mysteriously vanished. Nobody in the family now knows what happened to this carving, which Gill once listed as 'Lovers – a joke (small)'.[53]

Gill Championed by Fry

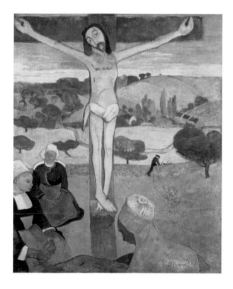

Fig. 17
Paul Gauguin, *The Yellow Christ*, 1889. Oil on canvas,
92.07 × 73.34 cm. Albright-Knox Art Gallery, Buffalo, NY

Fig. 16
Eric Gill, *c.* 1908

Not surprisingly, the carvings on view in Gill's Chelsea exhibition caused an immense stir. They did, after all, include *Crucifixion* and *A Roland for an Oliver*, but the Chenil Gallery's owner was astonished by the attention they received. Although some commentators berated them, Gill won new admirers among the emergent generation of artists who were about to revolutionise modern British art before the First World War. Wyndham Lewis was fascinated. 'Were you in London just now,' he wrote to a friend around February 1911, 'we should be discussing Eric Gill, the sculptor vouchsafed to England at last, according to Roger Fry. This Gill is an obtrusive, eager and clumsy personage. His works are small, excellent and ribald. He has done a Christ immolating himself on the Cross: next door to it, a saucy female figure … typifying Lechery.'[1] Savouring Gill's subversive willingness to challenge and upset conventional expectations, Lewis laughingly reported Augustus John's assertion that Gill 'may supply the mind sorely needed (selon ce dernier) by our friend Epstein. How much more mind do you think is needed to work the large & up to date machinery of Epstein's energy? Do you think Gill sounds as though he'd be enough?'[2]

Roger Fry, for his part, responded to Gill's exhibition with unqualified admiration. In the wake of the scandalous and seminal exhibition he had just curated at the Grafton Galleries, 'Manet and the Post-Impressionists', Fry was the most talked-about critic in Britain.[3] Desmond MacCarthy, his collaborator on the show, aptly described it as 'the Art-Quake of 1910', explaining that it aimed at 'no gradual infiltration, but – bang! an assault along the whole academic front of art'.[4] This landmark exhibition effectively introduced a reluctant and often infuriated nation to the heretical work of Paul Cézanne, Vincent van Gogh and, with the most generous number of works, Paul Gauguin. So Fry would have warmed immediately to the fact that Gill based the figure in his *Crucifixion* relief on Gauguin's painting *The Yellow Christ* (fig. 17).[5]

Above all, though, Fry relished the trio of tender, densely considered *Madonna and Child* carvings in Gill's show. They concentrated on the most human aspect of this time-honoured biblical theme. Rather than present-

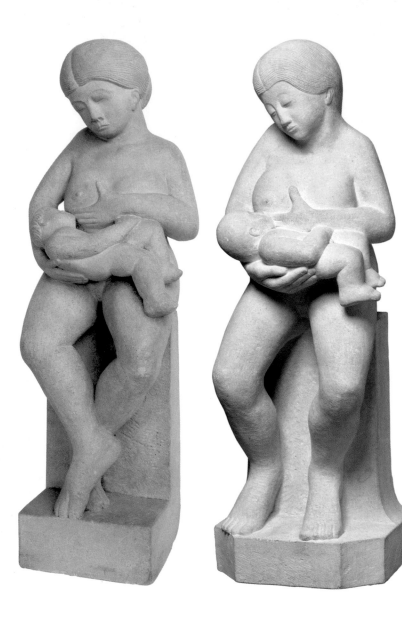

ing the Virgin and Christ Child as aloof and removed from bodily concerns, Gill insisted on showing them as baby and mother. In the earliest of the three carvings (cat. 13), she crosses her feet – possibly in order to give her offspring the support he needs. But she also slides her right forearm under his back and lifts him up towards her breast, proffering the nipple with her left hand. This gentle work is an embodiment of quiet intimacy. Although naked, the Madonna has none of the leering, erotic ostentation that Gill celebrates in *A Roland for an Oliver*. And he contrasts the mother's plump, rounded fertility with the severe, cubic simplicity of the Portland stone block on which she rests.

Just after Gill finished this carving in January 1910, his wife Ethel gave birth to their third and youngest daughter, Joanna. So his decision to focus

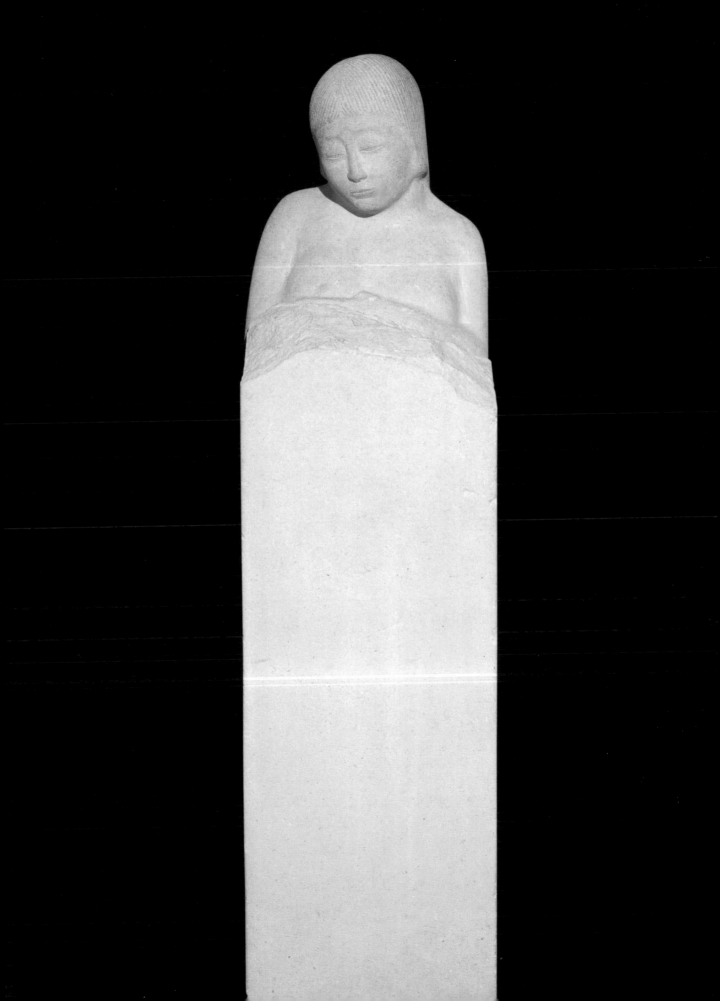

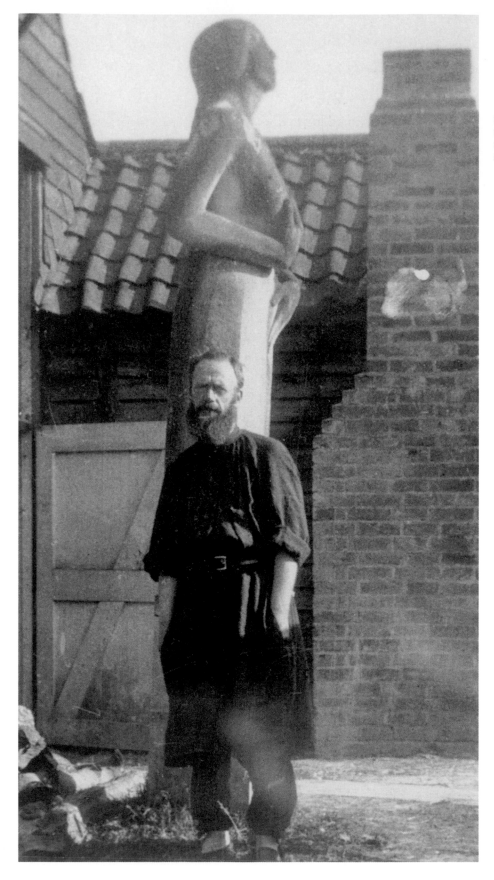

Fig. 18
Eric Gill standing in the courtyard at
Ditchling with *Mulier B.V.M.* in the
background, 1911

on this theme must have sprung from his awareness of imminent fatherhood as well as memories of observing Ethel nurturing their other children. A few months later he embarked on a closely related carving in the same stone (cat. 14), relying on a plaster copy of the clay model made in preparation. In this instance, then, 'carving direct' was not a matter of cutting straight into the stone and relishing an exploratory relationship with the material. Gill here wanted to be more careful, arriving at a fully finished piece in which the Madonna now places her feet apart. As a result, she looks more relaxed than in the first version, and seems remarkably uninhibited about exposing the part of her body from which the baby made his entrance into the world. The whole carving is more confident than before, demonstrating above all Gill's ability to convey the heartfelt bond between mother and infant.

Fry was so impressed that he reviewed the show with great enthusiasm, extolling Gill's 'simple, sincere and deeply-felt images' before asking: 'Has anyone ever looked more directly at the real thing and seen its pathetic animalism as Gill has? Merely to have seen what the gesture of pressing the breast with the left hand means, as he has, seems to me a piece of deep imagination.'[6] In the most mysterious of the three *Madonna and Child* pieces (cat. 15), though, Gill left much of the stone block in an elemental state. Only the mother emerges, stretching her left arm towards the right breast for her child to feed. The baby is invisible, and Gill has made no attempt to hide the broken handling of the stone block where he intended to start carving the infant. Although most contemporary sculptors would never have dreamed of displaying such a frankly 'unfinished' work, he made it the very first exhibit in his Chelsea show. Gill may have told Maynard Keynes, who acquired the work, that he intended to 'carry the Mother & Child somewhat further', but he predicted that 'it will still differ wholly from the other two on view here'.[7] In the event, Gill decided to reveal neither the baby nor the rest of the Madonna's body. They remained within the Portland stone, allowing the viewer to imagine them there even as Gill asserted the strong, uncompromising identity of the block itself. No wonder John Knewstub, the owner of the Chenil Gallery, reported that this version of the *Madonna and Child* carvings 'is far and away the most appreciated of the three'.[8]

Not that Fry favoured an 'unfinished' work when he invited Gill to carve a full-length stone figure (fig. 18) for the impressive garden of his house on a hill outside Guildford. Called Durbins, it had been designed in 1910 by Fry himself, with help from Gertrude Jekyll. The commission delighted Gill, who set to work with great fervour on his largest sculpture to date. He called the garden statue *Mulier B.V.M.* to emphasise that this

standing woman, with prominent breasts exposed, was indeed the Blessed Virgin Mary. She looks upwards, as though communing with heaven. But the Latin title indicates that she is mother of all mankind, and her right hand closes round a nipple as if offering it to everyone on earth. Perhaps that is why Gill posed beneath the statue with his own burgeoning family for a photograph taken at his Ditchling studio. He must have wanted her to vie with the fecundity of Epstein's *Maternity*, and the Virgin's other hand is pressed over her genital area to stress the miracle of birth.

Fry, however, reacted badly to the finished carving. For all the boldness he had shown in curating the notorious Post-Impressionist exhibition, Fry now decided that a half-naked figure of the Virgin could not, in the end, be displayed in his Guildford garden. 'This has nothing to do with the statue itself', he told Gill, claiming that it 'has splendid qualities … I think the hands are perhaps the finest thing you have yet done.'[9] The problem centred on Fry's awareness of what he called 'a good many people's susceptibilities'. The champion of avant-garde liberty felt surprisingly timid about causing offence to 'totally unartistic people coming to the house for my sister's philanthropic meetings and I can't have a largely provocative question mark stuck up for them on the way.'[10] Gill reacted with understandable impatience, telling a friend that Fry was 'frightened of it and, as my brother said, it hardly goes with strawberries and cream and tea on the lawn at Guildford.'[11]

Even when Gill stayed the night at Durbins to discuss a replacement, he fell out with his Quaker host on religious grounds and noted in his diary: 'Fry v. antagonistic re. Catholicism.'[12] Yet the two men agreed that Gill should carve a somewhat smaller statue, again in Portland stone, and this time the outcome proved acceptable. Preliminary drawings disclose that Gill initially considered carving a naked youth as well as a female figure. The clay model he made for Fry's approval, though, settled as before on a semi-naked woman. And the final work, called *The Virgin* (cat. 16), again shows her single foot appearing from beneath a long skirt. But in other ways, this second garden statue differs from its rejected predecessor. The woman, based on Gill's sister Angela who posed for the purpose, no longer calls attention to her genital area. Nor does she clasp a breast with her hand. Instead, she raises both arms upwards, echoing the angle of her head. This Virgin seems wholly absorbed in the heat and light emanating from the sky. She could easily be a Sun Goddess, a female companion to Epstein's *Sun God*. A plait hangs down her back, once more echoing its far more ample precursor in Epstein's *Maternity*. And taken as a whole, Gill's *Virgin* is more relaxed than his *Mulier B.V.M.* Her skirt now encloses a rounded body, dispensing with the angular treatment of the same garment in the first version.

48

Fig. 19
Installation of the Second Post-Impressionist Exhibition,
Grafton Galleries, London, 1912, with Eric Gill's
The Virgin in front of, from left to right, Henri Matisse's
Seated Nude (Olga), *Dance, I* and *Jeanette, IV*

opposite
17
Eric Gill
The Rower, 1912
Polished Hoptonwood stone,
25.6 × 28 × 5.1 cm
Private collection

When Gill travelled to Guildford to install the statue at Durbins in August 1912, the figure's flowing forms may well have reminded Fry of Henri Matisse. Two months later he included Gill's *Virgin* in his 'Second Post-Impressionist Exhibition' at the Grafton Galleries, a major survey which embraced young English and Russian artists as well as the titans of the Parisian avant-garde.[13] The prominence accorded to Gill can be seen in the exhibition catalogue, where *The Virgin* is shown positioned directly in front of Matisse's painting *Dance, I* and two bronzes by the same artist (fig. 19). Fry's show also displayed several examples of Gill's fascination with naked contortionists. Carved in polished Hoptonwood stone, they included a naked female figure owned by Fry himself.[14] Gill must have delighted in her acrobatic ability to kneel on her right knee while she clasps a jutting right foot in her hand. Perhaps the most witty and provocative of these contortionists is *The Rower* (cat. 17), a naked figure whom Gill photographed in two startlingly different positions. When seated, her toe-clutching pose does indeed resemble a woman rowing. But when shifted to a standing alternative, she allows her bare buttocks to protrude with shamelessly erotic bravado.[15]

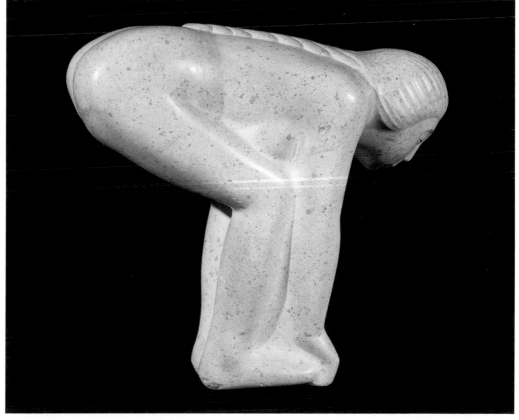

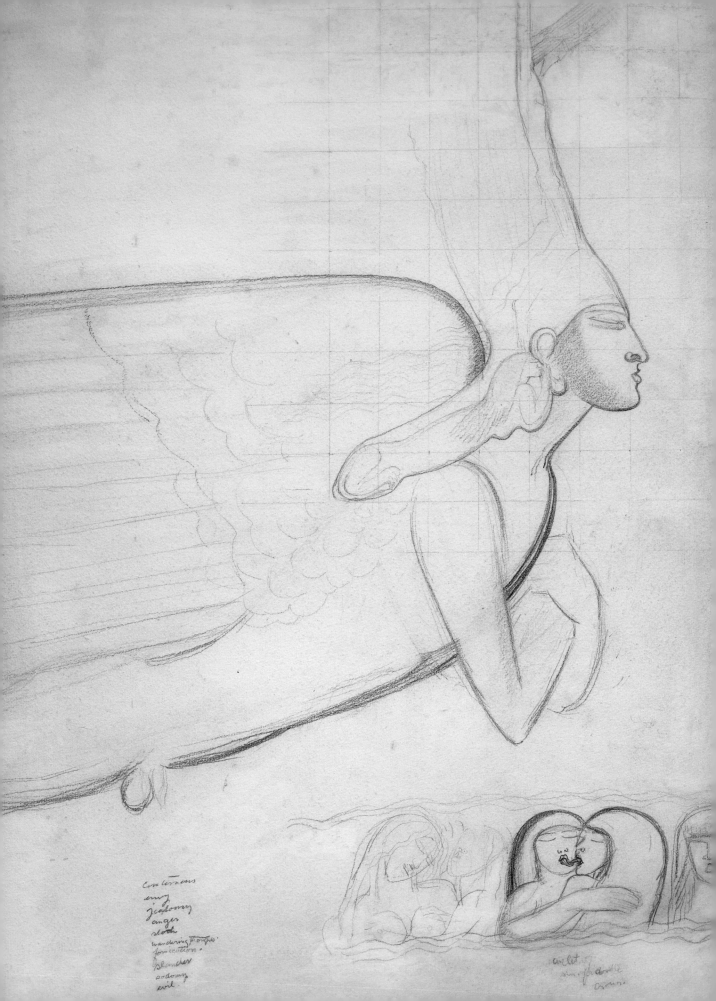

Covetousness
envy
Jealousy
anger
sloth
wandering thoughts.
fornication.
blasphemy
sodomy
evil.

CHAPTER FOUR

The Cave of the Golden Calf and the Tomb of Oscar Wilde

Fig. 20
Madame Strindberg, c. 1912

18
Jacob Epstein
Study for The Tomb of Oscar Wilde and a Frieze,
c. 1910
Pencil, 50.8 × 38.1 cm
Private collection

Fry's championship of Gill was, however, unaccompanied by admiration for the work of Epstein. He was a notable absentee from the 'Second Post-Impressionist Exhibition', for Fry had withdrawn the support he gave Epstein at the height of the hysteria surrounding the Strand statues in 1908. Back then, Fry calmly declared that Epstein's carvings were 'serious attempts to treat the figure in a manner harmonious with its architectural setting'. After maintaining that he had 'failed to find anything approaching "suggestiveness"' in the threatened statues, Fry concluded by hoping that 'such a praiseworthy attempt to solve a difficult artistic problem, and one so full of hope for the future, will not be checked in deference to an agitation which I believe no serious artist or student of art would endorse.'[1] Four years later, though, Fry reacted far less favourably to Epstein's *Maternity* (figs 12–13) when the monumental carving was first exhibited at the Allied Artists' Association in the summer of 1912. Although his friend the art critic Clive Bell considered that it would 'secure for its author pre-eminence among British sculptors',[2] Fry decreed that the pregnant figure lacked 'vitality' and lamented that 'it is terrible that such a talent and such a force of character and intellect as Mr Epstein has remained ineffectual.'[3]

Frida Uhl Strindberg thought otherwise. When she founded her Cabaret Theatre Club off Regent Street in 1912, Epstein was one of the five young artists commissioned to transform its interior. Madame Strindberg herself (fig. 20), an exuberant Austrian writer once married to the playwright August Strindberg, was infuriating, sexually ravenous, unreliable with money yet magnificently fearless. She issued an outspoken manifesto trumpeting her bold and emancipated aims: 'We want a place given up to gaiety, to a gaiety stimulating thought, rather than crushing it. We want a gaiety that does not have to count with midnight. We want surroundings, which after the reality of daily life, reveal the reality of the unreal.'[4]

From the moment it opened in June 1912, the Cabaret Theatre Club was hailed for the adventurous painting and sculpture galvanising its principal arena: the Cave of the Golden Calf (fig. 21).[5] London's first 'artists' cabaret' occupied suitably underground premises in a cloth merchant's

warehouse basement. And its astounded visitors were bombarded by incendiary images, assaulting them on every side. The abrasive new art was here unleashed in an overheated cavern brazenly devoted to the delights of sensual abandon. Only someone as headlong and cosmopolitan as Madame Strindberg could have realised such a vision in London. Excited by precedents in continental Europe, where artistic experiment and the cabaret tradition were closely linked, she echoed in the Golden Calf's title their fondness for giving clubs the names of animals – a cat, rabbit or bat. And the location she discovered for her Cave was as subterranean as the space occupied by Josef Hoffmann's innovative Kabarett Fledermaus in Vienna, or the French wine-cellars where the word 'cabaret' had originated in centres for informal dance, singing and circus acts.

Madame Strindberg wanted the performances on her cabaret stage to be above all 'spontaneous and flexible'.[6] Her choice of setting in Heddon Street, an obscure cul-de-sac off Regent Street, was defiant and subversive compared with the sumptuous interior of the Café Royal nearby. Its chandeliers, mirrors and red plush seats belonged to the old century, whereas the

A NIGHT IN THE CAVE OF THE GOLDEN CALF.

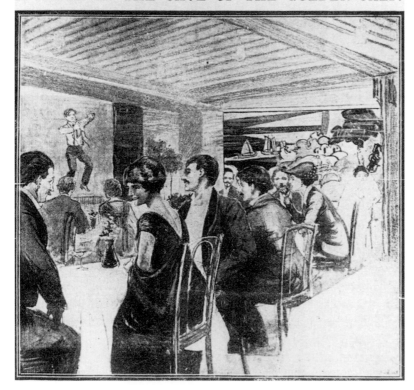

54

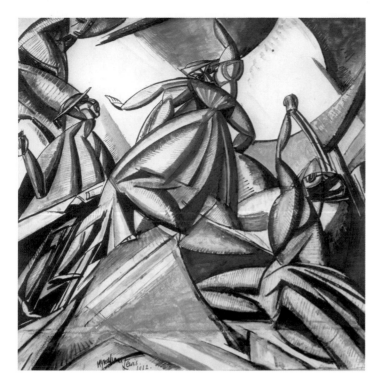

Fig. 22
Wyndham Lewis, *Kermesse*, 1912. Ink, wash and gouache, 30 × 29 cm. Private collection

Cave's air of dissent heralded a pugnacious new order. Augustus John, who was initially attracted to this Amazonian woman, ended up describing her as a 'walking hell-bitch of the Western World'.[7] For Madame Strindberg had no intention of enlisting his services for the Cave's decoration. Instead, she turned to five of the most promising young painters and sculptors in London, exhorting them to make her Cabaret a showplace for modern art at its most advanced.

Spencer Gore, then at the most audacious point in his sadly short-lived career, took responsibility for the blazing overall colour scheme. He also worked closely with his friend Charles Ginner on some monumental wall decorations with exotic locations. Jungle scenes painted by the Douanier Rousseau influenced them as much as Gauguin's Tahitian idylls, but both Ginner and Gore worked in a sharp-edged, stripped-down style of their own (fig. 21). They made sure that visitors to the Cave were surrounded by visions of a South Seas nirvana, where elephants, tigers and monkeys moved through scarlet vegetation and naked horsemen rode bareback after deer whose leaping contours were reminiscent of prehistoric art.[8] The most arresting of all the paintings, though, was by Wyndham Lewis. Called *Kermesse*, it referred to orgiastic festivals he had seen during his early travels on the Continent. This immense canvas, now lost, was Lewis's youthful masterpiece, and surviving studies show how dancing figures were turned into an aggressive display of thrusting, semi-mechanistic aggression (fig. 22).[9]

Nothing now remains of the sculpture Epstein produced for the Cave. But it probably chimed well with Lewis's work, for around this time Epstein approvingly told a friend that 'Lewis's drawing has the qualities of sculpture.'[10] When approached by Madame Strindberg, he probably found that the setting revived his architectural ideas for the abortive Temple project at Asheham. 'Two massive iron pillars supported the ceiling,' he recalled, 'and I proposed surrounding these with sculpture.'[11] Although no preliminary drawings appear to survive, let alone photographs of the finished work, Epstein later described it as 'a very elaborate decoration which I painted in brilliant colours'.[12] It could hardly have been further removed from the monumental work he had spent the previous few years labouring on: a stone carving, *The Tomb of Oscar Wilde* (see figs 24–25). At the Cave, by contrast, he 'proceeded directly in plaster',[13] covering both the iron pillars with a riotous array of images.

One awed visitor, Violet Hunt, recalled that 'all had scarlet details, the heads of hawks, cats, camels'.[14] The images Epstein modelled and then painted must have been raspingly in accord with the primitive jungle scenes on the walls nearby. But Lewis remembered that Epstein transformed the pillars into 'figures appearing to hold up the threateningly low ceiling'.[15] So they were probably a freewheeling amalgam of human and animal forms, laced with the kind of unabashed eroticism which appears in a slightly later drawing called *Totem* (cat. 19). Here, Epstein unleashed his fascination with the procreative act, showing an inverted man copulating with a woman while she triumphantly holds a baby high above her head. The caryatid-like images Epstein made for the Cave may well have been equally erotic, heightening the brazen, outlandish atmosphere that Madame Strindberg wanted her Club to possess.

Gill would have been even more enthusiastic than Epstein about making work for the Cave. After all, Madame Strindberg asked him to create the central image of the golden calf itself. Long before Damien Hirst set about making his own version of the same animal in 2008 with the help of 18-carat gold, silicone and formaldehyde,[16] Gill agreed to carve a gilded calf and, according to the Cave's promotional literature, build 'a pedestal' to ensure that the glowing creature was displayed with maximum prominence.[17] The idea of producing such an idolatrous symbol must have been irresistible to Gill, who enjoyed angrily pronouncing that 'it is high time to create works of art to destroy the morality which is corrupting us all.'[18] His calf was intended to ignite as much hedonistic revelry among the Cave's clientele as its biblical predecessor had done with the Israelites. And Gill would have savoured the thought of offending Catholic priests who believed that sex was 'like being in the W.C. (quite pleasant, not necessarily sinful, but only a dirty function)'.[19]

First of all, Gill drew a simple linear calf for the Cave's membership cards and, on their handsome red covers, stamped the animal in gold above the club's name. The placidity of this image may have been influenced by Madame Strindberg's insistence that the card had an official purpose, enabling members to get past security guards and enter the Cave. But when Gill turned his attention to a painted stone bas-relief of the calf, it became much friskier. A sprightly pencil and watercolour study for this carving (cat. 20) shows the animal in motion, striding eagerly forward and sniffing the air expectantly. His genitals are defined with greater prominence, while on the left side of the drawing Gill outlined an erect phallus. He also drew a curving penis near the top, and a photograph of the lost bas-relief reveals that the hooks on its frame were frankly phallic. This provocative carving was displayed in a position 'adjoining the entrance',[20]

20

Eric Gill
*Study for Bas-relief of Calf in
'Cave of the Golden Calf'*, c. 1912
Watercolour and graphite, squared for transfer,
24 × 40 cm
Yale Center for British Art, New Haven.
Paul Mellon Fund

so it might have been intended to entice anyone who felt wary about sampling the pleasures on offer within. Gill executed both animal and lettering with such lucid, incisive care that one marvelling visitor hailed the lost work as 'a masterpiece'.[21]

The larger calf carving (cat. 21), described in his account book as 'on pedestal in the round',[22] was probably intended to gleam in the lamplight and become a mesmerising focal point for the feverish dancers whose antics enlivened the Cave from midnight until dawn.[23] Gill's vigorous pencil study (fig. 23), more forceful than his drawing for the bas-relief, conveys the excitement he felt about making an alluring idol for the twentieth-century equivalent of all those revelling, licentious Israelites. Seen from the side, the calf in the pencil study strains forward, as if urging everyone to cast inhibitions aside. He may even yearn to join in the dancing. And his tail juts up behind him like a stiff rod, quite unlike the gently drooping tail of the animal in the bas-relief. Gill's pencil study also shows a front view of the calf, where his tail seems even more erect and both ears stick out – perhaps in a mischievous attempt to hear all the riotous noises around him.

Although Gill lowered the tail when he carved his final gilded sculpture, the sense of diagonally tilting urgency is retained. This would have been a calf ideally suited to the nocturnal excitement of a Cave where, as the writer Osbert Sitwell recalled, 'the lesser artistes of the theatre, as well as the greater, mixed with painters, writers, and their opposite, officers in the Brigade of the Guards.'[24] The underground nightclub appeared to Sitwell's intoxicated young eyes 'a super-heated Vorticist garden of gesticulating figures, dancing and talking while the rhythm of the primitive forms of ragtime throbbed through the wide room.'[25] Ezra Pound, Katherine Mansfield,

Fig. 23
Eric Gill, *Study for The Golden Calf*, 1912. Pencil,
13 × 16.7 cm. William Andrews Clark Memorial Library,
University of California

below
21
Eric Gill
The Golden Calf, 1912
Hoptonwood stone, originally gilded, now painted grey
with black hooves, 42 × 55.5 × 18 cm
Art Collection, Harry Ransom Center,
The University of Texas at Austin

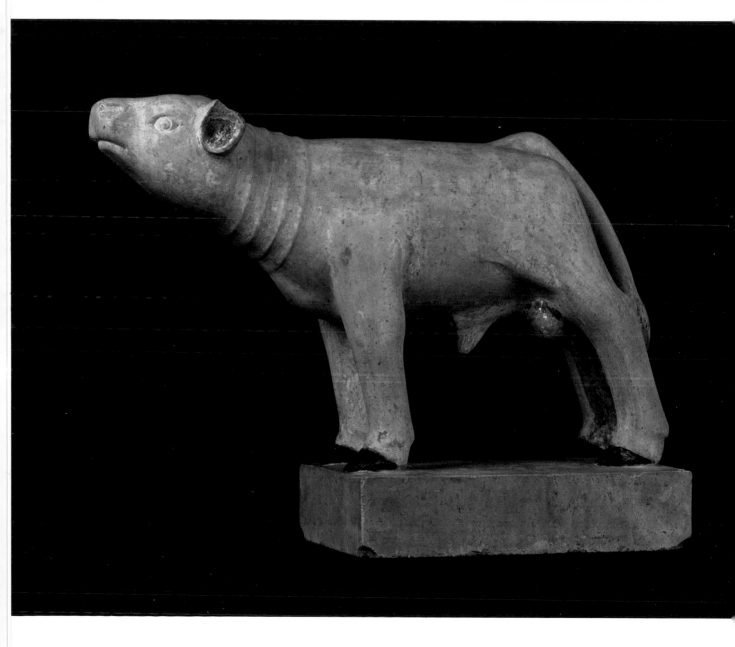

Gaudier-Brzeska Emerges

24

Henri Gaudier-Brzeska
Self-portrait, 1913
Pastel, 51.7 × 36.5 cm
Southampton City Art Gallery

Back in 1912, Epstein was able to share his hatred of French intolerance with another precocious sculptor in London: a young Frenchman called Henri Gaudier-Brzeska (cat. 24). The son of an indulgent yet quick-tempered and sometimes violent joiner who beat him as a child in Orleans, Gaudier had been intelligent enough to be enrolled by his school as a scholarship candidate. He was given government bursaries to study commerce in Britain, including a fruitful two-year sojourn in Bristol. There, at the age of sixteen, he incessantly drew in sketchbooks landscapes, buildings and people. His precocious command of line was outstanding even then, and Gaudier never stopped drawing for the rest of his life. But the urgent need to earn a living prevented him, at this stage, from making much sculpture. In Paris, where he met his highly intellectual yet neurotic Polish-born lover Sophie Brzeska while sketching fellow readers in a library (cat. 25), Gaudier spent his days bookkeeping at an office he hated.

Sophie, who was almost twenty years older than Henri, only agreed to live with him on condition that they avoided sex. Such an arrangement would have appalled Epstein and Gill, yet Gaudier went along with Sophie's proviso and even added her surname to his own. Scarred by previous relationships, and possibly suffering from gonorrhoea, she became a surrogate mother to the intense and excitable adolescent. Gaudier's real mother made no secret of disliking Sophie. His frustration increased when he tried, unsuccessfully, to sell caricatures to the Paris newspapers. And his disenchantment with France became terminal when Sophie was accused, by a hysterical man writing anonymously to the Public Prosecutor at Orleans, of prostitution. This groundless slur enraged Gaudier, who told a friend that 'the French disgust me more and more by their idleness, their heedlessness, and their excess of bad taste – I have irrevocably decided to leave them to the Furies and to get quickly to the frontier.'[1]

But life in London was no easier. Pretending to landlords that they were brother and sister, the unlikely couple moved from one gruesome set of lodgings to another. He called her 'Mamus' and she nicknamed him 'pick-aninny' or, more often, 'Pik'. For a year they remained unknown, while he

could have prepared him for the sheer visceral impact of the 'athletes' he subsequently saw at the Wrestling Club. 'My God I have never seen such a beautiful sight,' he wrote, describing with awe the 'large shoulders, taut, enormous necks like bulls, small in build, firm thighs, slender ankles, feet as sensitive as hands and not tall but they fight with a fantastic vivacity and spirit, turning in the air and falling back on their hands so as to jump up on the other side; utterly incomprehensible.'[11]

After drawing them with voracious agility, he started work on his plaster *Wrestler*. Evelyn Silber was right to observe that the finished figure 'marks a significant change in Gaudier's approach to modelling'.[12] Far bulkier than his previous figures, it moves away from their more Rodinesque handling towards a tougher alternative. The broken vulnerability of earlier pieces like *Workman Fallen from a Scaffold* (fig. 27) is replaced, here, by a sense of implacable certitude. Although the wrestler has not yet grasped his opponent, he advances while bending and preparing his hands with ominous assurance. The sense of calculated expectancy is powerfully conveyed, leaving us to imagine just how devastating his arm-grip might be. At the same time, though, this heavily muscled fighter shows a profound respect for his fellow combatant. His outstretched fingers also seem braced to ward off possible attack, and Gaudier even manages to suggest that the wrestler possesses a hint of sensual allure. Although he claimed

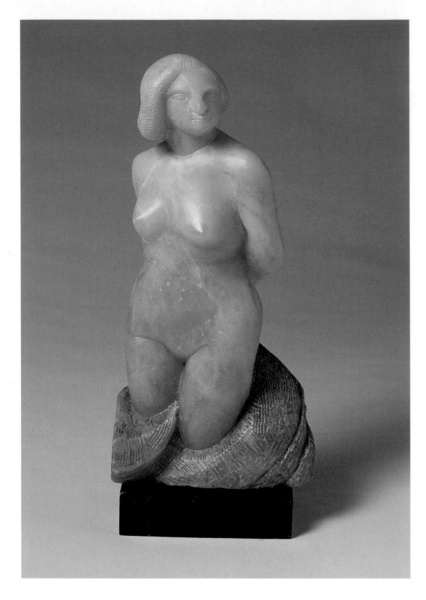

that his relationship with Sophie was platonic, Gaudier's work is often charged with a highly erotic awareness of the human body. He enjoyed confusing his friends by asserting that he was gay, yet the truth is that his work celebrates the sexuality of female bodies even more than their male counterparts.

When Gaudier made the momentous, Epstein-inspired move from clay modelling to stone carving, he focused above all on images of women. And he was still open to influences from a wide range of sources. The power of *Wrestler* may have derived in part from his response to a formidable crouching Hawaiian deity carving in the British Museum, where on a 'short visit' in November 1912 Gaudier had roamed restlessly through the galleries 'taking particular notice of all the primitive statues, negro, yellow, red and white races, Gothic and Greek'.[13] But the classical tradition still partially informs his early carving of *Female Figure* (cat. 27), a small alabaster nude

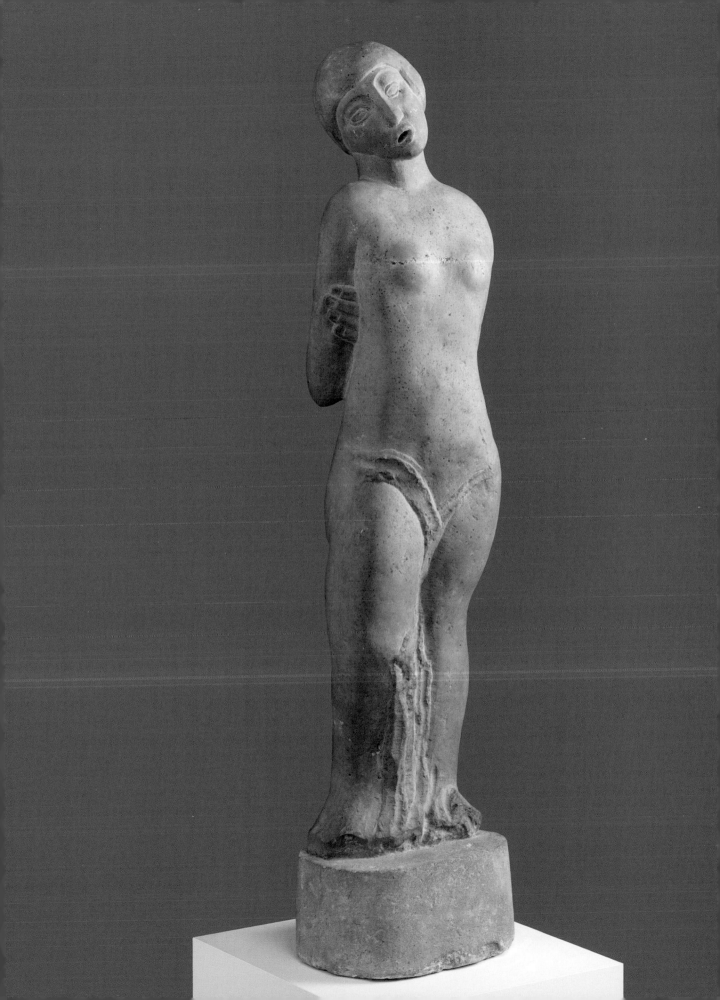

who emerges from her curved, roughly handled base with a serene expression. Wholly at ease with her nakedness, she may be identifiable as the 'Venus' which Gaudier sold for £3 to a visiting Jewish collector from Poland.[14] The rounded base might indicate waves, and this sea-woman connection suggests an intriguing link between Gaudier and Gill, whose very first carving *Estin Thalassa* had explored a similar theme (fig. 8). At the same time, Gaudier's *Female Figure* indicates his interest in Gauguin, who also lies behind the two flamboyant pastel portraits that Gaudier made of Sophie and himself in 1913 (cats 24–25). But *Female Figure* reveals as well an informed awareness of Alexander Archipenko – soon to be numbered among Gaudier's most admired contemporary sculptors.[15]

If *Female Figure* is indeed the carving Gaudier described with affection as 'my little alabaster Venus',[16] it may also indicate that he discussed this goddess of love with Epstein, who was about to embark on two major Venus carvings. Not surprisingly, the influence of Epstein can be detected in Gaudier's larger figure of a woman, cut in 1913 from what he described as 'hard Derby stone'.[17] Called *Singer* (cat. 28), his 'statuette'[18] appears at first to be a melancholy image. Her head is inclined at an angle suggestive of yearning, and when viewed from the front her arms almost seem trussed like a captive. As we circumnavigate this figure, though, she becomes more playful. Her right hand turns out to be dallying with her pigtail, and Gaudier may well be paying homage here to the plaits included in female carvings by Epstein and Gill. The monumental *Maternity* by Epstein, where the pigtail plays such a prominent role, would in particular have arrested Gaudier's attention (figs 12–13). Epstein's decision to leave the lower half of *Maternity* in a rough condition might likewise have encouraged Gaudier to let *Singer*'s drapery tumble around her legs in a frankly improvised, half-finished yet eloquent state.

He achieved a far greater fusion between figure and block in *Mermaid* (cat. 29), a small marble carving where the half-human sea-creature seems at one with the base on which she rests. Her peaceful head appears to be merging with the stone beneath. And although the upper half of her body rises like a mountainous landscape, this sense of physical abundance vanishes once the buttocks curve down towards the slim tail. She becomes a fish, floating just above the block. Gaudier still incises the contours of her fingers and thumbs, but most of the anatomical detail he had retained in *Singer* is dispensed with. Even the face is summarised with only a minimal amount of definition, suggesting that Gaudier shared Epstein's contemporaneous urge to simplify his carved work more radically than before. In the summer of 1913 Gaudier met Constantin Brancusi at a London exhibition where the Romanian sculptor was showing his work. And by the autumn

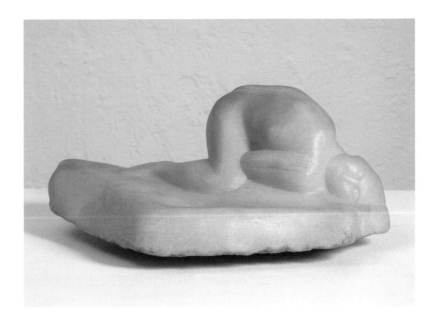

29
Henri Gaudier-Brzeska
Mermaid, 1913
Marble, 11.4 × 27.5 × 17.5 cm
Kettle's Yard, University of Cambridge

Fig. 28
Henri Gaudier-Brzeska, *Round Tray*, 1913. Wood with
marquetry, diameter 60 cm. Victoria and Albert
Museum, London

overleaf
30
Henri Gaudier-Brzeska
The Wrestlers, 1914
Plaster, 71.8 × 92.1 cm
Museum of Fine Arts, Boston. Otis Norcross Fund

Gaudier told Sophie that Epstein was 'making some extraordinary statues like the Polynesians … with Brancusi-like noses'.[19]

So when Gaudier returned to his obsession with the wrestler, he produced a sculpture far more pared-down than his earlier treatment of the theme. Instead of modelling a single, upright figure as before, he settled on a battle between two combatants. All the same, there is nothing conspicuously aggressive about the new *Wrestlers* (cat. 30). Instead of the sinewy, bunched-up man advancing in the earlier work, these figures are elongated and smoothed-out. They have been flattened into a carved plaster relief, which once rested on a canvas Gaudier originally painted in 1912.[20] A strong sense of linearity also pervades *Wrestlers*, where so much depends on essential contours rather than any detailed exploration of musculature. Burliness is replaced by attenuation. Both these men seem overcome by the length and slenderness of their bodies. Although they close their arms around each other, there is no feeling of violent constriction. The lower of the two wrestlers is almost clinging onto the other man's leg for support. And the upper athlete could be resting his head rather than striving to lock his opponent into constriction. Their choreographed poses suggest the lingering influence of Matisse, whose paintings of naked figures had excited widespread controversy in Roger Fry's 'Second Post-Impressionist Exhibition' towards the end of 1912. When Gaudier produced this *Wrestlers* relief, he was making occasional work for Fry's newly established Omega Workshops. Indeed, a similar theme of wrestling figures caught up in a strange dance was chosen by Gaudier for a round tray he designed during his involvement with the Omega enterprise (fig. 28).[21]

It is intriguing to realise that, in the summer of 1913, Eric Gill also made an ambitious, carefully considered relief of two naked male fig-

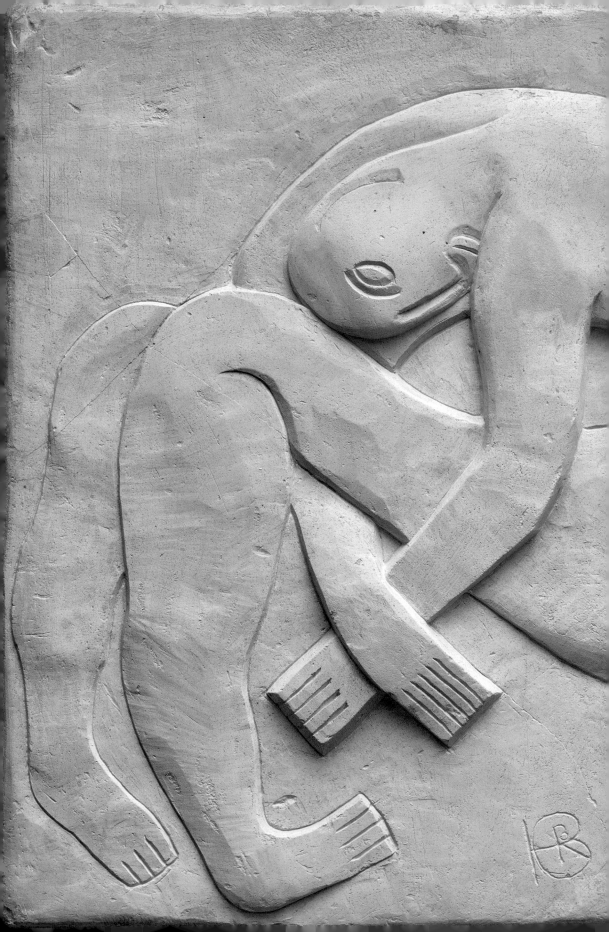

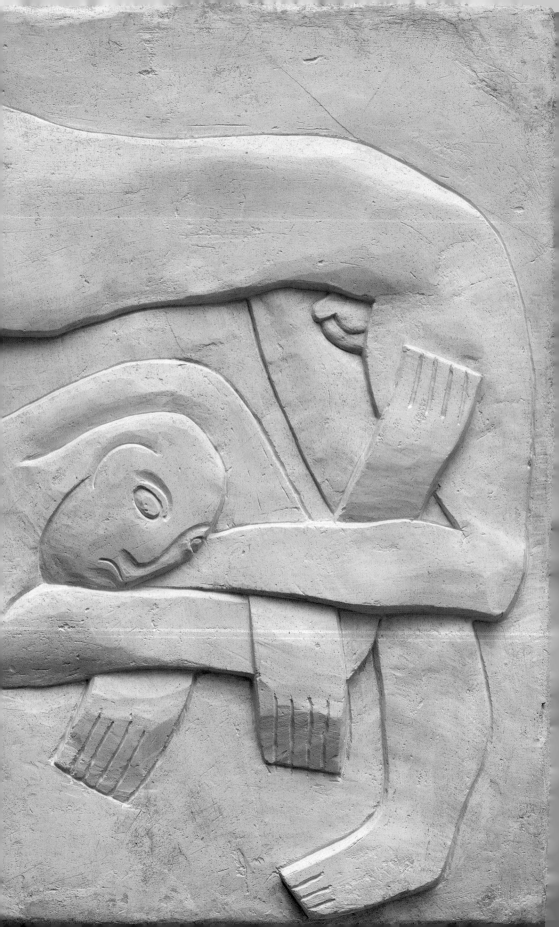

ures in combat. Called *Boxers* (cat. 33), it was made for his enthusiastic patron Count Harry Kessler. Three years before, Kessler had persuaded Gill to serve an apprenticeship with the sculptor Aristide Maillol in Paris. But after travelling to France, Gill suddenly fled back home, telling Kessler that Maillol was primarily a modeller and 'I want to have only so much to do with modelling as is necessary for that kind of client who wants to know what he's going to get before he gets it … The inspiration comes with the carving and is an entirely different inspiration from that which comes with the clay.'[22] From the outset, *Boxers* was conceived as a piece cut directly out of a Portland stone block. In a freely handled preliminary watercolour (cat. 32), Gill showed the two combatants wearing boxing gloves, and he coloured them. But when he drew a larger, more definitive study in pencil (cat. 31), the gloves were banished and colour no longer played a role. Both the boxers' faces are now clearly defined, while the feet of the fighter on the right have become far more tense and energetic. Gill clearly wanted to inject a greater sense of struggle, and sketches of clenched fists around the central figures prove that he grew fascinated by their aggression.

All the same, the unpainted *Boxers* relief he finally displayed at the

31
Eric Gill
Design for Sculpture: 'Boxers', 1913
Pencil and grey wash, 48.5 × 52.3 cm
Mr and Mrs Peyton Skipwith

32
Eric Gill
Design for Sculpture: 'Boxers', 1913
Pencil and watercolour, 12.3 × 12.3 cm
Art Collection, Harry Ransom Center,
The University of Texas at Austin

opposite
33
Eric Gill
Boxers, 1913
Portland stone with added colour,
55.8 × 49.5 × 19.7 cm
Private collection

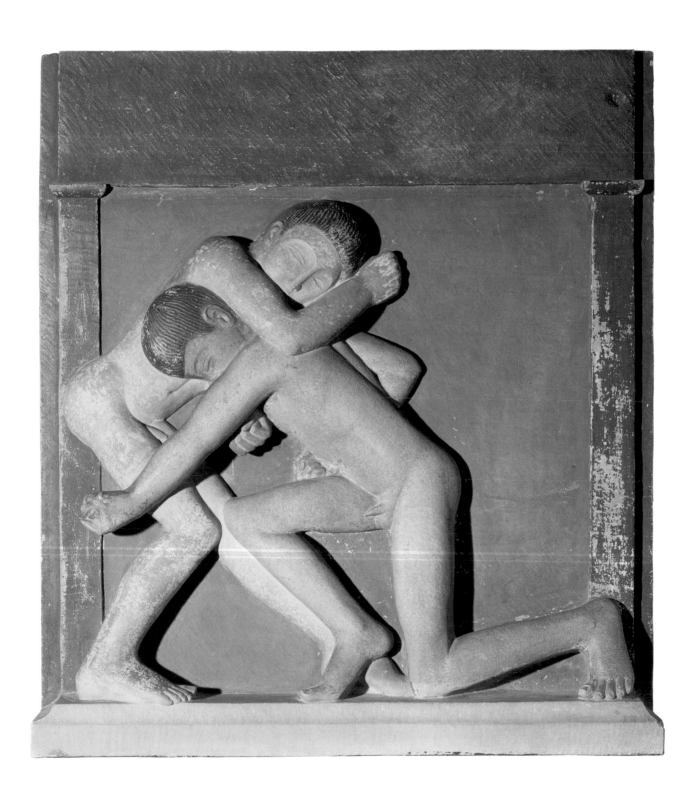

Goupil Gallery in January 1914 was as choreographed as Gaudier's *Wrestlers*. However closely entwined Gill's figures may be, they likewise seem caught up in a dance rather than setting out to overpower each other. The upper boxer leans his head on his opponent's shoulder with as much resignation as the equivalent figure in Gaudier's relief. Both fighters appear to be performing a rite, and their intimacy conveys a hint of erotic play. At all events, Kessler did not acquire the relief. It was returned to Gill's workshop where, some time later, he became dissatisfied with its pallor. The literary scholar Geoffrey Keynes, who eventually bought the work as a marriage gift for his friend George Mallory, recalled that Gill, 'in a fit of boredom with seeing it' unsold in the workshop, 'painted the figures in bright colours, one red, the other yellow, with a dark blue background. I was sorry he had put on the paint.'[23] Keynes even asked Gill if he could remove the colours, but the artist doubted that 'the paint would come off v. satisfactorily. It would be sure to stick in the pores of the stone.'[24] As a result, *Boxers* retains its colour, testifying no doubt to Gill's awareness that much of the medieval and earlier sculpture he admired was originally painted in surprisingly strong hues.

Many examples could be found in places of worship, and Gill particularly revered two powerful twelfth-century carvings he had first seen in Chichester Cathedral during his boyhood: *The Raising of Lazarus* (fig. 29) and *The Arrival of Christ at Bethany*. His large family had moved to the city in 1897, when he was fifteen. Ethel Moore was the daughter of the sacristan of Chichester Cathedral, and Gill married her in the city in 1904. So his impassioned feelings for these two great medieval carvings were intertwined with his religious convictions and love for the woman who became his wife. All this should be borne in mind when we try to understand what happened to Gill's work during the period culminating in the First World War.

Having produced the idolatrous images of the golden calf for Madame Strindberg's Cabaret Club, Gill and his wife – now called Mary – made the astonishing decision to join the Roman Catholic Church. They were duly received in a Brighton church on 22 February 1913, Gill's thirty-first birthday, before spending the rest of that momentous day walking the Sussex Downs with Leonard and Virginia Woolf. Around then, Gill devoted much of his formidable energy to *Mother and Child* carvings (cats 34–35, fig. 30). One was commissioned by the poet Rupert Brooke, who had admired Gill far more than Matisse at the Second Post-Impressionist Exhibition. Brooke travelled down to Ditchling in January 1913 with the collector Edward Marsh. They viewed the *Mother and Child* in Corsham stone, but Gill testily decided that his two visitors were 'atheistical beggars!'[25] Dissatisfied with the carving, he gave it to his wife at her request. Although it

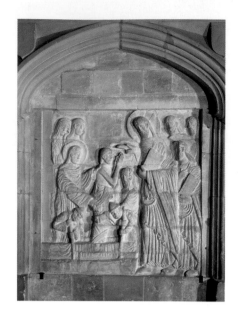

Fig. 29
The Raising of Lazarus, early 12th century. Relief from a former Romanesque jube. Chichester Cathedral, West Sussex

opposite
34
Eric Gill
Mother and Child – half length, 1913
Bath stone, 63.5 × 24.1 × 24.1 cm
Private collection

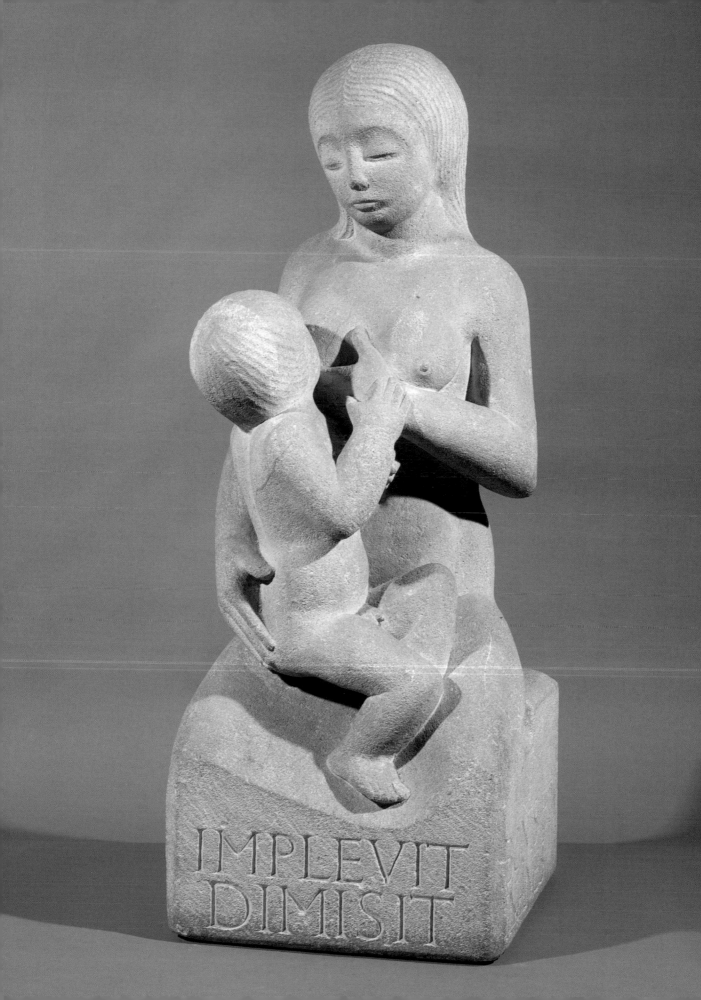

IMPLEVIT
DIMISIT

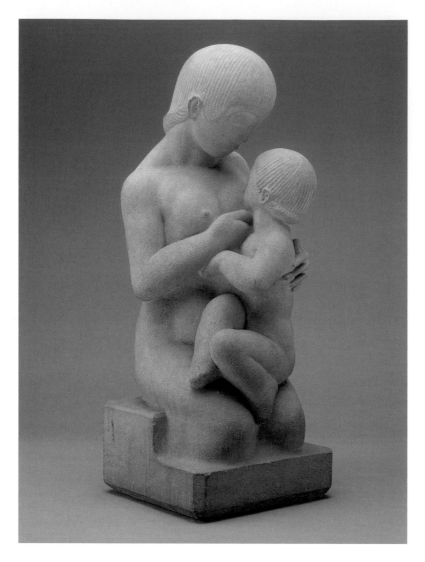

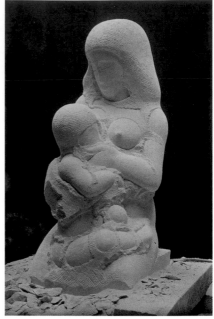

has since been lost, a photograph of the work in progress (fig. 30) suggests a kinship with another half-length *Mother and Child* commissioned by Geoffrey Keynes later in 1913 (cat. 34). Larger than the one intended for Brooke, and carved this time from Bath stone, it likewise terminates with the mother's thighs as they flow into the substantial base.

As the result of a miscarriage in August 1911, Gill's wife was unable to have any more children. So his heartfelt concentration on the act of breast-feeding in the Keynes carving takes on an additional poignancy. The relationship between mother and baby is even closer than in Gill's full-length 1910 carvings on the same theme. Now sitting upright and pressing eagerly on the proffered nipple, the child is more active than the reclining infants in the earlier versions. And, after Keynes visited Ditchling with Cosmo Gordon Lang to view this unfinished carving, Gill decided that lettering would add an unexpected dimension to the meaning of the work. Writing to Keynes after the visit, Gill declared that 'I am very glad you really like the stone and I think it a very good idea to put a little inscription round the

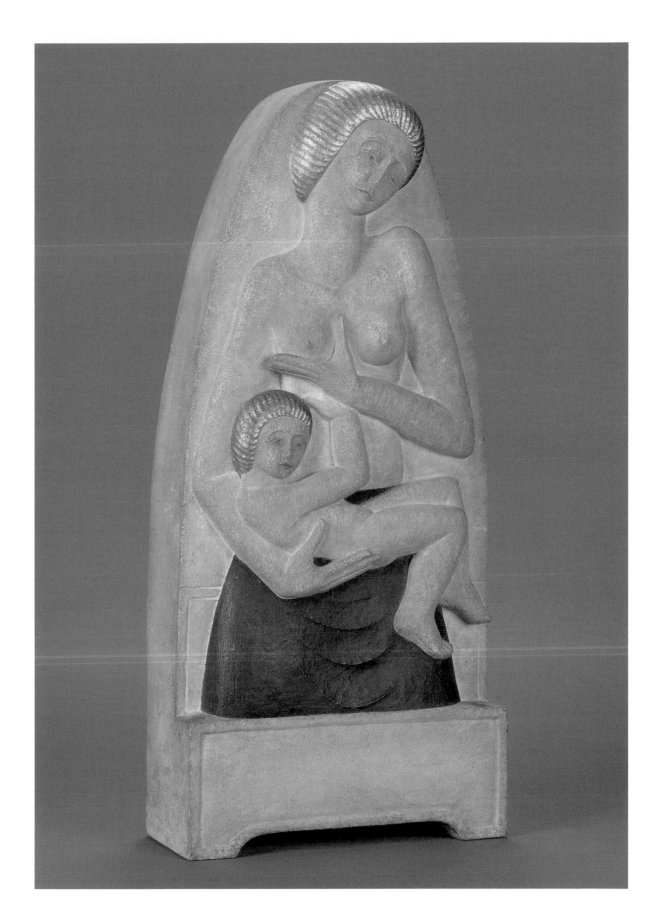

bottom on three sides. The cost of such an addition wd. be so little that … there wd. be no charge for it. As you suggest the Magnificat what do you say to this: ESURIENTES IMPLEVIT BONIS: ET DIVITES DIMISIT INANES? There might be many applications in that.'[26] The Latin words, from Luke I, 53, triumphantly announce that 'He has filled the hungry with good things: and the rich he has sent empty away.' Incised in capital letters around the base of the carving, they ensure that its beneficent placidity suddenly takes on a defiant sense of solidarity with the poor – thereby prophesying Gill's subsequent decision to devote his largest and most ambitious post-war work to the theme of Christ angrily driving the moneychangers out of the temple.

During the course of 1913, Gill grew increasingly obsessed with an overtly religious version of the mother and child subject. Already, by December of the previous year, he had made a Portland stone relief of a *Madonna and*

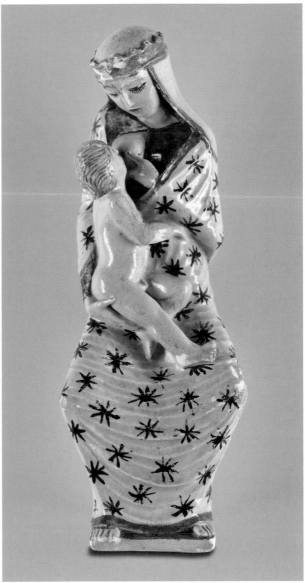

Child (cat. 36). But he produced the carving for his own pleasure, and it would probably have shocked many of his conventional religious friends. For Gill applied red paint to the lips of both Virgin and infant. He also added the same pigment to the Madonna's nipples, thereby giving her an allure reminiscent of his 1910 relief *A Roland for an Oliver* (cat. 9). The outcome was a disconcerting attempt to fuse the two opposed and in many ways irreconcilable sides of his own divided nature. The gilded hair on both figures possesses a religious aura, and Gill half-hid the Madonna's nudity by clothing her in a blue-painted skirt. Yet several subsequent versions of the theme, made from Plasticine and then cast in plaster, bronze and brass editions (cats 37–39), stress the word 'naked' in their titles. Gill wanted to bring secular and sacred into a new unity, so the bronzes were offered for sale at £15 each from Everard Meynell's bookshop close to Westminster Cathedral.

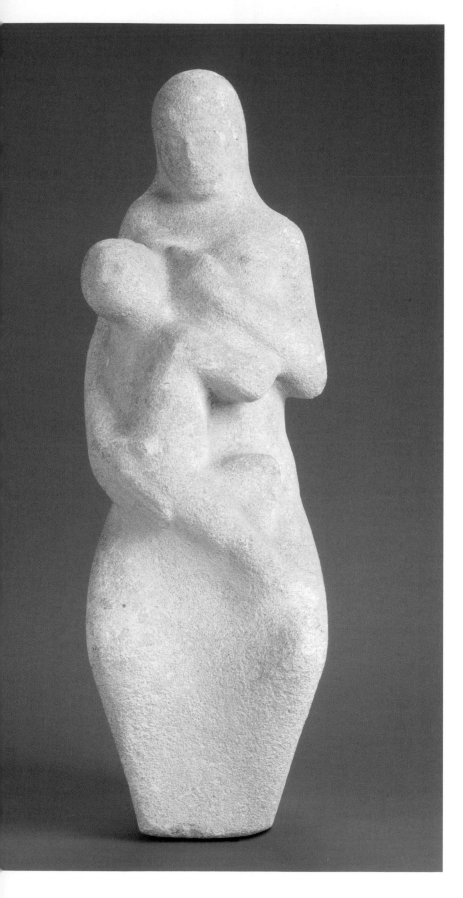

41
Eric Gill
Naked Mother and Child, 1912–13
Bath stone, 49 × 16 × 16.5 cm
Art Collection, Harry Ransom Center,
The University of Texas at Austin

Gill clearly hoped that the bronzes would be bought by Catholic worshippers. And even when he clothed a plaster Madonna in a long robe with gold crown and veil (cat. 40), she still insists on baring her breast to a child whose nakedness contrasts pointedly with her star-spattered garment.[27]

At the same time, Gill also returned to his earlier preoccupation with Christ crucified. In 1910 he had twinned a *Crucifixion* (cat. 8), very provocatively, with *A Roland for an Oliver*. But now he seemed to veer between the optimistic fertility of Mother and Child images and the far more attenuated suffering of Christ about to expire on the cross. Just how personal they may have been for the deeply troubled and divided Gill is hinted at in his diary, where on 27 March 1913 he notes the commencement of work on a 'little crucifix for self'.[28] Carving this *Crucifixion Relief* in Hoptonwood stone (cat. 42) took him a total of twelve days between then and July, when he sold it to Everard Meynell. Christ's figure is, if anything, even more etiolated and vulnerable than its predecessor in the 1910 relief. His head droops down as though robbed of all strength, and his slender legs resemble a child's. Yet he does at least have a cloth stretched across his loins, and the inscription painted with red pigment at the base of the cross sounds a note of hope. Rather than quoting from the Bible, Gill here devises his own message in Latin: 'O TE FELICEM'. It can be translated as 'O Happy Thou', thereby suggesting that the viewer gains consolation from realising the redemptive power of Christ's loving sacrifice. As if to reinforce this idea, the enfeebled Christ is still able to raise two fingers in blessing.

The same gesture of benediction enlivens *Crucifixion Relief with Rounded Top* (cat. 44), a smaller version carved in marble. Like the Hoptonwood stone relief, it was displayed in Gill's solo show at the Goupil Gallery in January 1914. But unlike the stone version, this marble relief does not include any reassuring inscription. The only letters incised here spell out 'I.N.R.I.' – the Latin abbreviation meaning 'Jesus of Nazareth, King of the Jews'. They seem almost oppressively large, positioned above Christ's disconsolate face, while the lack of a loincloth accentuates his emaciated helplessness. And the most haunting of all these Crucifixion images is a wood engraving (fig. 31) where a near-silhouetted Christ appears resigned to the advent of terminal darkness.

Gill's insistence on making these religious images available at the Meynell bookshop awoke some Catholics to the intensity of his work. Even so, it must have seemed to Gill truly miraculous when, on 16 August 1913, the Catholic Church awarded him a major commission to carve fourteen large-scale reliefs of the Stations of the Cross for Westminster Cathedral. Ever since the death of the Cathedral's architect J. F. Bentley in 1902, the places set aside for these reliefs had remained empty. But now,

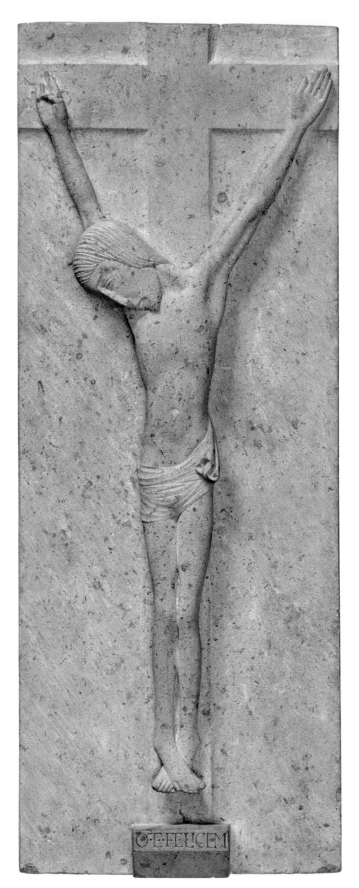

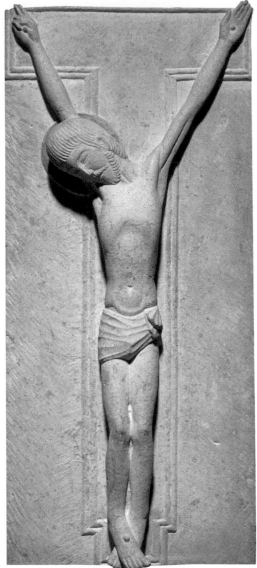

above
43
Eric Gill
Christ on the Cross, c. 1913
Hoptonwood stone, partly painted, 31.2 × 14 × 3.5 cm
Scottish National Gallery of Modern Art, Edinburgh:
bequeathed by Sir David Young Cameron 1945

left
42
Eric Gill
Crucifixion Relief, 1913
Hoptonwood stone with added colour,
incised letters painted with red pigment,
45.5 × 17.5 × 3.8 cm
Tate. Transferred from the Victoria and Albert Museum
1983

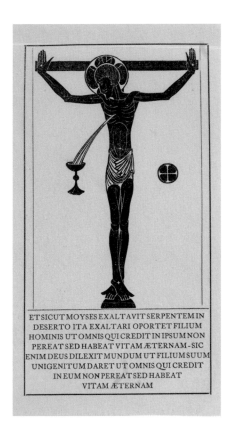

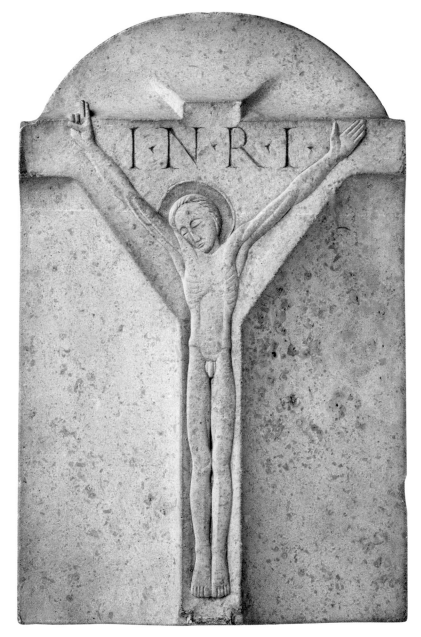

Fig. 31
Eric Gill, *Crucifixion*, undated. Wood engraving (third state), 41 × 28 cm. City Museum and Art Gallery, Stoke-on-Trent

44
Eric Gill
Crucifixion Relief with Rounded Top, 1913
Marble with added colour in the incised letters and a gilded halo, 27.7 × 17.8 × 3.2 cm
Museum of Art, Rhode Island School of Design, Providence. Gift of John M. Crawford

eleven years later, John Marshall, the architect appointed as Bentley's successor, was introduced to Gill.[29] Not that he initially entertained any great hope of securing such a monumental commission. 'I was almost unknown in any respectable circles and, I suppose, entirely unknown among catholic ecclesiastics,' Gill recalled later, wryly adding: 'Had it not been that I was willing to do the job at a price no really "posh" painter or sculptor would look at, I should certainly never have got it. As it was, the pious donors were getting restive and as the Cardinal-Archbishop is said to have said, if the architect didn't hurry up and do something about it, he would give the work to the first catholic he met in the street. So they gave it to me.'[30]

He might easily have felt daunted by the immense challenge of carrying out such a task. After all, Gill had only been carving for three years

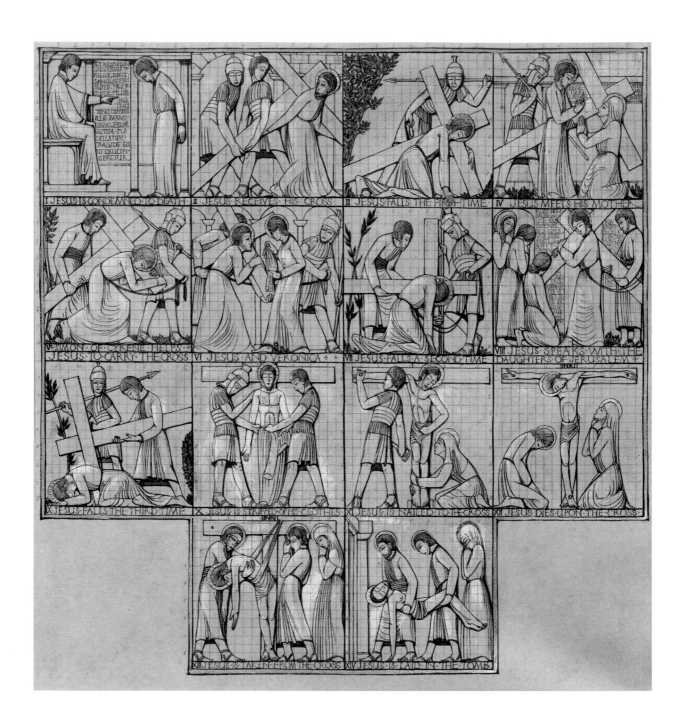

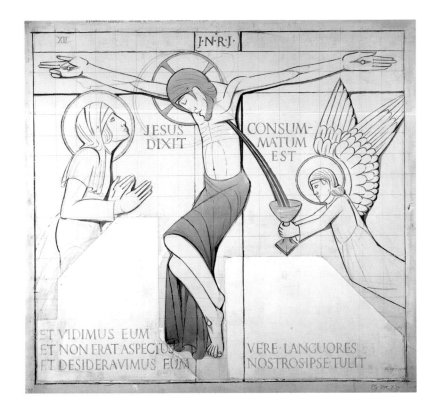

when this commission was granted, and he knew that many sceptical Catholic observers would closely scrutinise his attempts to convey the full, harrowing tragedy of Christ's final journey from condemnation by Pontius Pilate through to burial. Yet Gill also knew that his long and impassioned study of medieval religious sculpture, not only in Chichester but also at York, Wells and above all Chartres, had equipped him to tackle the Stations of the Cross. A remarkable sense of confidence permeates his *First Design* for the fourteen panels, drawn in 1914 with a mixture of pen and grey ink, touched with watercolour and gold (cat. 45). They already outline the essence of the reliefs he would make over the next few years, in a sustained bout of carving that was deemed sufficiently important to grant him exemption from war service (fig. 32).

Gill's early architectural training stood him in good stead when he tackled this austere and stoical project. His professional appraisal of the building must have helped him decide how the figures in the fourteen reliefs could be satisfactorily integrated with the nave piers they adorn; his lettering techniques enabled him to carry out the sometimes very elaborate inscriptions without detracting from the impact of the reliefs in their entirety; and his experience as a mason ensured he could master the shal-

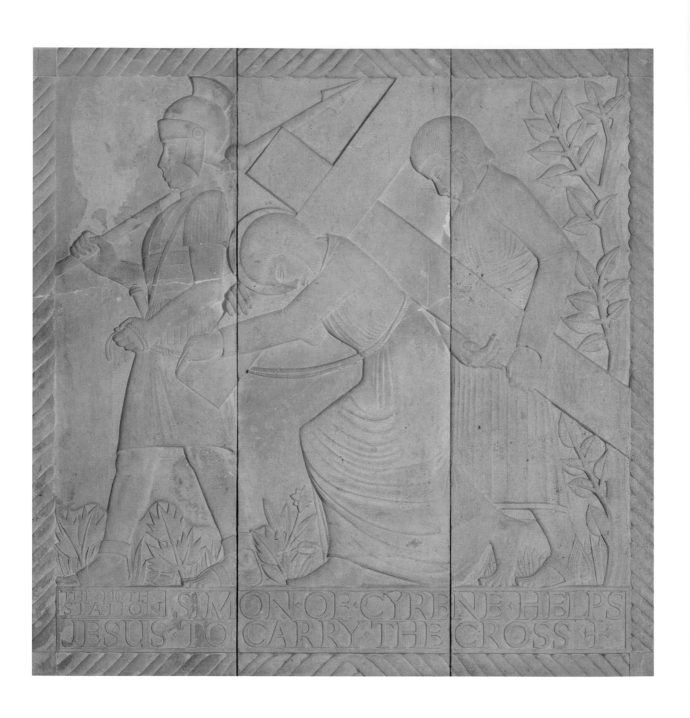

low, intensely linear carving that the Stations of the Cross required. When the occasion demanded, Gill therefore succeeded in bringing together all his diverse accomplishments to serve one end, and in this sense his lack of a conventional art-school training was probably an asset. With typical defiance, he defended himself in 1915 against hostile critics. 'It is generally supposed that I am endeavouring to imitate some bygone style,' he wrote in the *Observer*. 'Critics always say that I am a person who attempts to be Egyptian or Syrian, or something or other. That is simply not the case. I am working in the only style in which I can work. I am not a learned antiquarian who can work in any style at choice.'[31]

He did, however, consciously try to make his sculpture accessible and shunned the move towards ever more purged simplification being pursued by his erstwhile friend Epstein. Modernist abstract experimentation now held no interest for Gill, who wanted his carvings to employ 'plain language' rather than anything stylistically extreme. Hence the straightforward manner he adopts in the trial panel for the *Fifth Station of the Cross* (fig. 33), a carving he had to produce at his own expense before his Catholic patrons would let him proceed with the Westminster Cathedral reliefs. Its medievalism is clear, and marks the moment when Gill moved decisively away from the Post-Impressionist leanings which had won the admiration of Roger Fry. This relief, a reversed and smaller version of the *Fifth Station* he would go on to carve for the Cathedral, shows how much Gill wanted these panels to chime with the ecclesiastical interior where they would all be installed. The sober piety is self-evident, and at one with the religious convictions which in 1913 impelled him to move from his house in Ditchling High Street and settle on the nearby common, where he was to form the Guild of St Joseph and St Dominic. At the same time, though, the directness of the style deployed in the trial panel for the *Fifth Station* still possesses strong links with the *Boxers* relief he had carved earlier in the same year.

In 1915 Gill also proved that he had not lost the subversive humour enlivening so much of his previous work, from *A Roland for an Oliver* through to *The Rower* and *The Golden Calf*. Commissioned by his friend Douglas Pepler to make a wood engraving of the *Hog and Wheatsheaf* (cat. 46), Gill took time off from the *Stations of the Cross* and produced a quirky circular image of a dark, unruly creature leaping past a wheatsheaf in Doves Place, Hammersmith. As the letters curving round the edges of the engraving boldly proclaim, this was the location of the Hampshire House Bakery in west London. Pepler deemed Gill's print such a success that it became the logo, not only for the bakery bags, but also for notepaper. The bakery was part of an idealistic institution called the Hampshire House Social Club, founded in 1906 by Pepler and some like-minded allies. Intended for work-

46
Eric Gill
Hog and Wheatsheaf, 1915
Circular wood engraving, diameter 13.7 cm
Victoria and Albert Museum, London.
Given by Mrs Mary Gill, widow of the artist

47
Eric Gill
The Hampshire Hog, 1915
Stone, 50 × 78 × 22.5 cm
Hampshire County Council Museums
and Archives, Winchester

ing men, it followed the ideas of William Morris who had lived in nearby Hammersmith Mall. Pepler, formerly a social worker at Toynbee Hall in London's East End, aimed at establishing an equally committed institution in the west of the city. Soon he became manager of the Hampshire House Social Club, where working men enjoyed access to a classroom, library and reading room, as well as relaxing in a bar and billiard room. By 1913 Pepler had transformed the Club into the craft-based Hampshire House Workshops, organising a free picture exhibition there each year.

Before Gill moved to Ditchling in 1907, he had lived for two years in Black Lion Lane, Hammersmith. So he felt especially well disposed towards Pepler's ideals, and in 1915 set about carving a stone hog for the Workshops (cat. 47). Unlike the golden calf Gill had made for Madame Strindberg's Cave three years before, the substantial hog stands on a base that thrusts out in front of him. There was plenty of room for the words 'Hampshire/ House/Workshops' to be inscribed here, and the plump animal above them does not crane his head forwards like the idolatrous calf. Gill sets the hog's two front legs back at an angle, but only in order to emphasise their tense, reined-in expectancy. This cheeky animal seems ready for anything. His smile looks mischievous, contrasting once again with the more gentle solemnity of the golden calf. The hog's nostrils flare open, as if eagerly smelling a source of delight. And the downward angle of the calf's tail is not echoed here. Far from it: Gill makes the hog's tail rise friskily, while erotic energy seems to ripple right through the mane running along the animal's back.

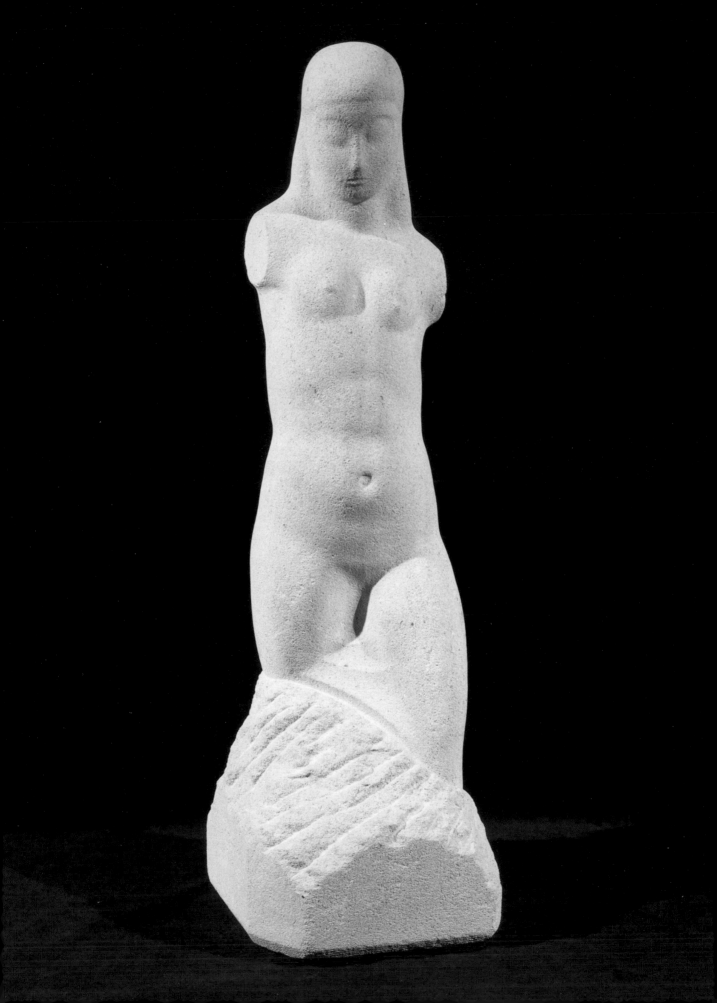

48
Eric Gill
Essay: Female Torso and Head, 1913–15
Bath stone, 56 × 16 × 16 cm
Private collection, London

The entire carving bears out Count Kessler's shrewd assessment of Gill in 1910, when he wrote to the artist declaring that 'there is a sort of rude, elementary force and humour in your work which is racy, of England, or even of the Anglo-Saxon swordsmen and seabears that came over with Hengist and Horsa. I have rarely seen anything so thoroughly personal and national.'[32]

The same words could be applied to the carved garden rollers that Gill was commissioned to make in 1915. One was for Sir Hugh Lane and the other for Douglas Pepler, who had now moved from London to Gill's old house in Ditchling and founded the St Dominic's Press. Many sculptors would have baulked at the idea of creating an object as 'lowly' as a garden roller, but Gill shared Gaudier's willingness to regard anything, even a doorknocker or a knuckle-duster, as a potential sculpture. To judge by a later version of the *Garden Roller*, carved in 1933 and now subtitled 'Adam and Eve' (fig. 34), Gill responded to the task with enthusiasm. Both the naked figures cut in the sides twist their bodies into contorted, seductive poses. They seem desperate to avoid being penetrated by the iron shaft piercing the stone, and Gill makes sure that both male and female genitals are clearly defined. They are very similar to the athletic, contorted figures that he had produced before the First World War,[33] and David Kindersley vividly recalled the experience of working on the 1933 garden roller. Newly apprenticed to Gill as a letter-cutter, he remembered that his master 'had a great hand in the drawing on the roller for me to carve the boy and girl. Incidentally he and I never thought of calling it Adam and Eve! The stone was Portland and it was masoned from a very rough lump and took a lot of doing and I shall never forget it, it taught me the beginnings of stone carving.'[34]

The overt eroticism informing both these figures is the work of a man who never managed to reconcile his unbounded sexual desire with his religious faith. The battle between them is fought once more in a Bath stone carving now called *Essay: Female Torso and Head* (cat. 48). Gill started it, for his own pleasure, back in September 1913. He described the carving on his job sheet as 'Statuette in Bath stone of Our Lady and Child standing'. But then, in March 1915, he decided to make very drastic alterations, changing it from a sacred icon to a secular siren. 'I cut off the crown and the baby and the clothes and the arms,' Gill wrote on his job sheet, 'and turned it into a nude "Essay".'[35] The destruction must have been alarming to witness, and yet a beguiling naked idol with long hair now arises from a base carved with a roughness reminiscent of Epstein's unfinished *Maternity* (figs 12–13). Gill's woman, emerging from the stone, is now as frankly desirable as Gaudier's *Female Figure* (cat. 27). These unresolved tensions within Gill eventually led him to suffer a mysterious breakdown in the autumn of 1930.

Fig. 35
Eric Gill, *Design for a War Memorial: Front Elevation
(Christ and the Moneychangers)*, 1916. Pencil and wash,
48.5 × 49 cm. Manchester City Galleries

He was found wandering around the quadrangle of his home without any notion of his own identity and whereabouts. For a time, after the headache-ridden amnesiac was taken to hospital in London, his life seemed to be endangered. A recovery was made, yet the temporary loss of selfhood surely points to a crisis in the persona he had so successfully established for himself. His apparently robust and clear-cut Christian beliefs hid a great deal of inner uncertainty, above all about defining the proper limits of his lust.

The truth is that the Catholic faith he had embraced back in 1913 never stopped him from indulging in licentious pursuits. Nor did his decision five years later, along with his wife and others, to become invested as a novice in the Third Order of St Dominic and found a guild of Catholic craftsmen. 'We could not go so far as to say that all Christian men and women must … engage themselves by vow or promise to live according to one or another of the Religious rules,' wrote Gill in his *Autobiography*. 'But in the complete mess which the men of business have made of the modern world – for though sinners will make a mess anyway, the particularly beastly and disastrous mess in which we find ourselves today is the product of the particular beastliness of men of business – it does seem as though as many as possible should enrol themselves under the disciplines offered by Religion in the special sense of the Religious Orders.'[36]

This hatred of the 'beastliness of men of business' had already led Gill, in 1916, to choose a most unusual subject for a war memorial. Fired by a competition for a large monument in memory of London County Coun-

Fig. 36
Eric Gill, *Christ Driving the Moneychangers from the Temple*, 1922–23. Portland stone, 168 × 459 × 22.6 cm. University of Leeds

cil employees killed in the Great War, he tried to plan a suitable proposal.[37] Typically, Gill found himself torn 'between thinking about women (in some detail) and thinking about what I could do for the LCC Monument'. At first, 'the former subject of cogitation seemed irresistible and I began on that, but somehow I got shunted on to the other subject and it suddenly occurred to me that the act of Jesus in turning out the buyers and sellers from the Temple as he did was really a most courageous act and very war-like.'[38] His proposal took the form of two elaborate pencil and wash drawings of a free-standing bronze figure group, ranged along a stone plinth designed by Epstein's architect friend Charles Holden (fig. 35). Not surprisingly, it was turned down and Gill supposed that the LCC 'took fright, or were insulted at the awful suggestion that London were a commercial city or that England were a Temple from which a money-changer or two might not be missed'.[39] But after the war Gill was finally commissioned by Michael Sadler, Vice-Chancellor of Leeds University, to carve an immense Portland stone relief (fig. 36) of the same subject, reinforced by an inscription which declared: 'Go to now, you rich men, weep and howl in your miseries which shall come upon you. Your riches are putrid.'[40] When first placed on view near Leeds University Library in 1923 it confirmed, to the disgust of Gill's angry detractors in a town renowned as a financial centre, that he was obsessed by modern war's relationship with the generation and accumulation of capital.

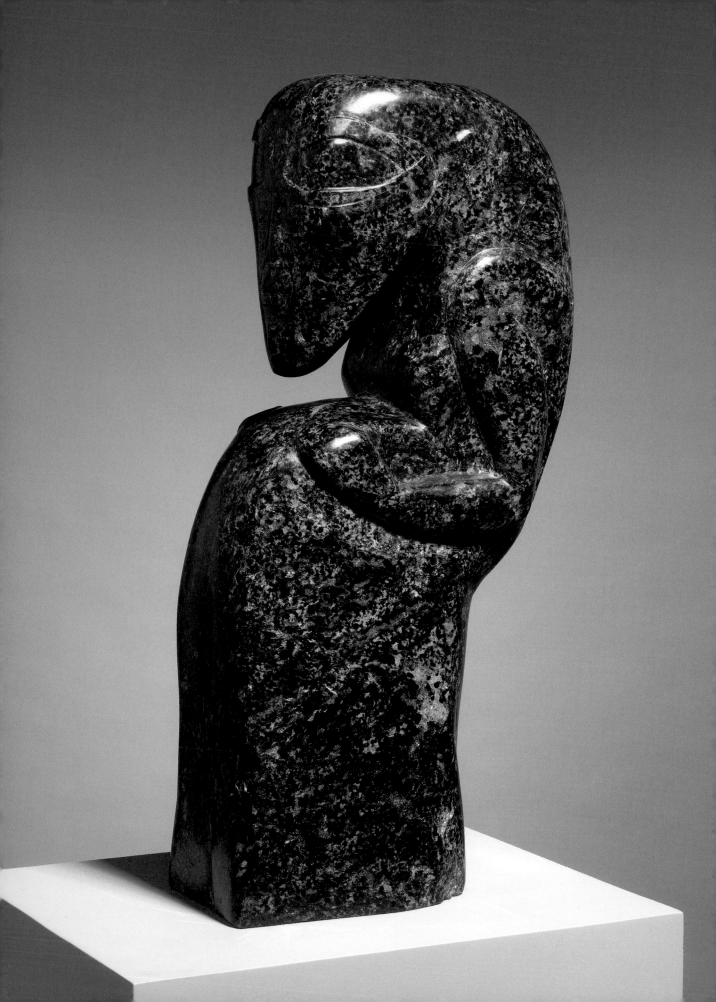

Epstein by the Sea

49
Jacob Epstein
Figure in Flenite, 1913
Serpentine stone, 61 × 16.2 × 28.9 cm
Lent by The Minneapolis Institute of Arts.
Gift of Samuel Maslon, Charles H. Bell,
Francis D. Butler, John Cowles, Bruce B. Dayton
and an Anonymous Donor

Epstein decided, in the wake of his experience with the *Tomb of Oscar Wilde*, to devote his best energies to carving. The friendships made in Paris, where he stayed in the latter half of 1912 and at various times the following year, encouraged him to approach the stone in an even more radical manner than before. Amedeo Modigliani, like him a Jewish artist far from home, proved especially congenial. And soon enough, Epstein forged a relationship with Modigliani almost as close as the one he had previously achieved with Gill. The two men saw each other 'for a period of six months daily', and tried to find a 'shed' they could share on the Butte Montmartre. The idea, according to Epstein, was to 'work together in the open air' – always a desideratum after his defining adolescent experience at Greenwood Lake. He may even have been tempted to revive the notion of a grand collaborative venture, for the mesmerising sight of the work gathered in Modigliani's 'miserable hole' of a studio reminded Epstein of his former obsession with an architectural ensemble. 'It was filled with nine or ten of those long heads which were suggested by African masks, and one figure,' Epstein recalled. 'They were carved in stone; at night he would place candles on the top of each one and the effect was that of a primitive temple.'[1]

Now that Epstein had lost touch with Gill, who had once shared his desire for a similar temple, Modigliani seemed a man after his own heart – even if the extreme elongation of these masks would never have recommended itself to Epstein in his attempt to find a similarly pared-down formal vocabulary. The closest he ever approached to Modigliani's attenuated *Heads*, one of which came to London after Epstein had been instrumental in encouraging a British collector to purchase it,[2] was *Sunflower* (cat. 50). The almond eyes are incised in the San Stefano stone with an elegant economy worthy of Modigliani, and Epstein resists the temptation to add facial features other than the nose.

Compared with the head of his earlier *Sun God* relief (fig. 10), *Sunflower*'s face is sparing indeed. But its circular head, squat nose and sturdy neck are far removed from Modigliani's characteristic elongation. Robust form was of prime importance to Epstein when he carved: his feeling for

slimmer and bonier limbs found its principal outlet in modelled sculpture. So rather than following Modigliani's example in a slavish way, he remained faithful to his own predilections when making *Sunflower*. Moreover, Modigliani would never have wanted to produce anything as aggressive as the double row of zigzag hair segments exploding from the head of Epstein's hallucinatory sculpture. Reminiscent of the dogtooth carvings which embellish the arches of so many Romanesque churches in Britain, they appear positively menacing after the mellifluous linear rhythm of the tendrils flowing from the head of the *Sun God* relief.

Contact with Brancusi and his work likewise impressed Epstein during his French sojourn, yet the Romanian's influence only surfaced later. 'This period in Paris was in itself, from the point of view of working, arid,' he explained afterwards, blaming his exasperation on practical difficulties and neighbours complaining about his incessant hammering. But the encounter with Brancusi may have had an inhibiting effect, for his intense single-mindedness helped to convince Epstein that a ruthless degree of simplification was now necessary. The chance to examine Brancusi's carving *The Kiss* in Montparnasse Cemetery probably led Epstein to reflect that his own tomb sculpture seemed over-elaborate in comparison. Nothing, after all, could be more purged of sculptural superfluities than Brancusi's embracing lovers (fig. 37). The block of stone seems scarcely interrupted by the eyes, lips, arms, hair and breasts chiselled so delicately into its surface. This extreme purification of form, which succeeded at the same time in retaining a remarkable amount of sensuous tenderness, soon bore fruit in Epstein's 1913 carvings. He realised that the last vestiges of his earlier enthusiasm for Michelangelo must be jettisoned, leaving behind only the absolute essentials permitted by the stone itself. Decades later Epstein still remembered how Brancusi 'would pluck at the back of his hand and pinch the flesh, "Michelangelo", he would say, "beef steak!"'[3]

Only after leaving the orbit of this immensely persuasive and dedicated man did Epstein manage to divest his sculpture of the last vestiges of superfluous flesh. Impressed by the 'saintly' commitment to work shown by Brancusi, who 'would exclaim against café life and say that one lost one's force there',[4] he decided to return to England and find a remote location where his carving could be carried out with a similar amount of devotion. This was a well-judged move. Freed from the constant distractions of metropolitan life, Epstein was able to settle into 'a solitary place called Pett Level, where I could look out to sea and carve away to my heart's content without troubling a soul'.[5] This secluded Sussex coastal village near Hastings, exposed to the stimulating immensity of the English Channel, was perhaps the most rural location Epstein had inhabited since his time on the shores of Green-

Fig. 37
Constantin Brancusi, *The Kiss*, 1910. Stone, height 89.5 cm. Montparnasse Cemetery, Paris

opposite
50
Jacob Epstein
Sunflower, c. 1912–13
San Stefano stone, 58.5 × 27.5 × 20.4 cm
National Gallery of Victoria, Melbourne, Australia.
Felton Bequest, 1983

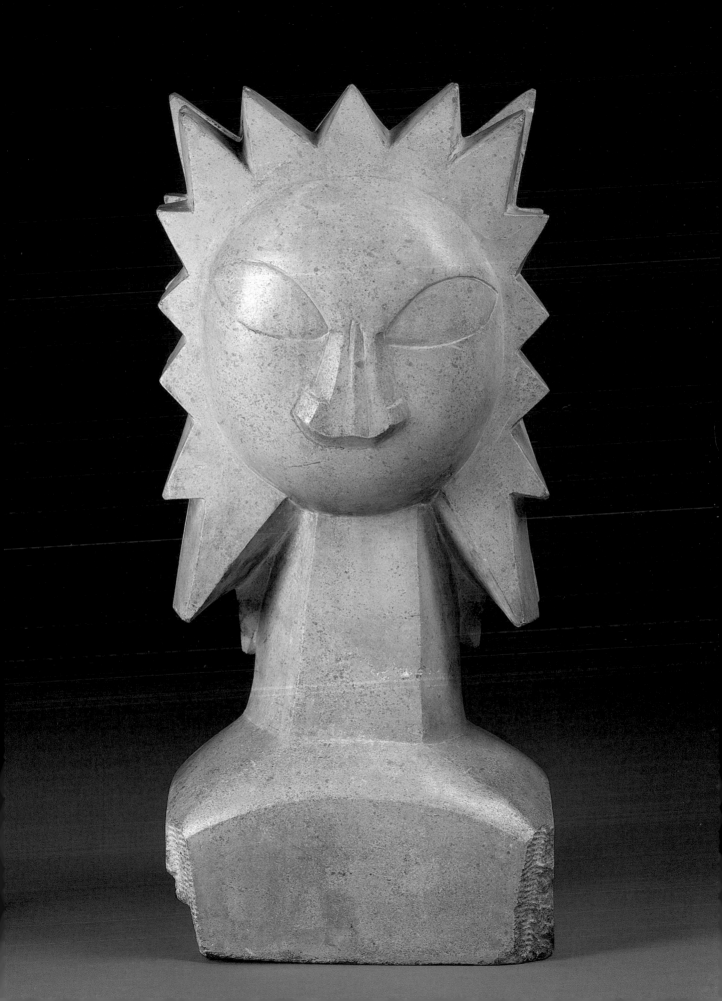

wood Lake. The rented cottage was a small one, and he worked from a shed in the back garden.[6] But the surroundings inspired him to think in terms of grander and more elemental forms than he had ever imagined before.

Even the smallest of his Pett Level carvings have a largeness of spirit which transcends their true dimensions. In *Birth* (cats 51–53), a little carving unfinished enough to suggest that it was one of the first and most tentative of the images he produced there, Epstein is at pains to stress the inviolate, cubic presence of the stone. It appears to play as prominent a part in the genesis of the child as the mother's legs and vagina, parting to allow the newborn baby to emerge from the womb.

Although the same moment is re-enacted on one side of the related *Flenite Relief* (cat. 54), the infant this time holds an ovoid form in his hands. The frankness and gravity with which he displays this germinating egg of creation recalls a statue called *Matter* produced by Epstein for the British Medical Association building five years before (fig. 5). Yet the 'inchoate

51
Jacob Epstein
Study for Birth, c. 1913
Pencil, 62 × 52 cm
Ivor Braka Ltd, London

opposite
52
Jacob Epstein
Birth, c. 1913
Stone, 30.6 × 26.6 × 10.2 cm
Collection Art Gallery of Ontario, Toronto.
Purchase, 1983

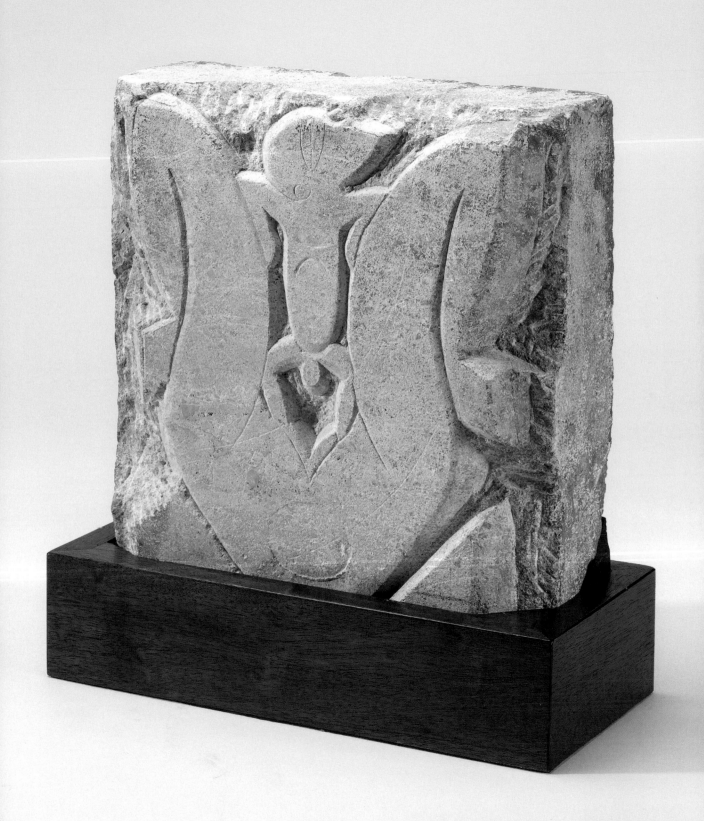

opposite
53
Jacob Epstein
Birth, 1913
Red crayon, 68.9 × 43.6 cm
The Museum of Modern Art, New York.
Gift of Mr and Mrs Richard Deutsch

54
Jacob Epstein
Flenite Relief, 1913
Serpentine stone, 30.5 × 28 × 9 cm
Leeds Museums and Galleries, City Art Gallery

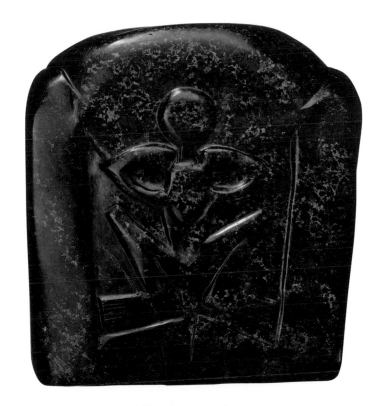

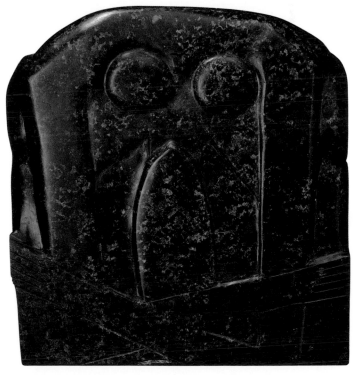

and lifeless'[7] lump of stone held by the patriarch in that earlier carving is now transformed into an eloquent, living force. The dark 'flenite' is still indisputably a primal slab, with which Epstein has interfered as little as Brancusi did when he carved the Montparnasse tomb sculpture. Nevertheless, Epstein has transformed it by the most minimal means into the body of a woman. The other side of the relief bears her inverted torso and head, topped by forearms which cross each other with a diagonal neatness reminiscent of the arms in Brancusi's *The Kiss* (fig. 37).

Just how mysterious Epstein wanted the fructifying process to appear in his flenite pieces can be discovered by examining the two pregnant women he also carved from this dark green serpentine. The very word 'flenite', Epstein's own invented name for these works, evoked not only the hardness of granite but the prehistoric associations of flint. And both these women inhabit a primeval world as surely as the archaistic mother and baby in *Flenite Relief* (cat. 54). The larger of the two, *Figure in Flenite* (cats 49, 56), adopts a defensive attitude to the life swelling inside her stomach. She cranes her Polynesian face forwards apprehensively, and yet the sheer block-like solidity of her dress counteracts at least some of the anxiety she transmits. Epstein honoured the integrity of his flenite in order to convey sturdy resilience as well as awesome primeval trepidation. *Figure in Flenite* seems unshakeable as she asserts a stony strength in the face of whatever dangers may confront her.

When Epstein revealed the legs of a similar woman in *Female Figure in Flenite* (cat. 55), her limbs turned out to be indomitably stocky. Viewed from the side, the figure's upper half sways back from her legs in an extraordinarily dramatic arc. It culminates in the great head hanging with solicitous solemnity over her pregnant belly, but the legs need to be strong in order to support this astonishing curve as it extends from the base of the spine round to her bulbous brow. In Paris, Brancusi had counselled Epstein against imitating the 'primitive' carvings they both admired, and *Female Figure in Flenite* avoids that risk by fusing its Polynesian inspiration with a wholly personal response to a woman's body. This mother, for all her prehistoric 'barbarity', is absorbed in a poignant solicitude for the baby growing in her stomach. One angry critic accused the flenite figures of 'rude savagery, flouting respectable tradition – vague memories of dark ages as distant from modern feeling as the lives of the Martians.'[8] Yet Epstein evokes these 'dark ages' only in order to recover the atavistic truths about motherhood, birth and sexuality which 'modern feeling' was in danger of forgetting. By showing the flenite women bestowing such loving concern on the bulges in their bellies, he wanted to remind his viewers that fertility was a miracle lying at the very core of human existence.

55
Jacob Epstein
Female Figure in Flenite, 1913
Serpentine stone, 45.7 × 9.5 × 12.1 cm
Tate. Purchased 1972

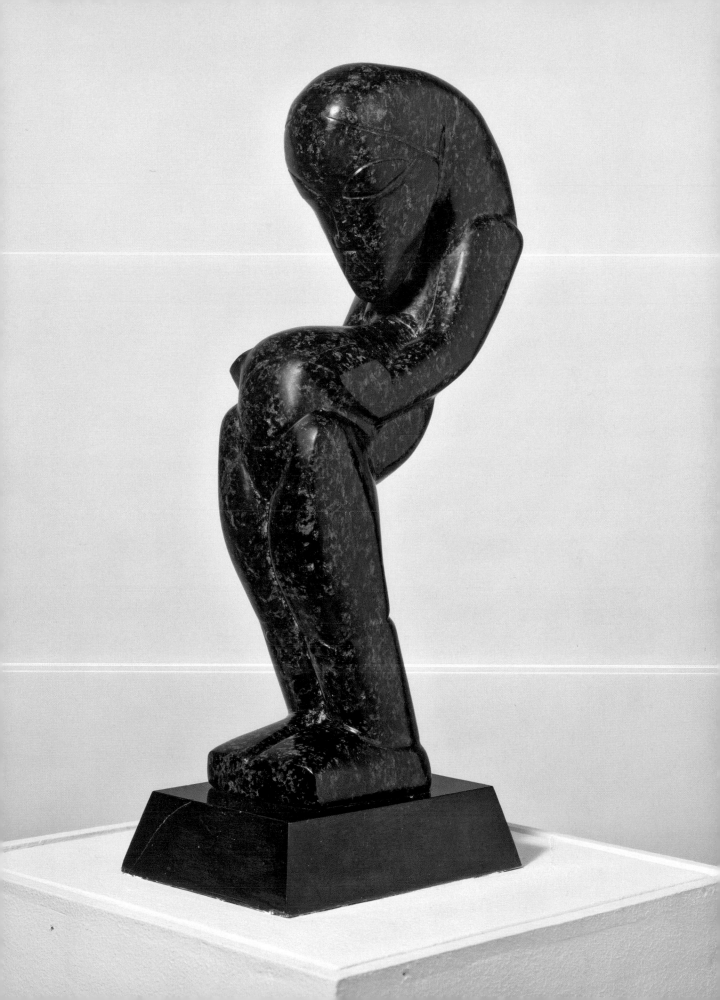

Epstein was also planning a monumental version of the themes explored by the three flenite images: *Mother and Child*. The final appearance of this imposing sculpture, which brought together the child of *Flenite Relief* and, perhaps, the mother of *Female Figure in Flenite* in one grand union, is unknown. The only surviving photograph (fig. 38) shows Epstein standing resolutely beside the half-finished block. But enough of its structure is visible to indicate that he proposed to dispense with the pregnancy theme and show the mother holding the child in front of her. Surely one of his most commanding images, it disappeared after shipment to John Quinn in New York and ended up, apparently, jettisoned in the depths of the East River.[9] The outlines of the child, firmer and more rigid than the near-

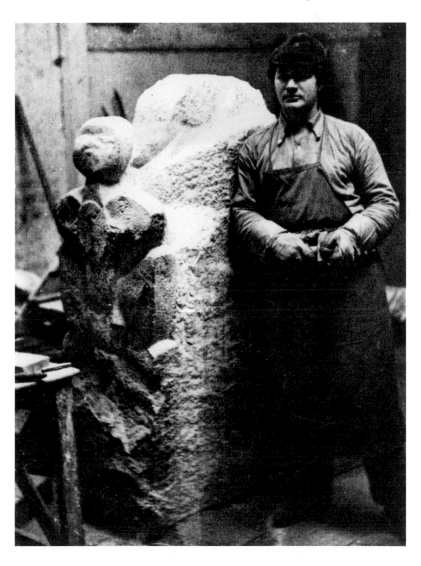

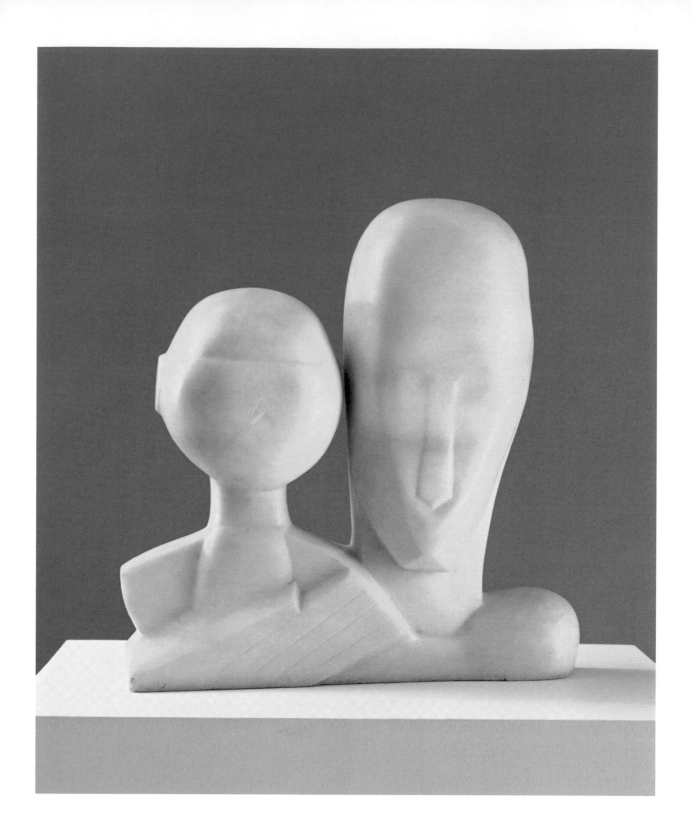

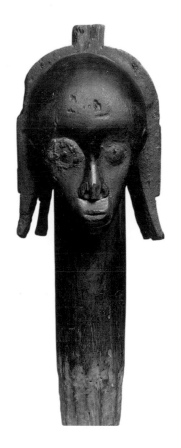

silhouette hewn out of the *Relief,* suggest that the group would have been more hieratic and geometrically defined than the flenite carving.

All the figures in Epstein's carvings of this period share the same sense of unfathomable strangeness. In the mesmeric marble *Mother and Child* (cat. 57), facial features are minimally defined so that he can explore the full contrast between the baby's convex rotundity and the woman's concave elongation. This remarkable work aims above all at purging every shred of descriptive excrescence from the human image. The maternity theme he had explored so many times before is here restated in its most purified form: instead of portraying the mother as an undeveloped primitive animal, terrified by the new life surging up inside her swollen belly, Epstein chose to convey the calm acceptance and enjoyment of procreation that childbirth brings. The baby is now placed beside its mother, an entirely separate egg-like ball of white marble balanced so delicately on a slender neck that it appears to be hovering in space. A fully thought-out contrast is established between the two heads, the one a compact oval and the other an elongated sphere; the one rotund and convex, the other shallow and concave. They sit there, these two highly refined entities, in a chaste and frontal frieze.

The back view emphasises the vertical rectitude of the mother as opposed to the horizontal expansion of the baby by contrasting her flat, patterned hair with his bald roundness. Epstein does not even allow the mother to show her ears: they are pared away in the interests of her verticality, whereas the baby's ears seem to enhance his floating equilibrium. They exist apart, yet they are conjoined by the material of the carving. And the union is strengthened by the mother's protective hand covering her baby's chest. This gesture is an important one, the sole demonstration of feeling in a sculpture otherwise remarkable for its aloof reserve. The two heads do not turn towards each other in a mood of domestic affection: they both face outwards, lost not so much in contemplation of some distant spectacle as in a deep introspection. The child's eyes are rendered as a single, unseeing horizontal line, while its parent's are mere sockets, a pair of shadowy valleys incapable of vision.

But there is nothing tragic about their lack of sight. Epstein meant the figures to be symbols of a state of mind, just as Brancusi had pared away human features in his successive versions of the *Sleeping Muse* to arrive at the essence of repose. This *Muse*, and Modigliani's *Heads*, would be the main influences on the marble *Mother and Child*, were it not for the remarkable resemblance that the mother herself bears to one of the most prized items in Epstein's collection of so-called primitive sculpture, the *Brummer Head* (fig. 39). The great curve of its forehead, the distended nose

and tapering chin are all close to the construction of the mother's features, and Epstein clinched the likelihood of this source when he recalled seeing the *Brummer Head* 'in Joseph Brummer's shop in Paris … in 1913'.[10] His admiration for this great Fang woodcarving, which originally surmounted a bark box containing the skulls and bones of ancestors, must have remained with him when he executed his own marble. And he helped to explain the impulses behind the sculpture when pointing out how the *Brummer Head* 'has qualities which transcend the most mysterious Egyptian work. It is an evocation of a spirit that penetrates into another world, a world of ghosts and occult forces, and could only be produced where spiritism holds sway.'[11] Epstein likewise wanted to create an image that would haunt the imagination. But he combined primitive magic with the urge to make a thoroughly avant-garde artefact, one of the most advanced European sculptures of its time.

A series of dove carvings moves further away from 'primitive' art towards an emulation of the work Epstein would have seen in Brancusi's Paris studio. One particular piece, the Romanian's *Three Penguins* (fig. 40), seems to have guided Epstein in his search for even greater simplification. Its translucent white marble, no less than its bare equation of minimal forms, affected the way he approached his trio of *Doves*. But they appear more naturalistic than Brancusi's *Penguins*. For Epstein was preoccupied with the characteristically sexual motif of two mating birds. And he wanted to go further than Gill's *Ecstasy* relief by exploring as many as three stages in the act of copulation. The idea may have come from rapt observation of the birds kept in his Pett Level studio. In *Doves – first version* (cat. 58) the male has alighted on the back of his partner, yet he has not gone further. Epstein is fascinated by the muscular tension of the bird's pose as he balances momentarily, claws splayed out on his female companion while he contemplates the next move. The simplified forms of the birds lend them a timeless quality that contrasts directly with the temporary nature of the action Epstein has dramatised.

Although the exact chronological order of the series is unknown, Epstein may then have moved on to the so-called *Doves – second version* (cat. 59), where the male settles into place on his partner's body. He is, nevertheless, spaced back from his companion so that their two poses are subtly varied. And whereas the male's front section is separated from his body by a sharply defined division in the marble, the female's front quarters flow smoothly back towards her rear in one uninterrupted expanse of white stone. Equally vital is the transition from upper to lower tail at the back of the carving. It becomes an eloquent, gradual slope. The result is an access of sensuality: the doves' bodies, plumper and less tightly partitioned into

Fig. 40
Constantin Brancusi, *Three Penguins*, 1911–12.
White marble, 56.5 × 52.7 × 34.3 cm. Philadelphia
Museum of Art

opposite
58
Jacob Epstein
Doves – first version, 1913
Marble, 34.7 × 50.3 × 18.5 cm
Hirshhorn Museum and Sculpture Garden,
Smithsonian Institution, Washington DC.
Gift of Joseph H. Hirshhorn, 1966

59
Jacob Epstein
Doves – second version, 1913
Parian marble, 47 × 72 × 30 cm
The Israel Museum, Jerusalem.
Gift from the Billy Rose Collection, through
the America-Israel Cultural Foundation

overleaf
60
Jacob Epstein
Doves – third version, 1914–15
Marble, 64.8 × 78.7 × 34.3 cm
Tate. Purchased 1973

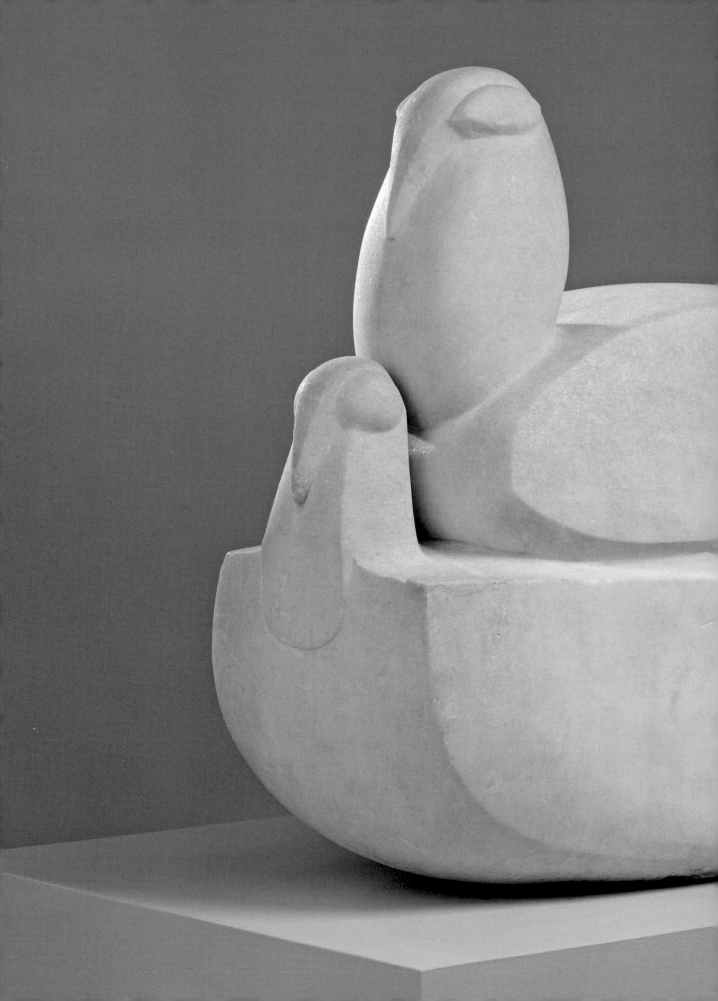

planes than the 'first' version, gain in organic credibility. They are no less simplified than the other pair, but seem by contrast far more alive.

In the even more impressive 'third' version (cat. 60), intercourse is openly represented and the male has settled in purposefully along the entire length of his partner. The new pose works with conspicuous success: now the feeling of extreme stasis promoted by the rigidly defined components of the birds' bodies is echoed in the serenity of their pose, slotted together in one compact mass of interlocking forms. Epstein has calculated his carving so carefully that each detail fits into the next with a satisfying sense of inevitability. The female's tail, for example, is stretched out along the base of the group to provide a ledge for the downward thrust of her mate's tail. The contours of both doves are treated as a single coherent whole, whereas the two birds in the 'first' version had remained separate entities. The difference was pointed out by the poet Ezra Pound, a great admirer of the *Doves*, when he wrote to John Quinn recommending him to purchase one of them for his collection. 'For God's sake get the two that are stuck together,' Pound warned, 'not the pair in which one is standing up on his legs.'[12] His advice prompted Quinn to write hurriedly to Epstein himself for reassurance, and the sculptor tetchily replied that his patron was indeed to receive the 'second' version, but 'wondered by what right Pound was commenting on his work with such vehemence: Pound might mind his own business.'[13]

When the 'second' doves carving was exhibited in October 1913 under the title *Group of Birds*,[14] at Frank Rutter's 'Post-Impressionist and Futurist Exhibition', it received a savage mauling from those critics who deigned to acknowledge its presence. 'About Mr Jacob Epstein's "Group of Birds" the less said the better,' chortled one reviewer. 'One good thing is that he hasn't messed the marble up much, so that it will come in nicely to make something else.'[15] It was the degree of simplification which infuriated the press: to them, Epstein's consummate refinement was a cheat, a short cut which bypassed all the hard work academic sculpture required before it could be considered properly finished. They did not know, or refused to let themselves realise, that the seeming facility of the dove carving had only been attained after careful analysis on Epstein's part. And when its formal qualities were not being attacked, the *Doves* were abused for their subject-matter. The adventurous Countess of Drogheda included them in an exhibition of Epstein's work held at her Belgravia house in 1914, until Lord Drogheda stalked in and exclaimed: 'I won't have those fucking doves in here – I'll throw them out of the window!'[16]

Ezra Pound, however, stood apart from this abuse and recognised the true quality of the *Doves* series, praising them in some of his most elevated

Fig. 41
Jacob Epstein, *Drawing* (lost), reproduced in *BLAST*, 1, 1914

prose. 'These things are great art because they are sufficient in themselves,' he declared in *The Egoist*. 'They exist apart, unperturbed by … the constant bickerings of uncomprehending minds. They infuriate the denizens of this superficial world because they ignore it. Its impotences and its importances do not affect them. Representing, as they do, the immutable, the calm thoroughness of unchanging relations, they are as the gods of the Epicureans, apart, unconcerned, unrelenting.'[17] Committed to similar aims in his own audacious poetry, Pound relished his fellow-countryman's daring and rapidly became one of Epstein's staunchest admirers. 'Epstein is a great sculptor,' he announced categorically to Isabel Pound in November 1913. 'I wish he would wash, but I believe Michel Angelo never did, so I suppose it is part of the tradition.'[18]

It seems, in fact, to have been Epstein who gradually awakened the poet to a new, polemical involvement in modern art during 1913. A little later Pound recalled that 'so far as I am concerned, Jacob Epstein was the first person who came talking about "form, not the form of anything"'.[19] Pound especially admired another dove carving entitled *Bird Pluming Itself*, of which no trace now remains. He likened it to 'a cloud bent back upon itself – not a woolly cloud, but one of those clouds that are blown smooth by the wind. It is gracious and aerial.' And the greatest compliment Pound ever paid Epstein came when he declared that the dove groups had altered his way of looking at the world. 'Last evening I watched a friend's parrot outlined against a hard grey-silver twilight,' his article in *The Egoist* concluded. 'That is a stupid way of saying that I had found a new detail or a new correlation with Mr Epstein's stone birds. I saw anew that something masterful had been done.'[20] Such an impassioned appreciation was surely a huge comfort to Epstein, bedevilled by admirers of his earlier work who were now retracting their support. Pound, the young American émigré in London, aimed at disseminating the spirit of modernism in his journalistic activities, just as Apollinaire boosted the efforts of his Cubist painter-friends with poetic celebrations of their work and Marinetti promulgated Futurist art through his noisy, high-octane propaganda.

Nothing could now prevent Epstein from realising his ambition to produce sculpture on the most monumental scale. His three-year period at Pett Level gave him the necessary solitude to tackle superhuman tasks, and he soon set about carving two large marble *Venus* figures that would bring together his twin obsessions with pregnancy and copulating doves in a monolithic résumé. All the Pett Level works seem to have grown out of each other, suggesting variations to the sculptor as he executed them. One of Epstein's lost drawings (fig. 41) outlines a pregnant mother enclosed in a mesh of whirling lines that form a cave-like protection around her.[21] It

stands as a bridge connecting the preoccupations of the flenite carvings with the Venuses. The central figure is no longer a rounded, essentially archaic creature as she was in *Female Figure in Flenite*. The head has now taken on the stiff angularity of a geometrical helmet, and the tensely summarised surroundings refer as much to a twentieth-century environment as to a primitive jungle.

Even *Rock Drill* is prefigured in this fascinating, multi-layered drawing, which may well have been one of the works on paper exhibited by Epstein in his first solo show at the Twenty-One Gallery in London. T. E. Hulme seized on them as exemplars of his new theories about art in a lecture he delivered at the Quest Society. 'The tendency to abstraction, the desire to turn the organic into something hard and durable, is here at work, not on something simple, such as you get in the more archaic work, but on something much more complicated,' Hulme argued. 'Abstraction is much greater in the second case, because generation, which is the very essence of all the qualities which we have here called organic, has been turned into something as hard and durable as a geometrical figure itself.'[22] With his usual perspicacity, Hulme had pinpointed the extraordinary paradox informing both the marble Venuses. While they celebrate the wonder of procreation and become goddesses of fertility, they are at the same time putting into practice Epstein's new-found interest in rigid dehumanisation.

African sculpture, and in particular the great *De Mire Figure* (fig. 42) which later entered Epstein's own collection, still informs the Venus carvings. And as if to emphasise the enigma of existence, the face of the first version (figs 43–44) remains impenetrably blank. She keeps her secret, and affirms complete serenity even though maintaining a precarious poise on the sloping back of the dove beneath her feet. This amply built Venus, with her dangling African breasts and heavy buttocks, seems to be encouraging the doves in their copulation below. She would, in reality, crush them with her colossal weight, but Epstein proposes a dream-like correspondence between birds and woman which allows them to coexist in an eerily calm union. He may, however, have been dissatisfied with the elements of ungainliness in this carving. Seen in profile, the Venus does appear to be sliding awkwardly down towards the male dove's head, and the bend in her legs seems a painful posture for her to adopt.

That, surely, is why he then set to work on a second version of the statue (cat. 61), twice as tall and far more satisfactorily integrated with the birds below. Displaying smaller and more compact breasts, a less drooping face and an expanse of falling hair more sensuous than its bunched counterpart in the first version, this cool personification of fertility is able to lean against the cock's comb for support. Her legs part as if in pleasurable anticipation

Fig. 42
Reliquary Guardian: 'De Mire Figure'. Gabon, Fang.
Wood and metal, height 69 cm. Musée Dapper, Paris

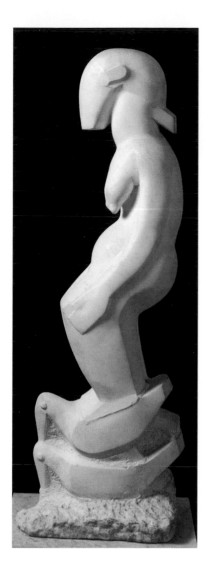

Figs 43 and 44
Jacob Epstein, *Venus – first version*, 1913. Marble,
height 123.2 cm. The Baltimore Museum of Art:
Alan and Janet Wurtzburger Collection

overleaf
61
Jacob Epstein
Venus – second version, c. 1914–16
Marble, 235.6 × 43.2 × 82.6 cm
Yale University Art Gallery, New Haven.
Gift of Winston F. C. Guest, B.A. 1927

of this meeting, and the dove in turn raises his tail to register delight at such beguiling contact with the slender goddess. He is far more satisfactorily integrated with his partner than the doves in the first *Venus*, where Epstein produced a pair of birds whose disjointed forms suggest that he had not yet learned how to amalgamate their bodies as well as Brancusi had done in *Three Penguins* (fig. 40). Working on the final and more unified pair of *Doves* helped him to resolve these difficulties, and the experience he gained there paid dividends in the tightly knit design of the doves below the second *Venus*.

Despite its commanding height, which suggests a very public statement on Epstein's part, this refined and self-assured carving retains a potent sense of privacy. He seems to have developed an unusual feeling of intimacy with this *Venus* as he carved her in the quiet isolation of Pett Level. When the work finally went on view in February 1917, the sculptor confessed to a friend that 'few will see what I've expressed or aimed to express in it; and if they did they would be unholily shocked. What sacrilege to present to public view that work which I for a long summer privately and almost in secrecy worked at for my own pleasure.'[23] Epstein was more than a little in love with his chaste yet seductive Venus, which should be seen as the culminating image in his prodigious sequence of Pett Level carvings. At once virginal and voluptuous, this subtly ambiguous creature extends her pale Cycladic body upwards in a column which, from front and back, exudes an aroused stiffness. But as well as reaffirming Epstein's obsession with sexual potency, this 'beautiful tower of white marble'[24] constitutes the crowning manifestation of his ardent desire to remain faithful to the tall block which must initially have confronted him in his garden studio by the sea. As if to retain a reminder of this original marble, Epstein deliberately left it broken and unfinished at the base of the statue. Yet he hardly needed to: its primal form is everywhere apparent in a carving which pays tribute to the governing inspiration of the stone at every turn.

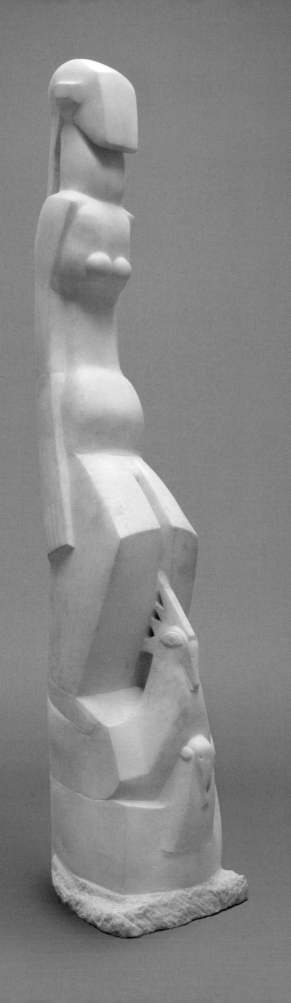

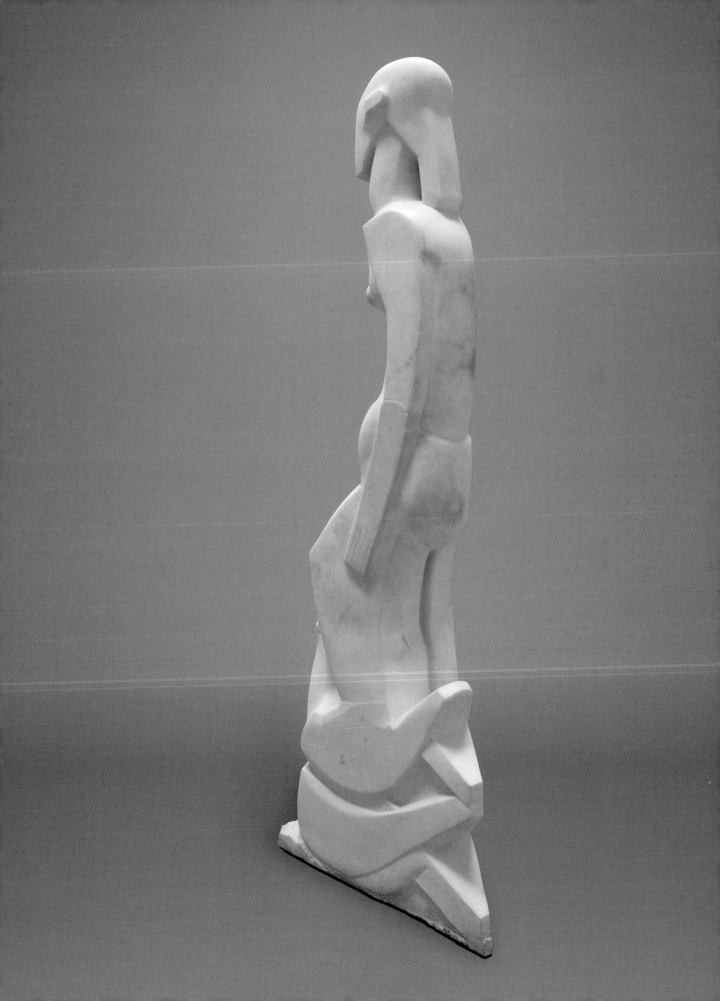

Gaudier-Brzeska, Pound and BLAST

Fig. 45
Henri Gaudier-Brzeska, *c.* 1913

Epstein was not the only sculptor who excited Ezra Pound's admiration in pre-war London. Soon enough, Gaudier enthralled him even more, and Pound wrote a vivid account of their first meeting. On a visit to the Allied Artists' Exhibition at the Albert Hall in July 1913, Pound and his future mother-in-law Olivia Shakespear were wandering about 'the upper galleries hunting for new work and trying to find some good amid much bad'. Suddenly, Pound realised that they were being followed at a distance by 'a young man … like a well-made young wolf or some soft-moving, bright-eyed wild thing'. The poet was 'playing the fool' and Gaudier 'was willing to be amused by the performance', no doubt sharing Pound's irreverent contempt for the majority of work on display. But the two visitors' light-heartedness turned into surprised admiration when 'on the ground floor we stopped before a figure with bunchy muscles done in clay painted green.' It was Gaudier's *Wrestler* (cat. 26) and belonged to 'a group of interesting things', so Pound 'turned to the catalogue and began to take liberties with the appalling assemblage of consonants: "Brzxjk–" I began. I tried again, "Burrzisskzk–" I drew back, breathed deeply and took another run at the hurdle, sneezed, coughed, rumbled, got as far as "Burdidis–" when there was a dart from behind the pedestal and I heard a voice speaking with the gentlest fury in the world: "Cela s'appelle tout simplement Jaersh-ka. C'est moi qui les ai sculptés." And he disappeared like a Greek god in a vision.'[1]

Pound's curiosity was aroused, so he 'wrote at once inviting him to dinner, having found his address in the catalogue'. Gaudier did not arrive, but his would-be host received a letter 'the morning after my date', calling him 'Madame' and inviting him to the studio Gaudier used in Putney.[2] The relationship developed from there and Pound, with characteristic generosity, did his best to help his penniless young friend in the most practical way he could. Short of money himself, he nevertheless bought two small pieces by Gaudier with some of the £40 given to him by W. B. Yeats from a prize awarded by *Poetry* magazine. The sculptor must have been delighted by the purchases, yet no more so than Pound himself, who told William Carlos Williams in December 1913 that he had 'just bought two statuettes

from *the* coming sculptor, Gaudier-Brzeska. I like him very much. He is the only person with whom I can really be "Altaforte".'[3]

Pound's reference here to one of his own early poems was appropriate, for Gaudier was sufficiently excited by his new friend's poem on 'Piere Vidal' – who ran 'mad as a wolf' through the mountains of Cabaret – to present Pound with a pen drawing of an old wolf, inscribing it 'à mon ami Ezra Pound en admiration de "Piere Vidal Old".'[4] Pound returned the compliment on 18 January 1914 by joining Yeats and other poets in a committee to present Wilfred Scawen Blunt with a Gaudier reliquary of a reclining female nude carved in pentelican marble (fig. 46). It was a token of their regard for the 74-year-old poet's opposition to the British Empire and all its institutions, while in his account of the presentation in the March issue of *Poetry* Pound took the opportunity to praise Gaudier as 'a brilliant young sculptor'.

But this was not the first time he had celebrated his friend's work in print. At the beginning of 1914 Pound found himself so involved in the progress of the artists soon to be associated with the Vorticist movement that he started writing about them in magazines where formerly he had only discussed poetry. Pound was becoming more interested in society as a whole, and grew anxious to demonstrate that the arts had a crucial place in any enlightened community. These views were first elaborated in a trio of articles on 'The Serious Artist' published in *The New Freewoman* between October and November 1913. The 'touchstone of art', he

Fig. 46
Henri Gaudier-Brzeska, *Coffer for Wilfred Scawen Blunt*, 1914. Marble, 11.4 × 26.3 × 12.2 cm. Private collection

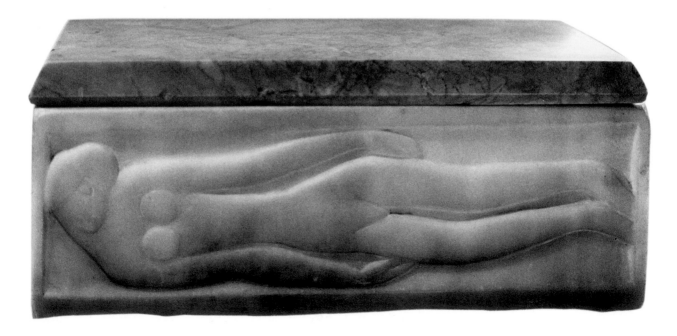

maintained, was 'its precision', and this discipline showed itself in literature when authors firmly controlled their energies and wrote only what they meant to express 'with complete clarity and simplicity', using the smallest possible number of words. In a prophetic phrase, Pound characterised poetry as the 'maximum efficiency of expression' – a definition he would carry over almost intact to his Vorticist theories – even though he also insisted that in verse the 'thinking, word-arranging, clarifying faculty must move and leap with the energising, sentient, musical faculties.'[5]

By January 1914 Gaudier was able to display, at the Grafton Group's Alpine Gallery show in London, a landmark carving called *Redstone Dancer* (cat. 62). It amounted to a far more extreme, dynamic statement than anything he had made before. One of the preliminary studies reveals, with admirable *élan*, that Gaudier now wanted to inject a more vigorous apprehension of movement into his work (fig. 47).[6] Three alternative figures blend into one burgeoning image, their heads, arms and legs jostling with each other to present a paradigm of Futurist simultaneity. The Italian group's experiments obviously helped Gaudier to incorporate so many successive stages of motion in a single sketch, and Umberto Boccioni's new sculpture must have been especially stimulating. But it would be unwise to limit the wide-ranging Gaudier to the inspiration of Futurism alone. Indeed, the abandon of a multi-limbed Indian dancer might also lie behind his drawing for *Redstone Dancer*.

The final carving, however, rejects any Boccioni-like ideas about aping a sequence of movement in sculpture. Now it is the geometrical extremism that commands attention, for Gaudier has dispensed with facial features and imposed a large triangle on the empty oval of the dancer's head, complementing it with a circle on the right breast and a rectangle on the left in place of nipples. Although these motifs sound dangerously dogmatic, they are given plastic life by the rest of the figure as it unfolds in a remarkable series of intertwining arabesques. The spiral of movement initiated by the round plinth, and the turning of the dancer's left foot towards its neighbour, is continued and accelerated as the torso settles at right angles to the pelvis. Then the wildly elongated right arm takes up the spiral with renewed force, wrapping itself round the impossibly tilted head in an extended serpentine curve which only comes to rest when it meets the top of the left breast. Gaudier takes astonishing liberties with human anatomy, moulding it like rubber to enhance the abstract rhythms of his sculpture. Viewed in its totality, the outcome is tortuous and lyrical, labyrinthine and disarmingly simple.

Redstone Dancer marks a decisive moment in Gaudier's precocious career. He puts eclecticism on one side and embraces the new geometrical

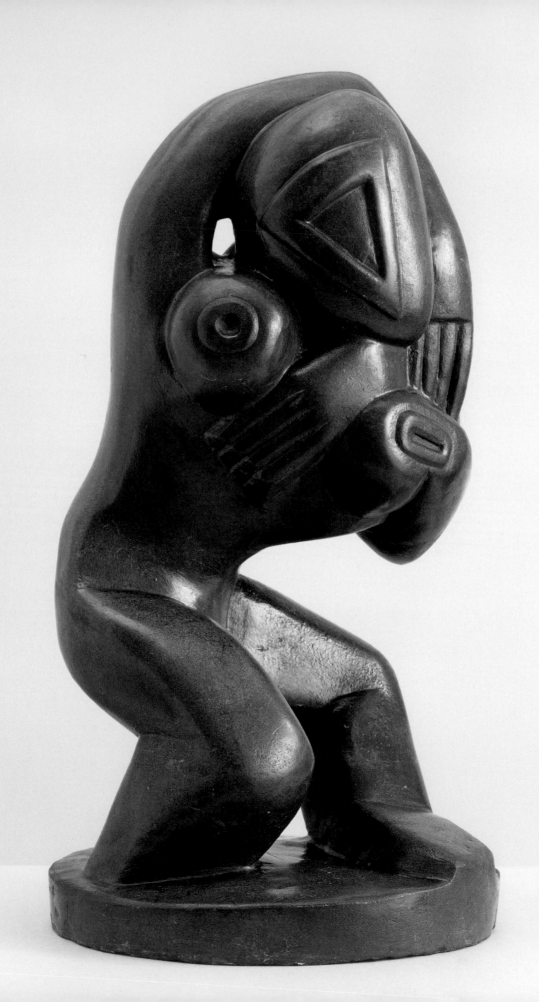

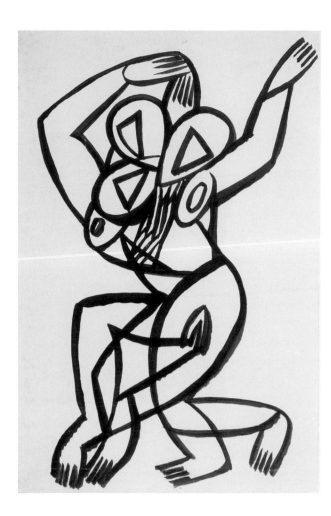

Fig. 47
Henri Gaudier-Brzeska, *Study for Redstone Dancer*,
c. 1913. Ink and brush, 38.5 × 25 cm. Musée National
d'Art Moderne – Centre Georges Pompidou, Paris

opposite
62
Henri Gaudier-Brzeska
Redstone Dancer, c. 1913
Red Mansfield stone, 60 × 35 × 40 cm
Tate. Presented by C. Frank Stoop through
the Contemporary Art Society 1930

art propounded by Hulme in his Quest Society lecture, 'Modern Art and Its Philosophy', delivered at a time when Gaudier's carving was still on view at the Alpine Gallery. Hulme's theories may well have impressed Gaudier at the philosopher's regular salons in Soho. Although it possesses plenty of spontaneity and organic life, *Redstone Dancer* looks almost as if it were constructed according to a theory of art that Gaudier wanted to proclaim as brazenly as possible. Pound noticed this, and chose to expatiate on the sculpture in one of his most closely argued passages of criticism. 'This ... is almost a thesis of [Gaudier's] ideas upon the use of pure form,' he wrote. 'We have the triangle and the circle asserted, labled [*sic*] almost, upon the face and right breast. Into these so-called "abstractions" life flows, the circle moves and elongates into the oval, it increases and takes volume in the sphere or hemisphere of the breast. The triangle moves towards organism, it becomes a spherical triangle (the central life-form common to both Brzeska and Lewis). These two developed motifs work as themes in a fugue. We have the whole series of spherical triangles, as in the arm over the head, all combining and culminating in the great sweep of the back of the shoulders, as fine as any surface in all sculpture. The "abstract" or mathematical bareness of the triangle and circle are fully incarnate, made flesh, full of vitality and of energy. The whole form-series ends, passes into stasis with the circular base or platform.'[7]

Although too neat and conceptual to serve as a wholly accurate summary of Gaudier's intentions, Pound's interpretation can stand as compelling evidence of the young sculptor's willingness to adhere to the principles of a new avant-garde group. The way was now clear for him to throw in his lot with the Rebel Art Centre founded by Wyndham Lewis and other future members of the Vorticist movement. Gaudier supported the Centre's activities with enormous enthusiasm when its London headquarters opened at Great Ormond Street in the spring of 1914. His effervescent and combative personality, no less than his extraordinary prowess as a sculptor, ensured that he rapidly became one of the leading adherents to the rebel cause. His callow stylistic fireworks became far less apparent, and he settled down to pursue a more consistent course of action. Meeting other artists in sympathy with emergent Vorticist theories helped him to fortify his resolve, put imitation behind him and strike out on his own as one of the most inventive, forward-looking sculptors anywhere in Europe.

Pound's dissatisfaction with the progress of Imagism, the innovative movement in English poetry, made him turn increasingly towards the more significant achievements of radical London-based artists.[8] In 1914 he decided to take up his pen in the cause of 'The New Sculpture'. The article he wrote – published in *The Egoist* on 16 February – was basically a defence of Epstein and Gaudier. But he widened it out to include his evolving theories on art and civilisation. He was no longer content merely to claim a place for art in society: the work of his two sculptor friends proved to him that artists should set no reasonable limits on the power they might exert. 'We turn back, we artists, to the powers of the air,' cried Pound, 'to the djinns who were our allies aforetime, to the spirits of our ancestors.' In an exalted mood the poet equated carvings like *Redstone Dancer* and the flenite women with the power of witch doctors, and considered that their magical qualities would enable artists to dominate the world. 'The aristocracy of entail and of title is decayed, the aristocracy of commerce is decaying, the aristocracy of the arts is ready again for its service,' he proclaimed rhetorically, 'and we who are the heirs of the witch-doctor and the voodoo, we artists who have been so long the despised are about to take over control.'[9]

Pound's sentiments represented a more melodramatic version of the theories outlined by T. E. Hulme in his major lecture three weeks earlier,[10] and Gaudier agreed with them. A number of avant-garde artists and writers in London were realising more and more that they shared the same theories about the direction modern art should take, and in March 1914 Gaudier wrote a letter to *The Egoist* voicing opinions that concurred with those of his theorist friends. 'The modern sculptor is a man who works with instinct as his inspiring force,' he began, showing himself in sympathy with Pound's ideas about the need for a return to the primitive. 'His work is emotional. The shape of a leg, or the curve of an eyebrow, etc., etc., have to him no significance whatsoever; light voluptuous modelling is to him insipid – what he feels he does so intensely and his work is nothing more nor less than the abstraction of this intense feeling.' Gaudier made clear that his 'intense feeling' was the same as Pound's 'power of the voodoo' by stressing that 'this sculpture has no relation to classic Greek, but ... is continuing the tradition of the barbaric peoples of the earth (for whom we have sympathy and admiration)'.[11]

Nor was Gaudier content to state his 'admiration' in writing alone. By the time he sat down to compose the *Egoist* letter he was engaged on a monumental portrait of Pound which put these theories into compelling form. The preliminary studies probably began in January or February 1914, after Gaudier's sitter had returned from a winter with W. B. Yeats at Cole-

Fig. 48
Ezra Pound, 1913

63
Henri Gaudier-Brzeska
Study for Head of Ezra Pound, 1914
Ink, 37.5 × 25 cm
Private collection, London

64
Henri Gaudier-Brzeska
Study for Head of Ezra Pound, 1914
Brush and ink, 50.8 × 38.1 cm
Kettle's Yard, University of Cambridge

man's Hatch in Sussex. 'Normally he could not afford marble, at least, not large pieces,' Pound recalled. 'As we passed the cemetery which lies by the bus-route to Putney he would damn that "waste of good stone".' Financial limitations seemed to dictate that Gaudier choose plaster – 'a most detestable medium', wrote Pound, 'to which I had naturally objected.' The poet therefore decided to help by purchasing the stone himself, 'not having any idea of the amount of hard work I was letting Gaudier in for'. During an arduous and dangerous period of physical labour, cutting Pound's block down to a manageable size, Gaudier sketched a whole series of studies of his model, brushing in the main lines of neck, face and mane of hair with decisive strokes of Indian ink (cats 63–64). 'In many of them he had undoubtedly no further intention than that of testing a contour,' Pound

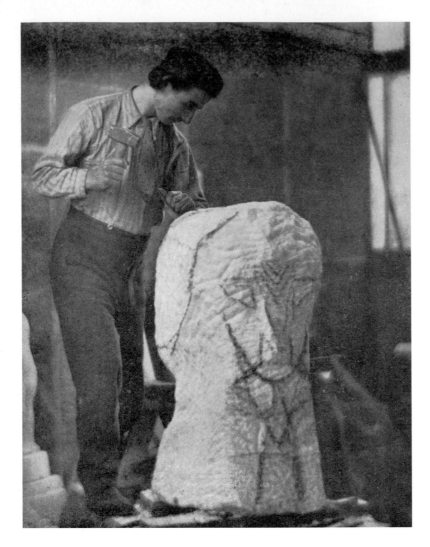

Fig. 49
Henri Gaudier-Brzeska carving *Head of Ezra Pound*, 1914

Fig. 50
Hoa Hakananai'a, Orongo, Easter Island, Polynesia, c. AD 1000. Basalt, height 242 cm. British Museum, London

opposite
65
Henri Gaudier-Brzeska
Head of Ezra Pound, 1914
(replica made in 1973)
Marble, 90.5 × 45.7 × 48.9 cm
Fondazione Giorgio Cini, Venice

explained, and their swift summary of basic outlines demonstrates that Gaudier wanted from the outset to create a hieratic, austerely simplified image. A photograph showing him hard at work on the marble (fig. 49) proves that he then envisaged the eyes as diamond forms rather than narrow slits, and that Pound's moustache curled up above his nostrils. The poet was warned while he sat for his portrait that 'it will not look like you, it will … not … look … like you. It will be the expression of certain emotions which I get from your character.'[12]

Despite Gaudier's explanations, he could never have prepared his sitter – perched 'on a shilling wooden chair in a not over-heated studio with the railroad trains rushing overhead'[13] – for the final product of these superhuman exertions (cat. 65). This time, Gaudier seems to have gone to the British Museum's primitive collections, like Epstein before him, and been deeply influenced by a gigantic carved figure called *Hoa Hakananai'a*, from the Easter Island cult village of Orongo (fig. 50). Ever since entering the Museum in 1869 the figure had reigned over the Polynesian collections, a towering testimony to primitive man's ability to create potent symbols of

65

Henri Gaudier-Brzeska
Head of Ezra Pound (side view), 1914
(replica made in 1973)
Marble, 90.5 × 45.7 × 48.9 cm
Fondazione Giorgio Cini, Venice

his own magical beliefs. Gaudier could not fail to have been impressed by such irrefutable proof of the power of primordial art, and his marble *Head of Ezra Pound* shows that he kept the Easter Island figure securely in the back of his mind as he disposed the various sections of his carving into their unpredictable format. If particular similarities between the two images centre on the areas of eyes and mouth, it appears likely that Gaudier has been inspired above all by the whole vertical identity of the Orongo figure, thrusting its way up into the air in one compact cubic mass of stone. Just as the head of *Hoa Hakananai'a* is wedged on to its torso without any regard for the thinner shape of an intervening neck, so Pound's face rests on a wide base which exists only to ensure that the outlines of the whole sculpture travel up in one consistent direction towards the wider block of hair at the top.

The overall silhouette thereby succeeds in suggesting a circumcised penis, and Epstein – who visited Gaudier while he was at work on the *Head* – recalled that 'Pound had asked him to make it virile and this Gaudier was

endeavouring to do, explaining to me the general biological significance.'[14] This interpretation is confirmed by the disapproving writer Horace Brodzky, who thought that 'there was too much sex-art talk' in Vorticist circles: he coldly declared that the *Head*'s 'purpose and beginnings were entirely pornographic. Both the sculptor and the sitter had decided upon that.'[15] And Wyndham Lewis reinforced this view of the carving by describing it, with disarming candour, as 'Ezra in the form of a marble phallus'.[16]

Yet there is nothing self-indulgent about this monolithic tour de force. Pound, with his almost sacred belief in the importance of artistic discipline, would have been the first to complain if his portrait had become merely immoderate, a dirty joke done for a snigger. Gaudier, likewise, would not have been prepared to expend so much of his time and energy on the creation of a naughty caprice, and the *Head* itself bears out the seriousness of his intentions. Compared with the eerie blend of realism and stylisation employed in the Easter Island figure, his carving appears to be tight and schematic, certainly. But the geometry is subtle, even devious. No single part of the face has been placed at the same angle as that of its companions; they are all tilted slightly off-balance, resulting in a palpable tension. Each separate feature, carefully isolated from the others by a generous expanse of bare marble so that its shape can register with the greatest possible impact, is at odds with its neighbours. Gaudier, despising conventional regularity, has opted for a sequence of slight disparities in order to keep the massive block alive with uneasy rhythms. And he has not overstepped himself in his desire for formal contrasts: in the final stages of the carving he deliberately cut out much of its dramatic swagger, fearing no doubt that he had gone too far in his desire for a grand theatrical statement. Pound recorded that the *Head* 'was most striking, perhaps, two weeks before it was finished. I do not mean to say that it was better, it was perhaps a kinesis, whereas it is now a stasis; but before the back was cut out, and before the middle lock was cut down, there was in the marble a titanic energy, it was like a great stubby catapult, the two masses bent for a blow.' The sitter was evidently torn between his excitement over the earlier state of the carving, and the realisation that it was probably too exaggerated. 'The unfinished stone caught the eye,' he remembered. 'Maybe it would have wearied it.'[17]

Pound was nevertheless satisfied with the results of Gaudier's last-minute alterations. 'There is in the final condition of the stone a great calm,' he wrote, as if in recognition of the fact that Gaudier had seen him as an implacable Buddha in at least one of the preliminary sketches.[18] When it was eventually put on display in May 1914, as part of the Whitechapel Art Gallery's major survey of 'Twentieth-Century Art', the carving must have

signified Gaudier's adherence to the programme formulated by Pound and the emergent Vorticist circle. But its brusque simplifications could not have looked at their best in the crowded environment of a mixed exhibition. The *Head* is essentially a public image, and the features chiselled so boldly into its surface were clearly meant to be appraised from a suitable distance. Just as its Easter Island prototype dominated its surroundings at the British Museum, so Gaudier – who had been a maker of small, intimate sculpture – wanted on this occasion to produce something a little larger than life, to prove that his admiration for the 'barbaric peoples' could be translated into a carving which would not pale in comparison with its primitive predecessors. And he justified the phallic metaphor of the *Head* by describing in an article how the Oceanic races, falling 'into contemplation before their sex: the site of their great energy: THEIR CONVEX MATURITY … pulled the sphere lengthways and made the cylinder'.[19] His carving is therefore as much a tribute to the power of an abstract cylinder as a symbol of virility, and in that sense its primitivism leads directly to the mechanistic geometry of Gaudier's Vorticist sculpture.

His friendship with Pound, celebrated so memorably in this carving, continued to flourish at an intense and cordial level throughout the summer of 1914. At some point, Gaudier carved another portrait of Pound (cat. 66), this time using a length of wood and turning the poet into a more slender, abstract totem who looks at once vulnerable, aggressive and vigilant.[20] Pound, for his part, became an ever more passionate advocate of the artists who adhered to the new movement he had christened while Gaudier was working on the *Head*. After coining the name Vorticism,[21] Pound helped Wyndham Lewis prepare the first issue of *BLAST* for publication at the beginning of July.[22] This activity involved close collaboration with Gaudier, who contributed a highly idiosyncratic and combative article of faith entitled 'Vortex' to the magazine. So did Pound, and Brodzky satirised the militancy driving this triumvirate of Vorticist insurgents in a lively little cartoon called *The Lewis-Brzeska-Pound Troupe*, who were shown 'blasting their own trumpets before the walls of Jericho' (fig. 51).[23] Although several other artists were also vigorously involved in the birth of the 'Great English Vortex', Pound always saw the movement in terms of the two men whose work and friendship he valued most highly. 'W. L. certainly *made* vorticism,' he wrote later. 'To him alone we owe the existence of *Blast*. It is true that he started by wanting a forum for the several ACTIVE varieties of CONTEMPORARY art/cub/expressionist/post-imp, etc. BUT in conversation with E. P. there emerged the idea of defining what WE wanted & having a name for it. Ultimately Gaudier for sculpture, E. P. for poetry, and W. L., the main mover, set down their personal requirements.'[24]

66
Henri Gaudier-Brzeska
Portrait of Ezra Pound, 1914
Wood, 73 × 17.2 × 17.2 cm
Yale University Art Gallery, New Haven.
Purchase Director's Fund

Fig. 51
Horace Brodzky, *The Lewis-Brzeska-Pound Troupe*,
reproduced in *The Egoist*, 15 July 1914

During the heady period of excitement and optimism which witnessed the publication of *BLAST*, with its defiant polemical assault on so many aspects of British culture, Gaudier and Pound remained continually in contact, as companions and as admirers of each other's work. On a social level there were Vorticist celebrations to be attended, most notably at the Dieudonné Restaurant in St James's on 15 July to mark the appearance of *BLAST*. The meal was, by all accounts, both memorable and hilarious. Gaudier, who could not afford the ten-shilling ticket, arrived with a carving which he placed on Pound's plate as an alternative form of payment. Pound remembered later that 'the feast was a great success ... Gaudier himself spent a good part of the meal speculating upon the relation of planes nude of one of our guests, though this was kept to his own particular corner.'[25]

Pound clearly relished Gaudier's impish and subversive sense of humour, yet he also admired the sculptor's 'Vortex' article in *BLAST*. Here, Gaudier employed the English language with such aplomb in his writing that Pound could hardly fail to respond to the headlong stylistic exuberance of a sentence like 'from Sargon to Amir-nasir-pal men built man-headed bulls in horizontal flight-walk.'[26] Indeed, after encountering Gaudier's 'Vortex' credo Pound was forced to 'confess that I read it two or three times with nothing but a gaiety and exhilaration arising from the author's vigour of speech'.[27]

Even so, once Pound had recovered from this initial delight he found himself agreeing wholeheartedly with many of the sentiments expressed in the article. His own definition of Vorticism for *BLAST* insisted that 'the vorticist relies on this alone; on the primary pigment of his art, nothing else.'[28] He went on to explain that the 'radiant node or cluster'[29] of the vortex signified a return to the elemental vitality of art's fundamental constituents, and pointed out that 'every conception, every emotion presents itself to the vivid consciousness in some primary form. It is ... the most highly energised statement, the statement that has not yet SPENT itself in expression, but which is the most capable of expressing.' Elsewhere in the article Pound emphasised, in bold capital letters, that the 'primary' characteristic of sculpture was 'FORM OR DESIGN IN THREE PLANES', and he defined Vorticism as 'art before it has spread itself into a state of flaccidity, of elaboration, of secondary applications.'[30]

Gaudier's 'Vortex' article was wholly in sympathy with these views, and it is fair to suppose that Pound had a considerable influence on his friend's thinking. Gaudier lauded primitive art at the expense of Hellenism, and brusquely announced that 'the fair Greek saw himself only. HE petrified his own semblance. HIS SCULPTURE WAS DERIVATIVE his feeling for form secondary.'[31] Like Pound, Gaudier wanted a 'primary' art and he prefaced his 'Vortex' article with a stern tripartite statement of creative priorities:

Sculptural energy is the mountain.

Sculptural feeling is the appreciation of masses in relation.

Sculptural ability is the defining of these masses by planes.[32]

Gaudier's article also makes clear his own commitment to the Vorticist call for an art directly expressive of machine-age dynamism in the new century. Despite his continuing love of animal and bird life in all their manifestations, he was capable of responding to the stress and pressure of his urban environment as well. Towards the end of his 'Vortex' essay he compared his own generation of sculptors with the African and Oceanic races, before concluding that, just as the 'primitives' had found that 'the soil was hard, material difficult to win from nature, storms frequent, as also fevers and other epidemics', so 'WE the moderns: Epstein, Brancusi, Archipenko, Dunikowski, Modigliani, and myself, through the incessant struggle in the complex city, have likewise to spend much energy.'[33]

67
Henri Gaudier-Brzeska
Cubistic Ornament (design), 1914
Black chalk, 47.5 × 37.8 cm
Kunsthalle Bielefeld

68
Henri Gaudier-Brzeska
Design for Vorticist Ornament, 1914
Crayon, 47 × 31.5 cm
Kettle's Yard, University of Cambridge

Apart from providing a useful checklist of the modern sculptors he most admired, this passage shows how closely Gaudier identified with the other rebels' response to the experience of existing in twentieth-century London. If Lewis likened the 'great modern city' to an 'iron Jungle',[34] Gaudier's love of archaic art made him take the image further and equate the tom-toms of tribal dances with the roar of contemporary machines. For all the sophistication of the latest inventions, humanity was still forced to pit its organic strength against the domineering force of an industrial environment (cats 67–70). And where prehistoric artists had expressed their reaction to the world in terms of the chase, drawing its schematic contours on the surface of cave walls, the Vorticists turned the machine into a similar kind of fetish and made it the centre of their art. 'Out of the minds primordially preoccupied with animals,' declared Gaudier in his 'Vortex' article, 'Fonts-de-Gaume gained its procession of horses carved in the rock. The driving power was life in the absolute.'[35]

Thousands of years later, this same need for a creative 'absolute' drove Gaudier himself to produce his commanding pastel *Vorticist Composition* (cat. 72). His subtle use of pale yellows, dark blue and black here creates a sense of solidity. The diagrammatic simplicity of the design emphasises flatness and surface pattern, yet the gradated shading allows depth to exist at the same time. Forms are suggested, and even the most dominant tend to fade away into an undefined space in which dark shadows take on the significance of the more fully elaborated shapes. Gaudier pulls his crayon across the paper, giving his mechanised components a paradoxically velvet texture that softens these cylinders, tubes and girders into objects of meditative splendour. And the measured tempo achieves the 'concentrated' quality Gaudier advocated in his 'Vortex' credo: *Vorticist Composition* has not only 'crystallised the sphere into the cube',[36] it has also made the compact strength of cubic units inform the framework of a dynamic Vorticist vision.

In a cut bronze sculpture called *Torpedo Fish* (cat. 71), which Hulme purchased for £2 and carried around in his pocket so he could handle it 'while talking',[37] Gaudier came closest to the militancy of the Vorticist ideal. According to Pound, who described it as 'the first experiment and the best' of three bronze carvings Gaudier made, this little work was a 'Toy'.[38] But the sculptor himself listed the work more appropriately as an 'ornement torpille!',[39] in other words, a type of flat torpedo fish capable of giving an electric shock. It was a metaphor after Lewis's own heart, for this piece of metal can also be seen as a standing sentinel, as harsh and combative as the 'Primitive Mercenaries in the Modern World' whose birth was announced in the *BLAST* manifestos.[40] Like Lewis's mechanised figures, *Torpedo Fish* would be perfectly capable of leading a Vorticist attack against the forces of reaction. Stiff and erect, as if lined up for battle, its sharp edges seem ready to tear their way through any struggle. Indeed, it is easy to imagine the pugnacious Hulme playfully threatening to use it as a weapon.

Although miniature in scale, this work is heroic in implications, both as a warrior and a milestone in the history of early twentieth-century sculpture. For *Torpedo Fish* is one of the first examples of a completely penetrated carving: later, perhaps, than Archipenko's pioneering experiments in the same field, yet innovative nonetheless. Gaudier has pierced the bronze, from front to back, in three places. And one side reinforces the image of a human body, possessing a spinal motif that runs down from the top into a knot of more organic forms towards the base. Gaudier liked to play around with ambiguity: a delightful alabaster *Imp* (cat. 74), carved in the same year, presents an abstract surface on one side and a figurative image on the other. In *Torpedo Fish*, however, high spirits are not allowed

71
Henri Gaudier-Brzeska
Torpedo Fish, 1914
Cut bronze, 15.9 × 3.8 × 3.2 cm
Collection Art Gallery of Ontario, Toronto.
Purchase, 1985

opposite
72
Henri Gaudier-Brzeska
Vorticist Composition, c. 1914
Pastel, 47.5 × 32 cm
Ivor Braka Ltd, London

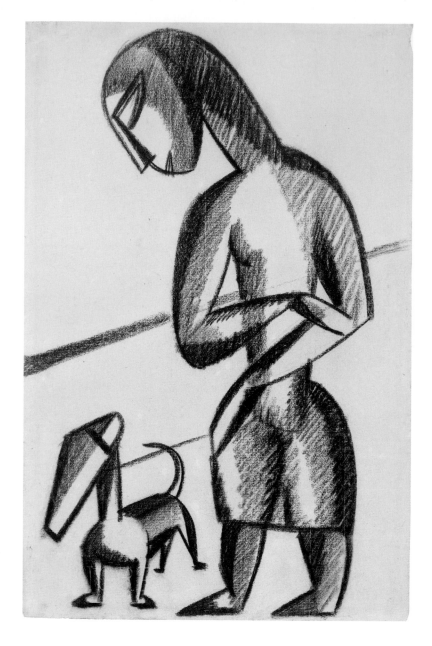

73

Henri Gaudier-Brzeska
Woman and Dog, 1914
Charcoal, 46.4 × 30.5 cm
Kettle's Yard, University of Cambridge

to interfere with the essential severity of a hieratic presence. It might eas-
ily have prompted the enthusiasm of Lewis's comments on Gaudier in
the second issue of *BLAST*, where he praises the 'suave, thick, quite
PERSONAL character' of Gaudier's work and explains how 'it is this, that
makes his sculpture what we would principally turn to in England to show
the new forces and future of this art.'[41]

Some of Gaudier's most admirable 1914 drawings are devoted to animals
and fish, ranging from the mischievous black chalk study of *Cows' Heads*
(cat. 76), the affectionate *Woman and Dog* (cat. 73) and the aptly named
Satirical Futurist Sketch (cat. 75) to the refined minimalism of a pencil draw-
ing outlining the stately, galleon-like contours of *The Swan III* (cat. 77).
He also delighted in carving a tender *Crouching Fawn* from Bath stone

74
Henri Gaudier-Brzeska
Imp, *c.* 1914
Red-veined alabaster, 40.6 × 8.9 × 8.3 cm
Tate. Presented by C. Frank Stoop through
the Contemporary Art Society 1930

top
75
Henri Gaudier-Brzeska
Satirical Futurist Sketch, 1914
Pen and Indian ink, 25 × 37 cm
Kettle's Yard, University of Cambridge

centre
76
Henri Gaudier-Brzeska
Cows' Heads, 1914
Black chalk, 30 × 45 cm
Kettle's Yard, University of Cambridge

bottom
77
Henri Gaudier-Brzeska
The Swan III, 1914
Pencil, 31.5 × 40 cm
Ivor Braka Ltd, London

(cat. 80) and the playful *Three Monkeys* (cat. 79) from a small block of sandstone, while the *Duck* (cat. 78) can be counted among his most satisfying smaller works. Yet he decided, in one ambitious and deeply considered sculpture, to bring creatures from both air and sea into a single, arresting image. Whether Gaudier actually witnessed the dramatic incident he chose for his most dynamic 1914 work, perhaps during a habitual walk in one of London's parks, is unknown. But when he set to work on *Bird Swallowing a Fish* (cats 81–83), it became a masterpiece of Vorticist sculpture.[42] Gaudier formalises the anatomical properties of the two protagonists with such rigidity that most of their recognisable features have completely disappeared. The fish slots into the bird like a key that can only fit one particular lock, and they are wedged together as a single dynamic entity.

It is hard, at first, to realise that two separate creatures are presented rather than a macabre amalgam containing the characteristics of both: they seem indistinguishable from each other, as if the fish were a sinister malignance growing out of the bird's extended beak. This ambivalence extends to the meaning of the act Gaudier has chosen to dramatise. The whole eerie operation has been frozen and held up for inspection, so that the most

81
Henri Gaudier-Brzeska
Bird Swallowing a Fish, 1914
Pen and ink, 30.5 × 37 cm
Kettle's Yard, University of Cambridge

complicated overtones are given full rein. It is no longer a simple matter of one creature engorging another. On the contrary: the fish is not really being devoured at all. Instead, it is ramming itself into the bird's open mouth. The predator's eyes seem to be straining in their sockets, which swell with the effort involved in finding room for this awkward visitor. Rather than swallowing, the bird could actually be choking on outsize prey it was unwise to hunt.

Examining the sculpture from a lower angle shows how equally matched the two combatants are in reality. The fish may be the smaller of the pair, but there is nothing slight about its structure. Its tail sticks up into space like the butt of a weapon, vividly echoing Vorticism's insistence on the 'maximum point of energy'.[43] And the bird's back thrusts itself into an ample triangle at the other end. Both sides shoot down with comparable strength towards the middle, where all the force of the sculpture is concentrated inside the bird's gullet. There the two meet, hidden from view, in a moment of contact that conveys more than a little sexual *frisson*. Violence and lust are never wholly separable impulses, and Gaudier has explored this truth in the core of his invention. He has selected the moment

of deadlock, when each party is still struggling for survival. The outcome remains undecided, and the sense of stalemate in this remarkable work eerily prophesies the course of the First World War which broke out soon after Gaudier completed the sculpture.

Despite the tension, there is no hint of a hectic struggle. The dispassionate dictates of Vorticist art ensure that both bird and fish have a detached air about them. No emotive expressions, whether of fear, greed or hate, are permitted to disturb the unruffled impersonality of the performance. What would normally be a trivial incident, a callous fact of nature, has been metamorphosed into an intractable ritual. And the belligerence of the formal language has found its match in the materials employed. Although Gaudier modelled the work in plaster, it was cast in gunmetal. Nothing could be more appropriate for a sculpture that shows above all how Gaudier managed to reconcile his dual involvement with nature and the machine.

Bird Swallowing a Fish proves, with impressive authority, that some of Gaudier's concerns were close to those of Raymond Duchamp-Villon. After all, this young French artist – likewise doomed to die during the First

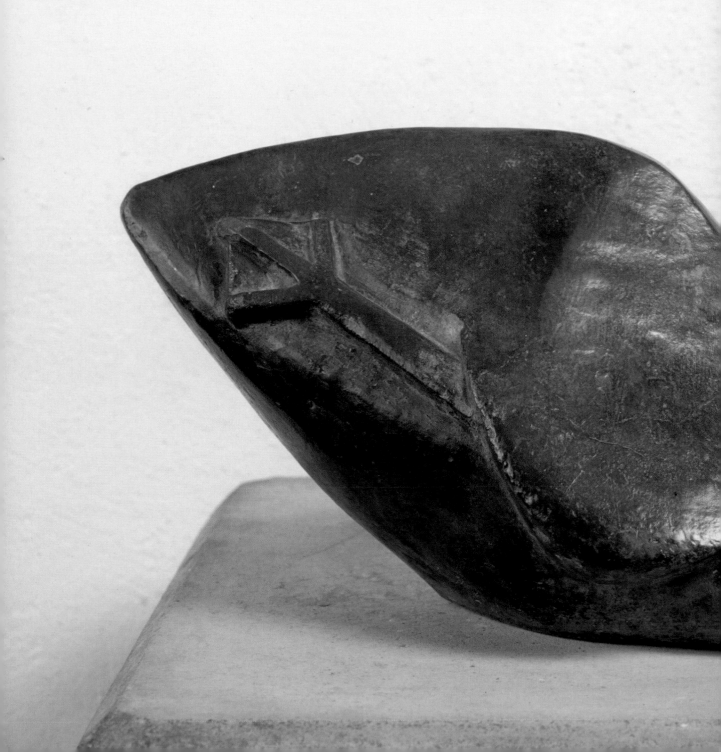

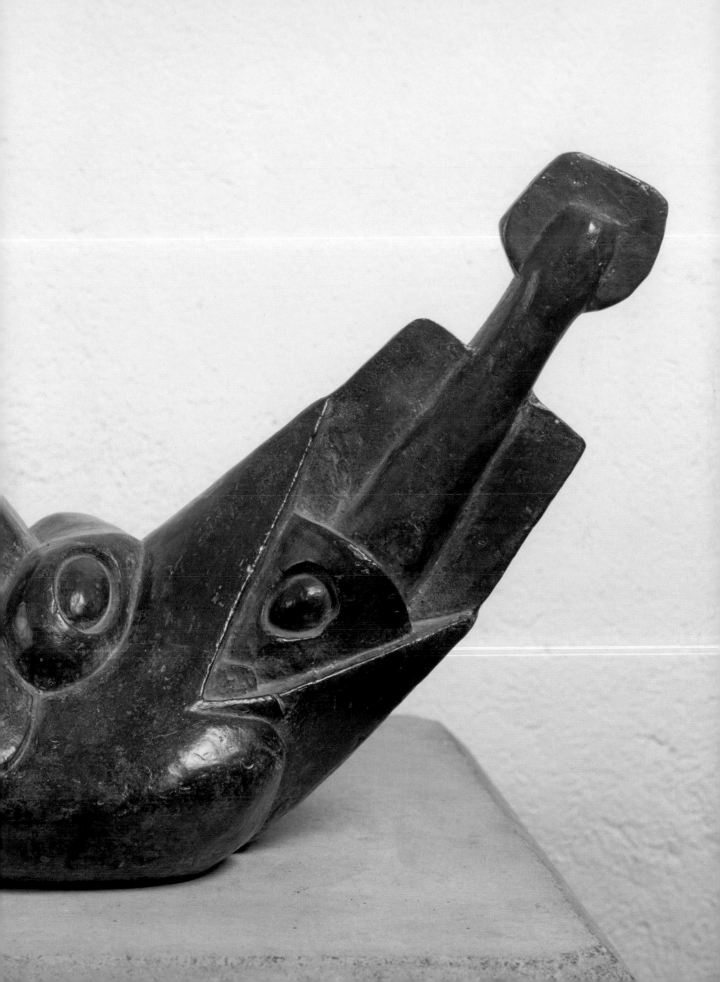

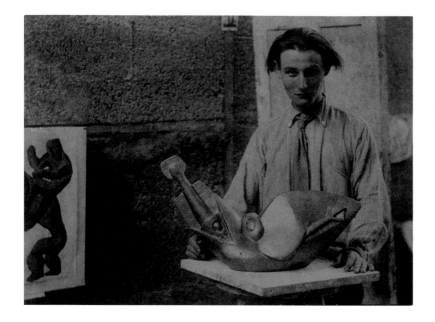

Fig. 52
Henri Gaudier-Brzeska with *Bird Swallowing a Fish*, 1914

Fig. 53
Raymond Duchamp-Villon, *The Horse*, 1914 (cast *c.* 1930). Bronze, 43.6 × 41 cm. Peggy Guggenheim Collection, Venice. Solomon R. Guggenheim Foundation, New York

World War – produced in 1914 a sculpture called *The Horse* (fig. 53) where the animal's body has been transformed into a pounding yet coiled metaphor of mechanistic power. Compared with *The Horse*, however, *Bird Swallowing a Fish* is characterised by an uncannily arrested stillness. Vorticism abhorred the Futurists' rhapsodic involvement with speed and blurred motion: Lewis, who wanted his movement to inhabit 'the heart of the whirlpool … a great silent place where all the energy is concentrated',[44] announced in *BLAST* that 'The Vorticist is at his maximum point of energy when stillest.'[45] To him, Marinetti's idea of dynamism was caught up in the outer chaos of the vortex whirlpool, a piece of hopelessly romanticised flotsam drowning in its own undisciplined frenzy. Gaudier shared Lewis's impatience with Futurism, and *Bird Swallowing a Fish* offers a tense affirmation of the Vorticists' commitment to rigidly concentrated definition.

Even so, carving remained fundamentally important to Gaudier. He had no hesitation in using the most heretical materials – like the toothbrush handle which became an *Ornament* (cat. 84) after he had transformed it into a totemic cult-object, with one end rounded into a helmet strangely reminiscent of Epstein's *Rock Drill*.[46] The real fascination of the piece lies in the extraordinary variety of forms Gaudier has invested in this tiny, fragile piece of bone: now solid and bulky, now cut right through, now narrowed down to a sliver and finally ribbed like the manufactured edges of a real

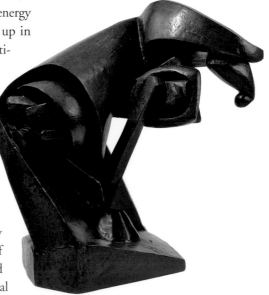

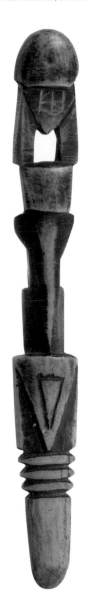

84
Henri Gaudier-Brzeska
Ornament (Carved Toothbrush), 1914
Bone, 10.6 × 2.26 cm
Private collection, London

toothbrush. Winifred Gill, who met Gaudier when he visited the Omega Workshops, later recalled in a poem how he showed her this carving:

'Look here', he said, and fished out of his pocket
A carved bone and laid it upon my palm,
Image with image linked in a subtle curve
Stained brown as with age and use, the surfaces polished
To ivory. He watched me turn it. 'Well, tell me
What country that came from?'
'Nigeria?'
He laughed his satisfaction, took it and muttered,
'Made it myself to-day from a toothbrush handle.'[47]

Gaudier proved equally inventive when cutting into brass and shaping a *Doorknocker* (cat. 85). The two prominent circles like eyes staring out from the top give the carving an avian identity, as wary as an owl. And Gaudier explained that 'the doorknocker is an instance of an abstract design serving to amplify the value of an object as such. No more cupids riding mermaids, garlands, curtains – stuck anywhere! The technique is unusual; the object is not cast but carved direct out of solid brass. The forms gain in sharpness and rigidity.'[48] It is safe to assume that an outright sexual reference is suggested by the genital forms in the lower half of *Doorknocker*. And Gaudier went much further in a cut-brass *Knuckle-Duster* (fig. 54) made for Hulme. Years later, Epstein recalled that Hulme 'was a virile type of man, and he once humorously confessed that his extensive knowledge of the geography of outlying parts of London came entirely from his suburban love-affairs.'[49] Hulme, for his part, proudly showed *Knuckle-Duster* to a female friend and explained that 'the two pieces curving out sideways at the bottom are the woman's parted legs. The central hole is her vagina, and the four holes at the top are the woman's head tossing and turning as she achieves orgasm.'[50]

The most impressive manifestation of Gaudier's devotion to carving is the limestone *Birds Erect* (cat. 86). Casting aside the mechanistic rigidity of *Bird Swallowing a Fish*, he turned back here to the more organic vocabulary employed in other pieces. Yet this time, he allowed no doubt to linger about the anti-realistic nature of his latest enterprise. These freestanding forms are indeed 'erect', like a group of birds thrusting out of a nest in readiness for the arrival of food. But there the connection with identifiable reality is cut short. Gaudier wanted to construct an autonomous equivalent rather than trying to reproduce an episode from natural life. The crisply articulated segments are grouped together in an ensemble that bristles with vitality. Gaudier has set them down on a tall base shaped into four main

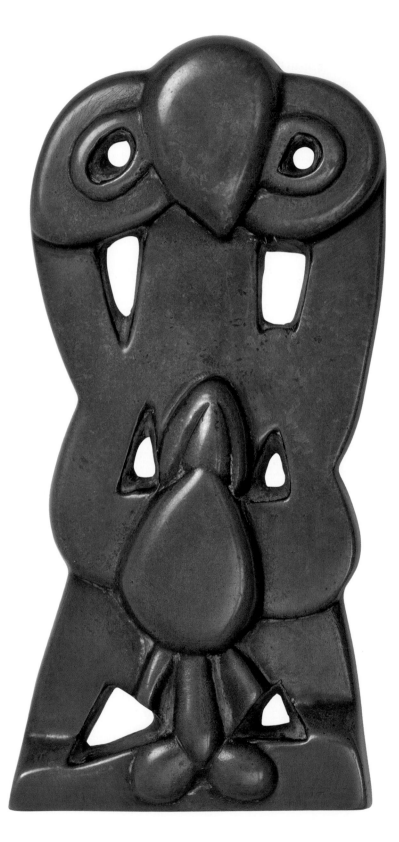

85
Henri Gaudier-Brzeska
Doorknocker, 1914
Cut brass, 17.7 × 8.5 × 1 cm
Kettle's Yard, University of Cambridge

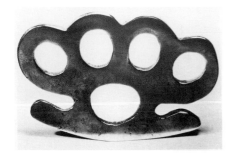

Fig. 54
Henri Gaudier-Brzeska, *Knuckle-Duster*, 1914.
Cut brass, 7.6 × 11.4 cm. Private collection

planes. These help to punctuate the continuous movement of the sculpture above and, more importantly, provide an uneven sloping surface for the work to rest on. Viewed from one angle, the birds seem to crowd in on each other as if to save themselves from falling off the edge of a precipice. The instability creates a feeling of tightrope tension: Gaudier is pushing asymmetry as far as he can, in the knowledge that the most exciting composition of 'masses in relation' invariably springs from a willingness to take risks, to shock and surprise.

So he drives his chisel deep into the fabric of the stone, undercutting in layers, carving violent Vorticist diagonals and zigzags into each swaying upright in order to set the whole structure jerking with syncopated motion. The rhythms created by the work as our eyes traverse its convoluted, ever-shifting surfaces are harsh and jarring. The abruptness is intimately related to the essential impact of a Vorticist picture, and yet it is not the same. These hewn fragments have an organic warmth that belongs to Gaudier alone, and goes some way towards counteracting the unrest of the sculpture. The stones appear to be unfolding and expanding outwards from their base, and the continuously changing surfaces they present when the work is walked around seem to reflect this process of growth.

Abstraction gave Gaudier the chance to inject several layers of meaning into a single carving. On one level, *Birds Erect* is full of associations with plant life. 'He had several small cacti in his studio,' recalled Brodzky, who maintained that the sculpture was directly inspired by their shapes. 'These he liked because they suggested new ideas. All the time, he was going to nature for his forms.'[51] On another level, however, *Birds Erect* seems to be derived from earlier drawings of human figures walking in the park. Just as Lewis always insisted, Gaudier never lost sight of his response to the outside world, even if *Birds Erect* makes plain his desire to create an alternative realm of his own ordering. 'This is one of the most important pieces', declared Pound, placing the work in a symbolic position at the end of his catalogue of Gaudier's *oeuvre*. The poet made his admiration evident by roundly asserting that 'as a composition of masses I do not think I have seen any modern sculpture to match it.'[52]

Birds Erect is without doubt among the most defiant and extreme sculptures to have been produced in Europe by 1914. Gaudier relishes the intrinsic character of the limestone, making its porous texture an integral part of the cool, bleached mood conveyed by the sculpture as a whole. He adjusted his working methods to suit the specific demands that his respect for the material imposed on him. What really counted was the use to which the sculptor put the various materials that came his way, enhancing their individual properties rather than hiding them in an attempt to pretend that he

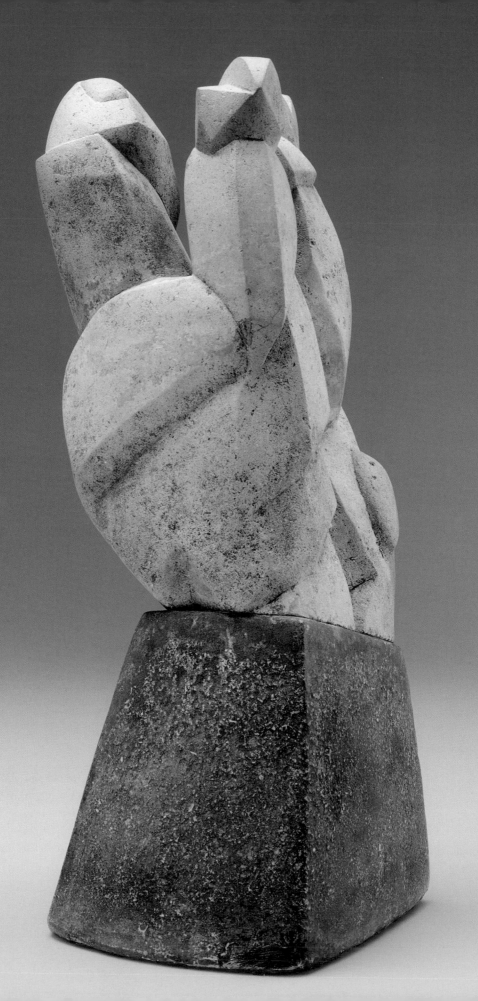

86
Henri Gaudier-Brzeska
Birds Erect, 1914
Limestone, 67.6 × 26 × 31.4 cm
The Museum of Modern Art, New York.
Gift of Mrs W. Murray Crane, 1945

only ever employed marble or bronze. 'The sculpture I admire is the work of master craftsmen', Gaudier wrote proudly in *The Egoist*. 'Every inch of the surface is won at the point of the chisel – every stroke of the hammer is a physical and mental effort. No more arbitrary translations of a design in any material. They are fully aware of the different qualities and possibilities of woods, stones, and metals.' He went on to acknowledge the source of his convictions by explaining how 'Epstein, whom I consider the foremost in the small number of good sculptors in Europe, lays particular stress on this. Brancusi's greatest pride is his consciousness of being an accomplished workman.'[53]

Pound, who now owned several of Gaudier's carvings, was able to study them at close quarters, handle them freely and acquaint himself with every inch of their surfaces. He knew just how much concentrated energy had gone into their creation, and he warmly approved of Gaudier's passion for controlling the entire business of making a sculpture. 'As if his … constant chipping at stone were not enough to occupy his hands,' Pound wrote, 'he made his own tools at a forge. It might take a full day to temper his chisels. These chisels were made from old steel spindles sent him by Mr Dray, who had … a factory somewhere in the indefinite "North". This also may have been an economy, but it was the sort of economy Gaudier liked. He liked to do the "whole thing" from start to finish; to feel as independent as the savage.'[54]

The importance of this emphatic belief in the sanctity of materials hardly needs to be stressed. Pound summarised many of the principles taken up by the young Henry Moore, and other members of the generation who came to early maturity in the 1920s, when he defined the 'new form' of sculpture as 'energy cut into the stone, making the stone expressive in its fit and particular manner. It has regard to the stone. It is not something suitable for plaster or bronze, transferred to stone by machines or underlings. It regards the nature of the medium, of both the tools and the matter. These are its conventions and limits.'[55] Many decades later, Moore himself recalled that 'when I came to London as a raw provincial student, I read things like *BLAST* and what I liked was to find somebody in opposition to the Bloomsbury people, who had a stranglehold on everything … Gaudier's writings and sculpture meant an enormous amount as well – they, and *BLAST*, were a confirmation to me as a young person that everything was possible, that there were men in England full of vitality and life.'[56] Even Ben Nicholson, whose principal ambitions lay with painting rather than sculpture, believed to the end of his life that among the Vorticists Gaudier was 'both in achievement & potential head & shoulders above any other artist involved'.[57]

Yet nobody can ever know how Gaudier might have developed. When military hostilities broke out, they quickly overshadowed the aesthetic

pugnacity of *BLAST*. Gaudier was not cowed. On the contrary: he could not wait to join the French army and 'avenge all the brutalities committed by the Germans against his family in the Franco-Prussian conflict of 1870'.[58] Soon after making a will and leaving for France, Gaudier returned. He had been arrested by a recruiting officer in Boulogne for an earlier failure to perform his military duties. And, after imprisonment in a Calais guardhouse, he escaped to London. But the shelling of Rheims Cathedral soon shocked him into crossing the Channel once more. Gaudier always proudly claimed that his medieval ancestors had been masons and stone carvers at Chartres Cathedral, and Pound described how Gaudier's 'disgust with the boches was too great to let him stay "idle".'[59] His final departure, attended at Charing Cross Station by Epstein, Hulme and Lewis, mortified all his friends. 'I remember him in the carriage window of the boat-train, with his excited eyes,' Lewis wrote. 'We left the platform, a depressed, almost a guilty, group. It is easy to laugh at the exaggerated estimate "the artist" puts upon his precious life. But when it is really an artist – and there are very few – it is at the death of something terribly alive that you are assisting. And this little figure was so preternaturally alive.'[60]

In the French army, Gaudier's super-abundant vitality and reckless courage were to prove his undoing. He somehow found time to compose a short essay for *BLAST*'s second issue (fig. 55), insisting in defiant capital letters that '<u>MY VIEWS ON SCULPTURE</u> REMAIN ABSOLUTELY THE SAME. IT IS THE <u>VORTEX</u> OF WILL, OF DECISION, THAT BEGINS.'[61] Moreover, in order to cite a practical example of his unchanging radicalism, a model for the sculpture he would have executed if the war had not prevented him, he told his Vorticist friends that 'I have made an experiment … Two days ago I pinched from an enemy a mauser rifle. Its heavy unwieldy shape swamped me with a powerful IMAGE of brutality.' Gaudier had been overwhelmed by the form of the rifle, not by the fact that it was a weapon of destruction. And so, deciding that 'I did not like it', he counteracted the 'brutality' with an alternative shape of his own. 'I broke the butt off and with my knife I carved in it a design, through which I tried to express a gentler order of feeling, which I preferred', he wrote. 'BUT I WILL EMPHASIZE that MY DESIGN <u>got its effect</u> (just as the gun had) FROM A VERY SIMPLE COMPOSITION OF LINES AND PLANES.'[62]

It was a conclusion after Pound's own heart, but the poet continued to worry about the effect that prolonged exposure to battle would have on his friend's future work. When he wrote to Gaudier in January 1915, he 'threatened him that in reaction from his present life of violence, he would react into … the nineties, delicate shades and half lights.' Gaudier replied

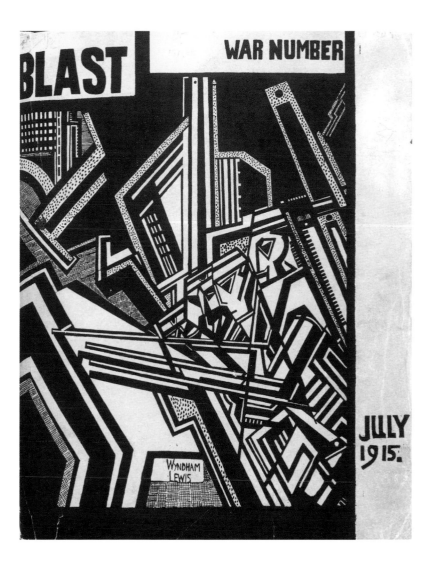

Fig. 55
Cover of *BLAST*, 2, 1915

firmly that, if he returned, 'I believe I shall develop a style of my own which, like the Chinese, will embody both a grotesque and a non-grotesque side. Anyway, much will be changed after we have come through the blood bath of idealism.'[63]

Gaudier, however, did not come through. He never gave up planning new work, and in February 1915 he wrote to his Vorticist friend Edward Wadsworth thanking him for sending some woodcuts. 'I am very pleased to look upon them after 14 days of nothing but muddy holes,' Gaudier wrote. 'I must not complain though. We had several attacks in the nights and by god we sent hundreds of rockets – the germans too & this added to the flashes from the rifles & the big flames of exploding shells provided magnificent nocturnes. The only things I can prey upon for my own work of sculptor [*sic*] are putrefying corpses of dead germans which give fine ideas to sculpt war demons in black stone once the fight's over.'[64] Yet he was never given the chance to fulfil these macabre, haunting dreams. His courage in battle became legendary, and after swift promotion from

corporal to sergeant he started training to be a lieutenant (fig. 56). But on 5 June 1915, after months of heavy fighting, Gaudier was killed by a machine-gun bullet during a charge near a village aptly named La Targette (fig. 57). He was only twenty-three years old. Towards the end of the war, Lewis passed the fields where Gaudier had fallen. 'The ground was covered with snow, nobody about,' he wrote, 'and my god, it did look a cheerless place to die.'[65]

If Gaudier had not 'gone out through a little hole in the high forehead',[66] as Ford Madox Ford lamented in an emotional obituary notice, his contribution to the subsequent course of twentieth-century sculpture would surely have been notable. But the war brought Gaudier's potential development to an appallingly premature end, and Pound was stunned. 'We have lost the best of the young sculptors, and the most promising,' he wrote soon after hearing the news. 'The arts will incur no worse loss from the war than this is. One is rather obsessed with it.'[67]

Gaudier's death deeply affected his unstable partner Sophie Brzeska, who blamed herself and devoted the next three embittered years to planning a Memorial Exhibition.[68] This was held at the Leicester Galleries in 1918, and Pound declared in the catalogue preface that 'the volume and scope of the work is, for so young a man, wholly amazing, no less in variety than in the speed of development.'[69] But the exhibition could not compensate Sophie for the loss of Gaudier. After moving to the solitude of a cottage in Gloucestershire, her mind further deteriorated. She was confined to a mental hospital and, certified as insane, died of bronco-

Fig. 56
Henri Gaudier-Brzeska in 1915 with fellow soldiers shortly before his death (second from the left)

Fig. 57
Henri Gaudier-Brzeska's grave, Nécropole Nationale, La Targette Cemetery, Pas-de-Calais, France

Fig. 58
Cover of *Gaudier-Brzeska: A Memoir* by Ezra Pound,
London, 1916

pneumonia in 1925. Gaudier's entire estate, including 13 oil paintings and pastels, 25 sculptures and 1,630 drawings, was valued at £250 and became the property of the state. Yet the Tate Gallery, displaying unbelievable lack of judgement, decided to retain only 3 sculptures and 15 drawings, allowing the rest of his work to be sold in 1927.

But at least Pound was able to commemorate his friend in the permanent form of a book. He set to work immediately after Gaudier's death, turning his profound grief into an eloquent *Memoir* (fig. 58) which incorporated all the artist's published writings, a 'partial catalogue of the sculpture', and a lavish series of reproductions. 'In undertaking this book I am doing what little I can to carry out Gaudier's desire for accessibility to students,' he explained, 'and I am, moreover, writing it very much as I should have written it had he lived, save that I have not him leaning over my shoulder to correct me and to find incisive, good-humoured fault with my words.'[70] The *Memoir* was published both in London and New York in 1916, and its unashamed devotion must have been obvious to all who read it. At once elegiac, combative, passionate and analytical, it is an outstanding tribute from a poet to a sculptor. But above all it is a heartfelt testament to a friendship. 'I have known many artists,' Pound wrote, trying hard to come to terms with his terrible sense of loss. 'I am not writing in a momentary fit of grief or of enthusiasm. I am not making phrases. I am not adding in any way to statements I had made and printed during Gaudier's lifetime. A great spirit has been among us, and a great artist is gone.'[71]

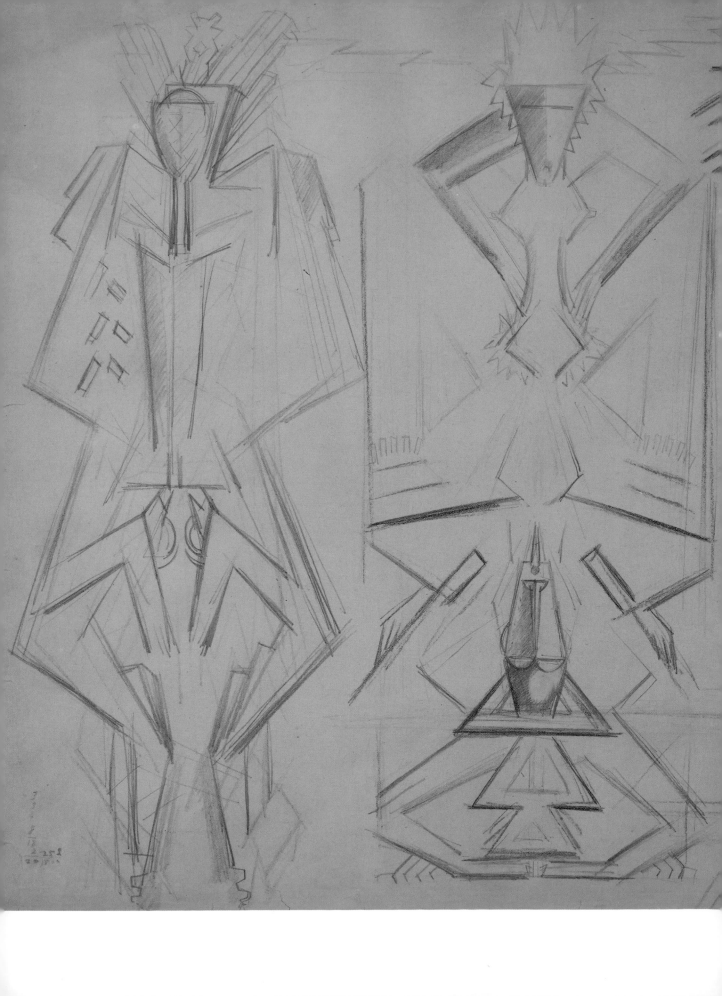

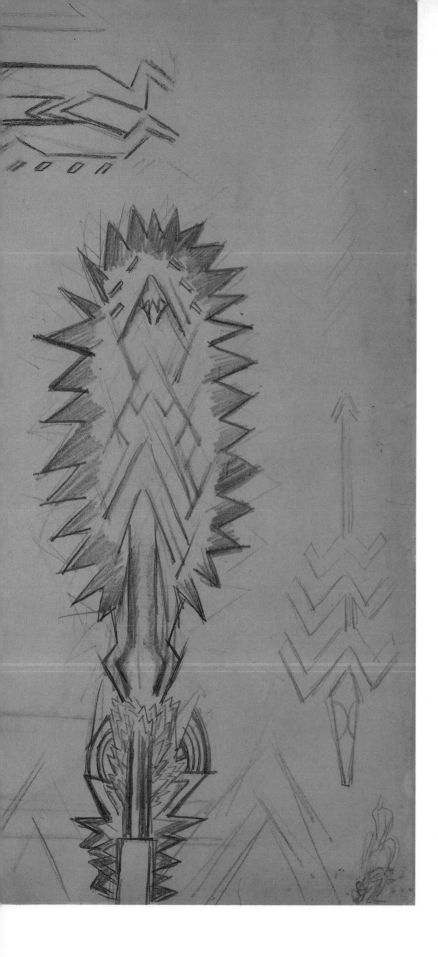

87
Jacob Epstein
Six Studies for 'Rock Drill', 'Venus' and 'Doves', c. 1913
Pencil and crayon, 45.5 × 58.5 cm
Private collection, California

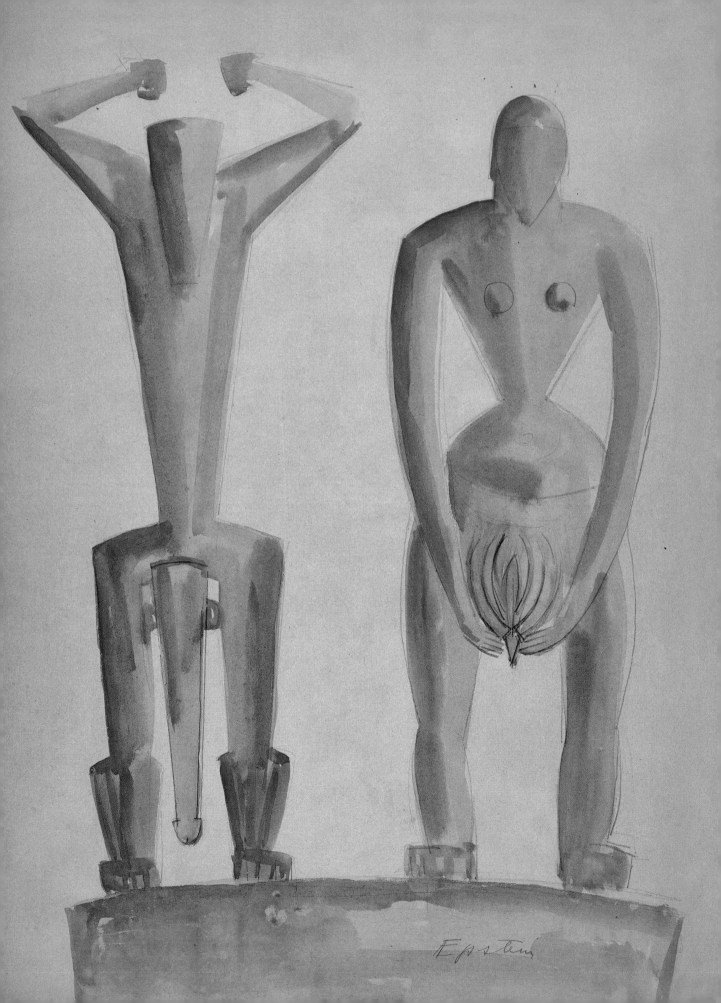

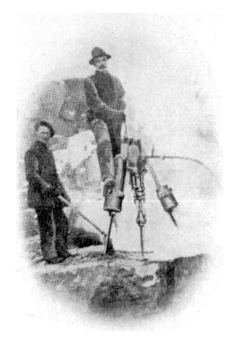

Fig. 60
Driller working with a Rock Drill Tripod, 1910–20

23). And as Hulme grew more fascinated by the implications of avant-garde art, and Epstein's sculpture in particular, he came to believe that 'the new "tendency towards abstraction" will culminate, not so much in the simple geometrical forms found in archaic art, but in the more complicated ones associated in our minds with the idea of machinery.'[2] Hulme was bound to encourage his new friend to think about moving on from 'archaism' towards a mechanistic language, while Epstein's passionate concern with sexuality and the procreative force ensured that he would cast around for the mechanical equivalent of a penis. Two drawings of this period, *Totem* (cat. 19) and *Study for Man-Woman* (cat. 88), reveal his preoccupation with this theme. Both their figurative form and sexual content rely strongly on precedents in primitive sculpture like the *Standing Male Figure* from Fang, Gabon, a highly phallic wood carving once in Epstein's own collection.[3]

The bold idea of turning a phallus into a drill may have occurred to him during a visit to a stone quarry. Epstein remembered later that 'it was in the experimental pre-war days of 1913 that I was fired to do the rock drill',[4] and his choice of the word 'fired' implies that it was a sudden, almost impulsive enthusiasm. Perhaps the sight of a drill boring into a rock-face with deafening force came as a revelation to him, for there was no doubt about the formidable power of this mechanical tool. Mounted on a tripod, and capable of dislodging impressive quantities of rock in the mines where it was principally employed, the modern drill seemed an implement of prodigious strength and effectiveness. Fascinating photographs survive of the drills in powerful action at the Rand Mines in South Africa (fig. 60), proudly substantiating their manufacturers' claim that 'the conditions prevailing on the Rand gold mines were such that they practically revolutionised existing types of drills'.[5] Looking at these archetypal machines, and possibly excited by the militant power demonstrated in the British miners' national strike of 1912, Epstein must have decided that his *Rock Drill* would do its best to revolutionise twentieth-century sculpture as well.

The first drawings to outline his ideas for the work (cat. 89) stress the indomitable character of the machine, and place it in the charge of a driller with equally daunting powers. Framed by the gaunt, jutting sides of a cleft which seems to have been created by his mighty weapon, the driller stands on his tripod with legs as straight as pistons. He looks upwards, as if to display his superhuman confidence, and only in a subsequent back view of the ensemble (cat. 90) does his head bend down towards the task in hand. The locale, however, has become even more awesome. Viewed from behind, the driller now appears to ride far above the ground, and a cloud floats from the side of the drill as if to emphasise his airborne dimensions.

left
89
Jacob Epstein
Study for 'Rock Drill', *c.* 1913
Crayon, 63.5 × 47 cm
Ivor Braka Ltd, London

right
90
Jacob Epstein
Study for 'Rock Drill', Back, *c.* 1913
Crayon, 67.5 × 41.5 cm
Private collection, Rome

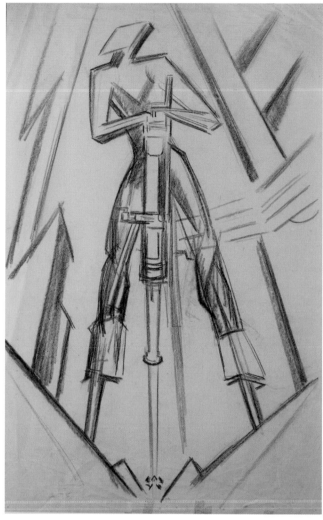

But this cloud also signified a rush of steam from the machine, proving that it was in motion. As the drawings progressed, and the driller's legs curved into an arch which contrasted more strikingly with the pyramidal structure of the tripod (cats 91–92), Epstein became more obsessed by the possibility of activating the drill. Doubtless aware of the kinetic experiments conducted by some Futurist sculptors, he thought at one stage 'of attaching pneumatic power to my rock drill, and setting it in motion, thus completing every potentiality of form and movement in one single work'.[6] The plan was subsequently abandoned, not so much because it seemed impractical but because Epstein shared the Vorticists' antipathy towards the blurred, hectic motion of so much Futurist art.

Like Lewis, who abhorred multiple movement in his art, Epstein preferred to enclose his forms in rigid outlines. The two men shared a respect for each other's work in the 1912–13 period, and Pound recalled in 1916 that 'years ago, three I suppose it is, or four, I said to Epstein (not having seen these things of Lewis, or indeed more than a few things he had then exhibited), "The sculpture seems to be so much more interesting … than the painting." Jacob said, "But Lewis's drawing has the qualities of sculpture."'[7] Epstein was right to point out the kinship between his work and Lewis's, above all when they both explored the idea of turning male figures into proto-robots (fig. 61). The *Rock Drill* drawings show how much reliance Epstein placed on the clean, hard clarity of defining contours, even when he focused on an especially dynamic study of the drill's head biting into the rock (cat. 93). The lines radiating from the point of impact may represent shattering vibration, but they are handled with a robust lucidity which leaves no room for excitable Futurist confusion. So a machine shuddering with movement was ultimately incompatible with Epstein's own stern imperatives as an artist.

He did, however, go ahead with the audacious plan to incorporate a real machine in this extraordinary sculpture. With a boldness which still seems astonishing today, Epstein arranged 'the purchase of an actual drill, second-hand, and upon this I made and mounted a machine-like robot, visored, menacing, and carrying within itself its progeny, protectively ensconced.'[8] This unexpected foetal form, whose rounded masses could hardly be more opposed to the schematic harshness of the driller's torso, is the successor to the embryonic baby lodged within the rock carried by *Matter* on the BMA façade.[9] There, on the Strand frontage of Holden's building, it was exposed to view in the care of an ancient sage (fig. 5). Now, by dramatic contrast, it is securely embedded in a cavity guarded by the armoured structure of the driller's ribcage.

But its presence in this strange assemblage still conveys a sense of apprehension. Turning the handle to operate his machine, the driller is unavoidably conscious of his responsibility towards the new life of the future. Epstein attached great importance to symbolism, even during this most

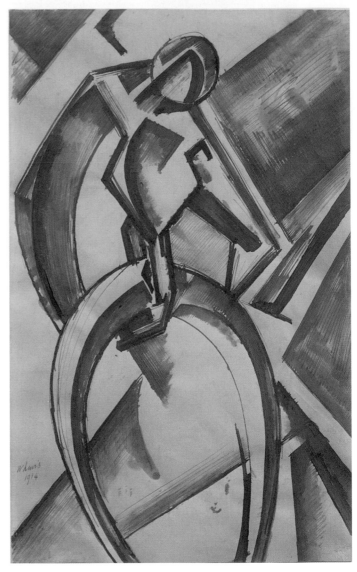

Fig. 61
Wyndham Lewis, *Arghol*, 1914. Pen, ink and brown wash, 33 × 20.5 cm. Ivor Braka Ltd., London

opposite
93
Jacob Epstein
Study for 'Rock Drill', Drill Head, c. 1913
Crayon, 68.5 × 40.5 cm
Ivor Braka Ltd, London

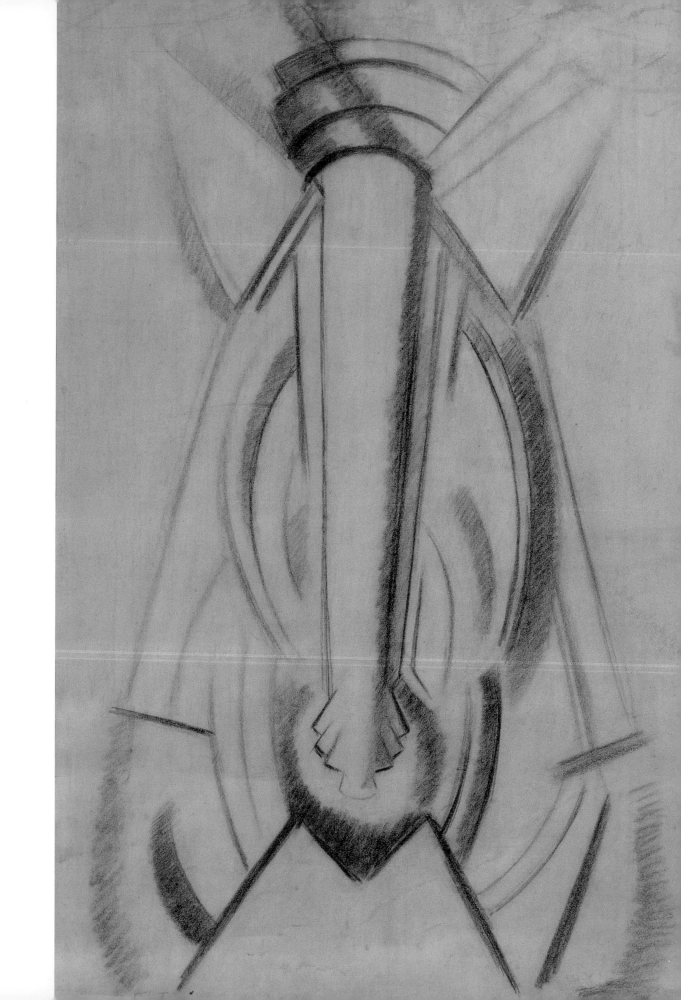

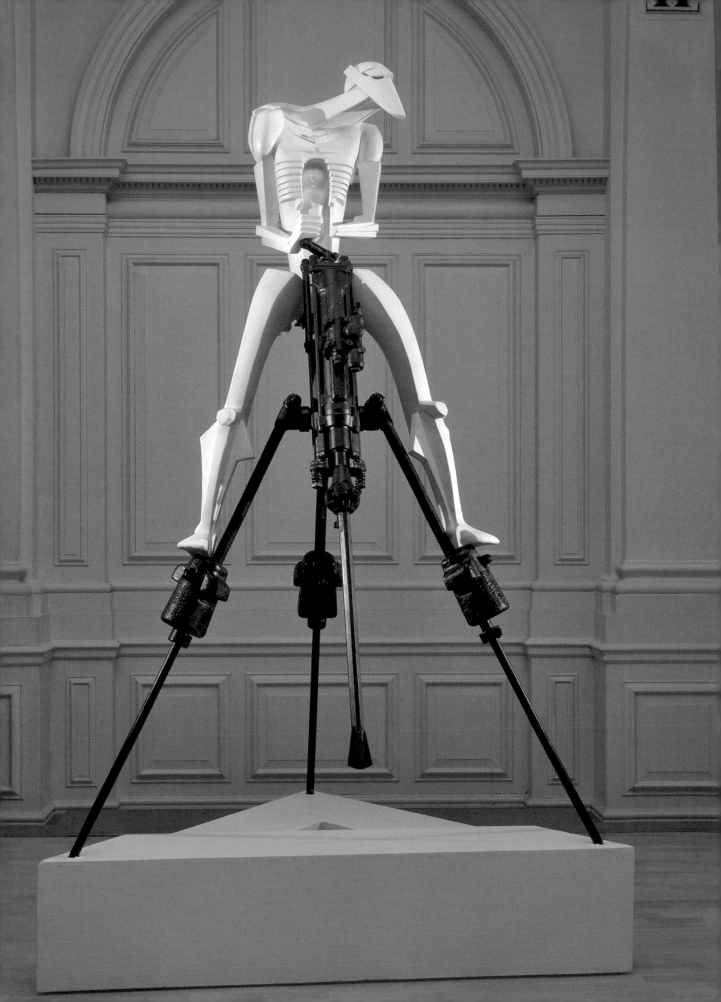

Jacob Epstein
Rock Drill, 1913–15
(reconstruction by Ken Cook and Ann Christopher RA,
after the dismantled original, 1973–74)
Polyester resin, metal and wood, 205 × 141.5 cm
Birmingham Museums and Art Gallery

innovative period when he came nearer to reductive purism than at any other time in his career. He seems to be asking whether the organic form of the foetus will be transformed, with the advent of maturity, into a robot as dehumanised as the driller himself. A careful drawing of this child (cat. 53), apparently falling out of a womb-like slit and being born in the rock-face, drives home the baby's utter defencelessness. The sculptural version of this huddled figure burrows into its abstracted shelter as if in recoil from the frightening force of the drill.

While he was at work on the first, full-length version of *Rock Drill* (cat. 94), Epstein's self-confessed 'ardour for machinery'[10] probably prevented him from pondering too deeply on its more sinister implications. His admiration for the drill was, after all, great enough to convince him that it deserved to become an integral and, indeed, dominant part of a major sculpture. Gaudier certainly thought so after Epstein invited him to view *Rock Drill* in the Lamb's Conduit Street garage where this revolutionary sculpture had been made (fig. 59). 'Brzeska was very enthusiastic about it when he visited my studio in 1913 with Ezra Pound,' wrote Epstein, who wryly remembered that 'Pound started expatiating on the work. Gaudier turned on him and snapped, "shut up, you understand nothing!"'[11]

Epstein might well have been tempted to utter a similar retort to the hostile critics who saw *Rock Drill* when it was placed on view, for the first and only time, in the March 1915 London Group exhibition. One month earlier, the English Futurist C. R. W. Nevinson had exhibited at the Alpine Club Gallery a highly mechanistic bust called *Automobilist*, a dynamic image with headlights slicing through the chauffeur's face (fig. 62). But *Rock Drill* went much further. Its extreme daring astounded and alienated most of the reviewers. For Epstein had gone almost as far towards the ultimate aesthetic heresy as Marcel Duchamp, who in 1913 nominated a *Bicycle Wheel* as a work of art. The ready-made drill was, admittedly, augmented by the man-made figure of a driller, cast in white plaster to distinguish it still more dramatically from the black, shining drill supported by the tripod (fig. 63). Yet Epstein was still challenging his audience to accept that a real machine could be recognised as a legitimate part of a sculpture. Most of the critics writing about it in 1915 responded with predictable anger and contempt, siding with P. G. Konody who declared in the *Observer* that 'the whole effect is unutterably loathsome. Even leaving aside the nasty suggestiveness of the whole thing, there remains the irreconcilable contradiction between the crude realism of real machinery (of American make) combined with an abstractly treated figure.'[12]

Only one newspaper reviewer, the *Manchester Guardian*'s correspondent, understood why Epstein had been tempted to place the machine itself

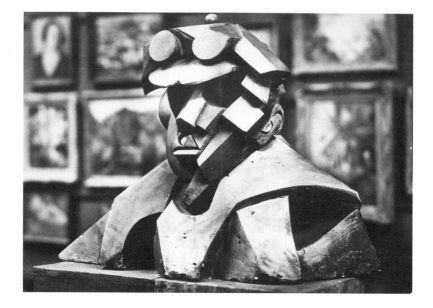

on view, and his excited reaction vividly conveys the astonishment with
which *Rock Drill* must have been greeted by the London Group's visitors.
'He has accepted it all, the actual rock drill is here in this art gallery,' wrote
the stunned *Guardian* critic. 'Mr Epstein has accepted the rock drill, and
says frankly that if he could have invented anything better he would have
done it. But he could not. One can see how it fascinated him; the three long
strong legs, the compact assembly of cylinder, screws and valve, with its
control handles decoratively at one side, and especially the long, straight
cutting drill like a proboscis – it all seems the naked expression of a defi-
nite force.' Although the reviewer acknowledged that Epstein had 'found
in a rock-drill machine the ideal of all that is expressive in mobile, pene-
trating, shattering force', he finally decided that the inclusion of a ready-
made machine was too raw, clashing uncomfortably with the driller above.
'Even if the figure is to be cast in iron,' he concluded, 'the incongruity
between an engine with every detail insistent and a synthetic man is too dif-
ficult for the mind to grasp.'[13]

The criticism was all too understandable, for nothing like *Rock Drill*
had ever been exhibited as sculpture in a gallery before – either in Britain
or anywhere else. Its reviewers failed to understand why Epstein had not
taken as many liberties with the drill as he did with the driller, whose entire
body was metamorphosed into a creature of the sculptor's own imagination.
The visored helmet, attached to a neck as straight and sharp-edged as the
shaft of some mighty engine, led down towards a torso angular and faceted
enough to suggest mechanical components fit for inclusion in a rock drill

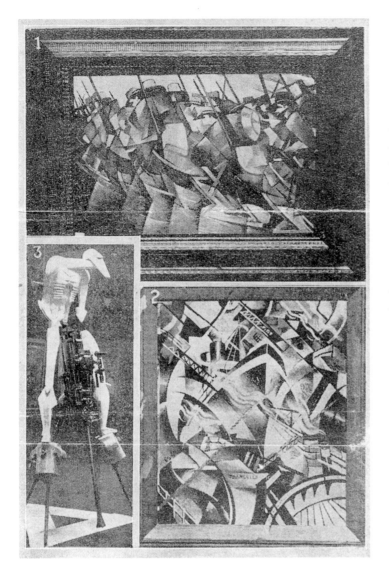

Fig. 63
'War as the Futurist Sees It', *Daily Graphic*, 5 March 1915, showing Jacob Epstein's *Rock Drill* at the London Group, Goupil Gallery, 1915

itself. The mighty Gothic arch described by the legs, as they sprout so surprisingly from the driller's narrow waist, introduces a more expansive note. But even here the sense of dehumanisation remains as strong as ever, reflecting Epstein's belief that the machine age was transforming humanity into a race of armoured and rigidly constructed figures.

Why, then, had he not altered the drill in any way at all? The most convincing reason was voiced by Gaudier, who told Pound in 1914 that 'machinery itself has used up so many of the fine combinations of three-dimensional inorganic forms that there is very little use in experimenting with them in sculpture.'[14] How, Epstein must have thought, could he possibly improve on the ultimate phallic magnificence of a real rock drill? There was no point. And besides, he doubtless wanted to make people appreciate the innate qualities of the machine. Pound insisted in 1916 that 'the forms of automobiles and engines ... where they are truly expressive of various modes of efficiency, can be and very often are very beautiful in themselves and in their combinations, though the fact of this beauty is in itself offensive to the school of sentimental aesthetics.'[15] Epstein would have agreed with this argument when he installed *Rock Drill* on its triangular plinth at the London Group exhibition, where the mighty implement and its tripod challenged 'sentimentalists' to deny that machinery deserved the respectful attention they normally reserved for more conventional works of art.

It was an amazingly provocative act. Even Lewis, whose own mechanistic figure drawings may have helped Epstein to develop the analogical language employed in the driller's body, could not accept *Rock Drill* without voicing some reservations. By this time, he and Epstein had 'some feud or other',[16] which prevented the sculptor from becoming a member of the Vorticist movement or exhibiting in the June 1915 Vorticist Exhibition at the Doré Gallery. The tensions between the two men were also evident when Lewis, writing about *Rock Drill* in the second issue of *BLAST*, asserted that 'the combination of the white figure and the rock-drill is rather unfortunate and ghost-like'. Yet he went on to declare that 'its lack of logic has an

effectiveness of its own. I feel that a logical co-ordination was not intended. It should be taken rather as a monumental, bustling, and very personal whim.' Lewis was right to argue that Epstein had deliberately created an irrational apparition in *Rock Drill*. The dream-like amalgam of black machine and blanched worker certainly had the power to haunt the imagination, and Lewis concluded that it was 'one of the best things Epstein has done. The nerve-like figure perched on the machinery, with its straining to one purpose, is a vivid illustration of the greatest function of life.'[17]

When *Rock Drill* was first exhibited in March 1915, and the *Daily Graphic* published an invaluable photograph of the sculpture on display (fig. 63),[18] few writers linked it with the First World War. Epstein had conceived the sculpture long before hostilities were declared, and only later did David Bomberg realise that the assemblage he had first seen in Epstein's studio around December 1913, with the 'tense figure operating the Drill as if it were a Machine Gun', amounted to 'a Prophetic Symbol … of the impending war'.[19] As the grotesque carnage increased, however, and Britain began to understand just how many young lives were being annihilated in a struggle which showed no sign of ending, so it affected Epstein's attitude towards the sculpture he had made. Looking back on the work many years afterwards, he maintained that *Rock Drill* possessed 'no humanity, only the terrible Frankenstein's monster we have made ourselves into'.[20] But this verdict was delivered with the benefit of hindsight, and bore little relation to the vision which had inspired the superhuman heroism of his original *Rock Drill* drawings. Only in the latter half of 1915, when Epstein and everyone else left at home began to appreciate just how senselessly destructive the struggle in the trenches had become, did his attitude towards the machine age really alter.

The Great War was the first industrialised conflict suffered by the world, and it claimed an obscene number of victims with the help of inventions as murderous as the tank and the rapid-fire machine gun. Once the devastating power of such weapons became widely understood, it was no longer possible to regard an object like the rock drill in a straightforwardly positive light. The menacing character of this aggressive implement was now unavoidable, and Epstein came to the conclusion that it should be excluded from his sculpture. His widow Kathleen remembered him explaining, decades later, 'that he abandoned the drill because he hadn't made it himself, it was just a machine',[21] and so Epstein may also have been impelled by misgivings about the controversial status of a ready-made in his own art. He was beginning to reconsider the extremism of his work and contemplate returning to a more figurative approach. It is announced in a frankly schizophrenic bronze *Portrait of Iris Beerbohm Tree* (cat. 95), whose

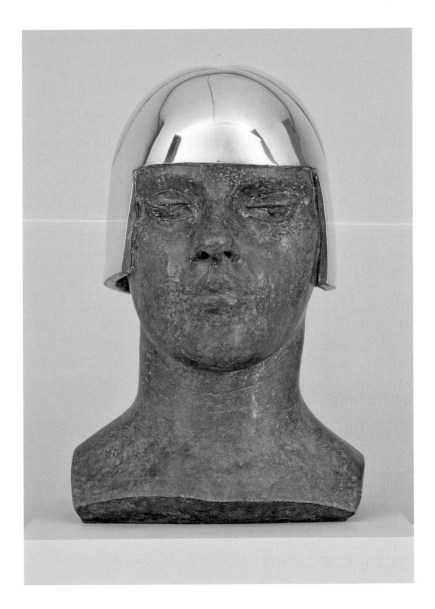

smooth, burnished helmet of metallic hair contrasts very strangely with the far more broken, representational treatment of her face. A growing preference for traditional materials and methods precluded any further dalliance with Duchampian experiments, and Epstein decided that only the man-made part of his *Rock Drill* should be retained and cast in metal.

All the same, an examination of the final version of the sculpture, exhibited in the summer 1916 London Group show under the title *Torso in Metal from the 'Rock Drill'* (cat. 96), proves that the discarding of the drill was not prompted simply by objections to the validity of a ready-made. For the driller is now a figure far removed in meaning from the indomitable male who had once straddled his machine with such imperious confidence. His legs are lopped off, as well as the robotic penis which gave him a super-charged virility. Only the truncated upper part of his body remains. And the hand that previously held the drill's controls has been severed,

too, along with the forearm and elbow. Although the other arm is left unchanged, it likewise lacks a hand and thrusts outwards only to hang uselessly in space. The driller's mask-like head takes on a more defensive and even hesitant air, peering forward as if to search for signs of imminent danger. But his amputated limbs hold out no hope of warding off an assault, and the embryonic form still nestling in his ribcage appears far more vulnerable than it ever did when positioned above the drill.

Seen from behind, the driller's body looks frail rather than impregnable (cat. 96). His back is riven by a crooked fissure extending from the shoulders to the base of the spine. The left arm is similarly split by a gash savage enough to resemble a wound. In retrospect, Epstein declared that *Rock Drill* was 'a thing prophetic of much of the great war and as such within the experience of nearly all'.[22] He did not explain precisely what he meant, yet his shattered *Torso* possesses the melancholy, stooping pathos of a soldier returning from the Front as a helpless invalid. This broken body will never recover from the damage inflicted by the horror of war, and it would certainly be unable to remount the drill and resume the triumphant battle against the primal rock-face. The struggle has been lost.

Epstein abhorred war, and this final tragic version of *Rock Drill* shows how determined he was to resist the propagandist view of the conflict still promoted by a government anxious to sustain the troops' flagging morale. But the transformation of *Rock Drill* also goes a long way towards explaining why he would never again explore machine imagery in his sculpture. Two of his most valued friends, Gaudier and Hulme, had died during the war. The loss of Hulme (fig. 64) was especially grievous to Epstein, who never forgot how 'he was killed by a German shell while serving in the Royal Marine Artillery at Nieuport in Flanders on September 27th, 1917. A book he had written on my sculpture, and which he had with him in manuscript, disappeared from his effects, and has never turned up. Later I met a naval man by accident in a train, who … remembered Hulme very well, and recalled that during one of the recurring bombardments, a shell came over which Hulme, apparently absorbed in some thoughts of his own, failed to hear. He kept standing up, paying no attention, when all the others in his company had thrown themselves down flat. The news of his death, when it reached London, caused widespread pain and sorrow; he had been so much and so strongly alive.'[23]

The brutal, shocking loss of Hulme surely contributed to the 'complete breakdown' Epstein suffered a year later.[24] After failing to gain an appointment as an Official War Artist, he was forced to enlist as a Private in the Jewish 38th Battalion of the Royal Fusiliers. Stationed at a training barracks near Plymouth, he suddenly went missing on Dartmoor and ended

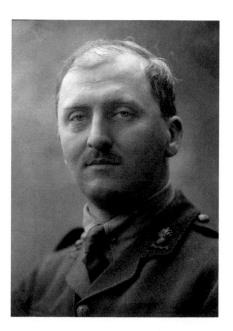

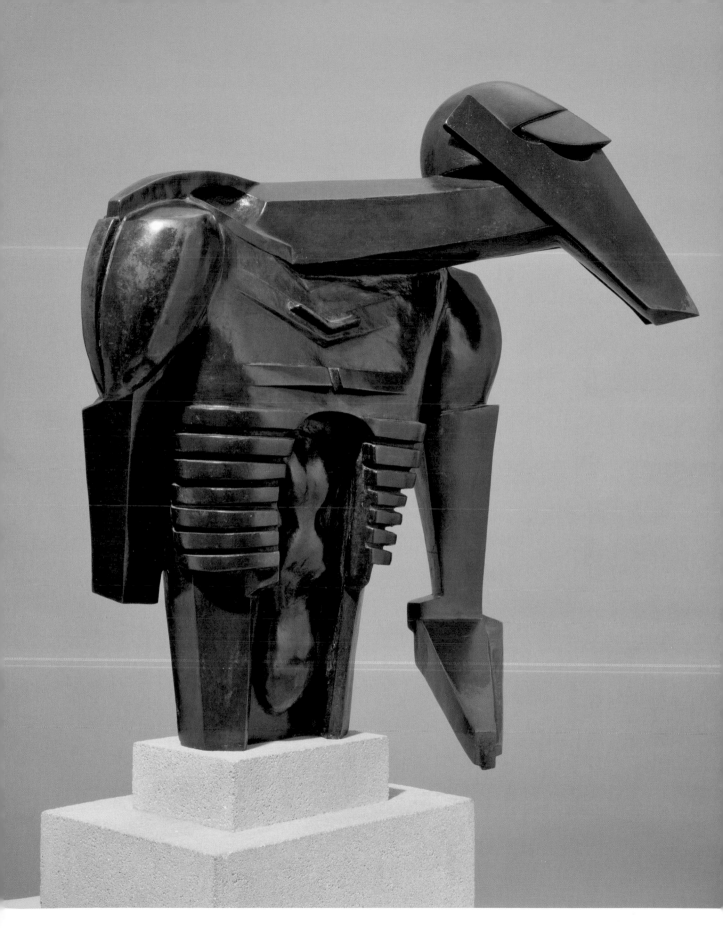

up in hospital suffering from 'a wretched state of nerves'.[25] The trauma-tised Epstein could not, in all conscience, return to the optimism which had produced his early *Rock Drill* drawings. The aggression both of the driller and his instrument were now anathema to a man who wanted in the post-war world to put the machine age far behind him.

But Epstein could never escape the often humiliating vitriol hurled at him by disgruntled viewers who saw his most radical sculpture as the embodiment of everything they hated about modern art. He was particu-larly appalled by the devastation inflicted on his early Strand carvings in 1937, and reported with understandable sadness that 'what is left of the statues now is a portion of the torso here, and a fore-leg there, and an arm somewhere else. Not a single head remains. The mutilation was complete.'[26] No wonder that Henry Moore, whose early work in the 1920s benefited enormously from Epstein's example and encouragement, paid tribute to his mentor's courage and resilience in a 1959 obituary tribute. Epstein, wrote Moore, 'took the brickbats, he took the insults, he faced the howls of derision … and as far as sculpture in this century is concerned, he took them first.'[27] But Epstein always remained defiant, thereby setting an invaluable example to the adventurous sculptors who came after him. As Moore pointed out, 'we of the generation that succeeded him were spared a great deal, simply because his sturdy personality and determination had taken so much … I believe that the sculptors who followed Epstein in this country would have been more insulted than they have been had the popular fury not partially spent itself on him, and had not the folly of that fury been revealed.'[28]

Nowhere was this folly more vehemently expressed than in the press reaction to *Rock Drill* in 1915. One reviewer, enraged by the sight of the mechanised driller mounted on his thrusting equipment, condemned it as 'a nightmare' and 'an abortion', a 'kind of gigantic human locust' which was 'indescribably revolting.'[29] Even Augustus John, whose son Romilly had been so memorably portrayed by Epstein (cats 4–5), wrote that under the driller's ribs 'is the vague shape of a rudimentary child or is it something indigestible he's been eating? Altogether the most hideous thing I've seen.'[30] But the truth is that *Rock Drill* can now be seen as the most innovative, far-seeing work Epstein produced. It foreshadows, not only the unprecedented machine-age devastation of twentieth-century warfare, but also western culture's never-ending obsession – in everything from comic-books to major Hollywood movies – with sinister and implacable robotic power. This ability to offer a haunting prophecy ensures that *Rock Drill* has lost none of its pertinence today.

96
Jacob Epstein
Torso in Metal from the 'Rock Drill' (back view), 1913–16
Bronze, 70.5 × 58.4 × 44.5 cm
Tate. Purchased 1960

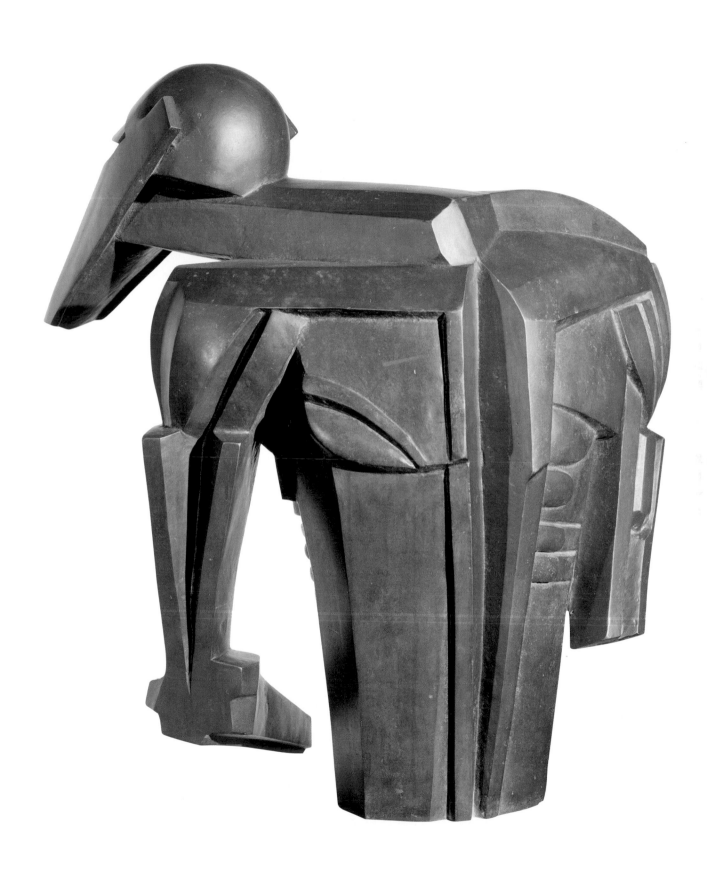

Endnotes

CHAPTER ONE
Scandal on the Strand pages 10–17

1 Pound 1916, p. 45.
2 Gaudier-Brzeska 1914.
3 *Pall Mall Gazette*, 6 June 1912.
4 Fisher 1957, p. 1105.
5 Beattie 1983, p. 231.
6 Epstein 1940; Readers Union edition, 1942, p. 17.
7 Epstein 1940, p. 22. For a detailed analysis of the Strand statues see Cork 1985, chapter one.
8 *Evening Standard*, 19 June 1908.
9 *British Medical Journal*, 11 July 1908.
10 Holden 1905.
11 Epstein 1908.
12 *Evening Standard*, 19 June 1908.
13 *Evening Standard*, 23 June 1908.
14 Vaughan 1959, p. 174.
15 Anonymous verse, n.d.
16 The inspectors included the President of the Royal Academy, Sir William Llewellyn, who had refused to sign a letter of protest to the Press from many distinguished signatories. He said that the appeal to save the statues was 'not an Academy affair' (*Evening Standard*, 10 May 1935).
17 George Bernard Shaw to Robert Ross, 13 March 1905 (Ross 1952, pp. 111–12).
18 Epstein 1940, p. 22.
19 Epstein 1940, p. 1.
20 Jacob Epstein to Edward W. Ordway, March 1904 (Barker 1988, p. 907).

CHAPTER TWO
Epstein Befriends Gill pages 18–41

1 Gill 1908.
2 MacCarthy 1989, p. 13.
3 Gill 1940, p. 53.
4 Gill 1940, p. 119.
5 Gill 1940, p. 119.
6 Gill 1940, p. 158.
7 Gill 1940, p. 159.
8 The Whitechapel Art Gallery exhibition was held in May–June 1910.
9 Epstein 1940, p. 2.
10 Epstein 1940, p. 6.
11 Epstein 1940, p. 10.
12 Epstein 1940, p. 10.
13 Epstein 1940, p. 10.
14 Rose 2002, p. 26.
15 Walt Whitman, 'We Two Boys Together Clinging', in Whitman 1938.
16 Epstein 1940, p. 64.
17 Epstein 1940, p. 42.
18 Epstein 1940, p. 43.
19 Hind 1911, p. 67.
20 Asheham House, four miles south-east of Lewes, was situated in a six-acre plot with grazing sheep. It commanded an excellent view of the Ouse Valley, across to the villages of Rodmell and Iford, and the Sussex Downs beyond. In January 1912 it was rented by Virginia Stephen shortly before she married Leonard Woolf (see Shone 1994).

21 Eric Gill, diaries, 9 December 1913 (William Andrews Clark Memorial Library, University of California, Los Angeles).
22 Eric Gill to William Rothenstein, 25 September 1910 (Speaight 1966, p. 51).
23 Augustus John to Eric Gill, n.d. (Speaight 1966, p. 49).
24 Eric Gill to William Rothenstein, 25 September 1910 (Speaight 1966, p. 51).
25 Eric Gill to William Rothenstein, 25 September 1910 (Speaight 1966, p. 51).
26 Eric Gill to William Rothenstein, 1911 (Shrewring 1947, p. 36).
27 Epstein finished deepening the relief in 1933, when he exhibited it at the Leicester Galleries. But the author discovered, when viewing it in a storage depot at the Metropolitan Museum of Art, New York, that it had subsequently suffered from severe weathering outdoors before entering the Museum's collection.
28 *Maternity* was first exhibited (unfinished) at the Allied Artists' Association, London, 1912.
29 Gill 1917.
30 Epstein 1940, p. 43.
31 Gill 1940, p. 161.
32 One of Gill's smocks, made of '*c.* early twentieth-century cotton', is now displayed in Ditchling Museum.
33 Gill's pamphlet, *Trousers and the Most Precious Ornament*, was published in 1937.
34 Eric Gill, 'Studies of Parts', 23 October 1940, unpublished, British Museum Prints and Drawings Dept.
35 Eric Gill, 'Studies of Parts', 23 October 1940, unpublished, British Museum Prints and Drawings Dept. The offer was made to the Royal College of Surgeons in November 1948.
36 Gill 1940, p. 159.
37 Williams 1963, p. 15.
38 Quoted by Collins 1998, p. 25.
39 Collins 1998, p. 25.
40 Collins 1998, p. 66.
41 Collins 1998, p. 66.
42 Algernon Swinburne, 'Hymn to Proserpine', in Swinburne 1866.
43 Collins 1992, p. 23.
44 Coomaraswamy 1913, p. 64.
45 *Crucifixion / Weltschmerz* was given to the Tate Gallery in 1920, and *A Roland for an Oliver* was given to the University of Hull Art Collection in 1960.
46 Gill sold the work to Laughton on 7 April 1912 and noted it was 'Easter Sunday' (Collins 1998, p. 70).
47 Warren bought the *Ecstasy* relief on 23 April 1912 for £60.
48 Quoted by Collins 1998, p. 72.
49 MacCarthy 1989, p. 104.
50 Quoted by Collins 1998, p. 70.
51 MacCarthy 1989, p. 104.
52 MacCarthy 1989, p. 104.
53 See Collins 1998, p. 70.

CHAPTER THREE
Gill Championed by Fry pages 42–51

1 Wyndham Lewis to T. Sturge Moore, *c.* January 1911 (unpublished, owned by the Sturge Moore Papers, University of London Library).
2 Wyndham Lewis to T. Sturge Moore, *c.* January 1911 (unpublished, owned by the Sturge Moore Papers, University of London Library).
3 'Manet and the Post-Impressionists' opened at the Grafton Galleries, London, in November 1910, and ran for three months.
4 MacCarthy 1945.
5 A handwritten note on the back of an old photograph of *Crucifixion / Weltschmerz* declares: 'EG 1910 – Early work inspired by Gauguin's *Christ Jaune*.'
6 Roger Fry, *The Nation*, 15 February 1911.
7 Eric Gill to Maynard Keynes, 2 February 1911 (Collins 1998, p. 67).
8 John Knewstub to Maynard Keynes, 6 February 1911 (Collins 1998, p. 67).
9 Roger Fry to Eric Gill, 23 June 1911 (Collins 1998, p. 73).
10 Roger Fry to Eric Gill, 23 June 1911 (Collins 1998, p. 73).
11 Eric Gill to William Rothenstein, 15 July 1911 (MacCarthy 1989, p. 107).
12 Eric Gill, diary, 8 August 1912 (MacCarthy 1989, p. 114).
13 The 'Second Post-Impressionist Exhibition' opened on 5 October 1912. In the catalogue, Gill's sculpture is called *Garden Statue*.
14 *Contortionist* is now lost.
15 Gill wrote the name 'Mrs Barry' on the back of an old photograph of *The Rower*, implying that this unknown woman was the model for his carving.

CHAPTER FOUR
The Cave of the Golden Calf and the Tomb of Oscar Wilde pages 52–65

1 Roger Fry to the *British Medical Journal*, 4 July 1908.
2 Clive Bell, *The Nation*, 27 July 1912.
3 Roger Fry, *The Nation*, 20 July 1912.
4 'Aims and Programme of the Cabaret Theatre Club', May 1912, in *Cabaret Theatre Club. The Cave of the Golden Calf*, illustrated brochure published from 9 Heddon Street, London W1 (unpaginated).
5 For a detailed analysis of the Club and its commissioned artworks, see Cork 1985, chapter two.
6 'The Cabaret Theatre Club', 16 April 1912, an announcement signed by the 'Preliminary Committee' and sent to the Press in spring 1912.
7 John 1952, p. 103.
8 A photograph of Ginner's lost tiger-hunting mural in the Cave of the Golden Calf is reproduced in Cork 1985, p. 78. So is Gore's deer-hunting mural, visible in a drawing illustrated in the *Daily Mirror*, 4 July 1912 (Cork 1985, p. 105).
9 The two most important studies for Lewis's lost *Kermesse* are reproduced in Cork 1975–76, pp. 40–41.

10 Ezra Pound to John Quinn, 10 March 1916 (Paige 1951, p. 122).

11 Epstein 1940, p. 116.

12 Epstein 1940, p. 116.

13 Epstein 1940, p. 116.

14 Goldring 1943, p. 246.

15 Lewis 1950, p. 125.

16 Damien Hirst's *The Golden Calf* was mounted on a Carrara marble plinth and auctioned at Sotheby's, London, in the Hirst sale, 15–16 September 2008.

17 Gill's account books describe the larger calf sculpture as 'on pedestal in the round' (William Andrews Clark Memorial Library, University of California).

18 Kessler 1971, p. 330.

19 Speaight 1966, p. 174.

20 Gibson 1930, p. 104.

21 Gibson 1930, p. 104.

22 See Gill's account books (William Andrews Clark Memorial Library, University of California).

23 The performances on offer included *Veil Dance*, *Exultations*, *A Love Mask*, *Tarantella*, *Gipsy Folk-Lore* and *Playing with Fire*.

24 Sitwell 1948, p. 208.

25 Sitwell 1948, p. 208.

26 Stock 1969, p. 145.

27 A liquidator announced that a creditors' meeting would be held at the Cave on 7 July 1913.

28 This near life-size *Narcissus* was destroyed by Epstein himself. It is illustrated in Silber 1986, p. 126.

29 Epstein 1940, p. 65.

30 Epstein 1940, p. 65.

31 Epstein 1940, p. 65.

32 Holden recognised that the Tomb presented a 'most unusual problem demanding an unusual solution' (Charles Holden, memoir dated 3 December 1940, unpublished, preserved in the archives of Adams, Holden & Pearson, London).

33 Eric Gill to William Rothenstein, January 1911 (Shewring 1947, pp. 36–37).

34 *Pall Mall Gazette*, 6 June 1912.

35 *Evening Standard*, 3 June 1912.

36 Epstein 1940, p. 61.

37 Jacob Epstein to Eric Gill, 31 March 1911 (William Andrews Clark Memorial Library, University of California).

38 Jacob Epstein to John Quinn (Reid 1968, p. 130).

39 French customs demanded that an import duty of £120 be paid on the value of the stone.

40 Jacob Epstein to Francis Dodd, *c.* late September 1912 (Evelyn Silber, 'The Tomb of Oscar Wilde', in Silber and Friedman 1987, p. 127).

41 Bazille 1912.

42 Howard 1988, p. 130. Recently, Howard recalled his research in Père Lachaise: 'I met in the cemetery office the retired head guardian. He was quite sure that "deux madames anglaises" had struck the fatal blows with their umbrellas. Both guardians remembered using the fragment as a paperweight' (Howard to Richard Cork, 20 December 2008).

43 The plaque was almost covered with floral tributes from Wilde's devotees when the author last visited the tomb in November 2008.

CHAPTER FIVE
Gaudier-Brzeska Emerges pages 66–99

1 Henri Gaudier to Dr Uhlemayr, 11 November 1910 (O'Keeffe 2004, p. 81).

2 Bagnold 1969, p. 66.

3 Epstein 1940, p. 44.

4 Henri Gaudier to Dr Uhlemayr, 18 June 1912 (Cole 1978, pp. 21–22).

5 Epstein 1940, p. 45.

6 Henri Gaudier to Sophie Brzeska, October 1912 (Ede 1931, p. 256).

7 Henri Gaudier to Sophie Brzeska, 17 November 1912 (Ede 1930, p. 199).

8 Murry 1911, p. 36.

9 Henri Gaudier to Sophie Brzeska, 28 November 1912 (Silber and Finn 1996, p. 258).

10 Henri Gaudier to Sophie Brzeska, 28 November 1912 (Silber and Finn 1996, p. 258).

11 Henri Gaudier to Sophie Brzeska, 3–5 December 1912 (Ede 1931, pp. 217–18).

12 Silber and Finn 1996, p. 104.

13 Henri Gaudier to Sophie Brzeska, 28 November 1912 (Silber and Finn 1996, p. 258).

14 Henri Gaudier to Sophie Brzeska, 8 October 1913 (Silber and Finn 1996, p. 262).

15 In 'Vortex. Gaudier Brzeska', *BLAST*, 1, London, 1914, Gaudier cited Archipenko as one of 'the Moderns' whom he admired (p. 158).

16 Henri Gaudier to Sophie Brzeska, 8 October 1913 (Silber and Finn 1996, p. 158).

17 Henri Gaudier, List of Works for 1913 (Silber and Finn 1996, p. 262).

18 Henri Gaudier, List of Works for 1913 (Silber and Finn 1996, p. 262).

19 Henri Gaudier to Sophie Brzeska, 8 October 1913 (Silber and Finn 1996, p. 258).

20 Brodzky 1933, pp. 31–32.

21 Nina Hamnett described how 'I brought Henri round one day and he did a design for a tray which was eventually carried out in inlaid woods' (Hamnett 1932, p. 43).

22 Eric Gill to Count Harry Kessler, 20 January 1910 (Shewring 1947, p. 28).

23 Keynes 1981 (Collins 1998, p. 85).

24 Eric Gill to Geoffrey Keynes, March 1915 (Collins 1998, p. 85).

25 Eric Gill, diary, 18 January 1913 (Collins 1998, p. 82).

26 Eric Gill to Geoffrey Keynes, 7 October 1913 (Collins 1998, p. 89).

27 The number of painted plaster casts made from the Plasticine original is unknown, but the cast owned by West Sussex Record Office is 36. The painted decoration is believed to have been executed by Desmond Chute.

28 Eric Gill, diary, 27 March 1913.

29 Gill was introduced to Marshall by Gerald Siordet in the spring of 1913.

30 Gill 1940, p. 200.

31 Gill 1915.

32 Count Harry Kessler to Eric Gill, 26 October 1910 (Speaight 1966)

33 In particular, the 1911 *Contortionist* figure reproduced in Collins 1998, p. 73.

34 David Kindersley (Collins 1998, pp. 186–87).

35 Eric Gill, job sheet, 1915 (Collins 1998, p. 55).

36 Gill 1940, p. 211.

37 This competition was organised by the Civic Arts Association in the summer of 1916, and the monument was supposed to be installed in County Hall, London.

38 Eric Gill to William Rothenstein, 22 July 1916 (Shewring 1947, p. 82).

39 Shewring 1947, p. 98.

40 James V, 1–2.

CHAPTER SIX
Epstein by the Sea pages 100–123

1 Epstein 1940, p. 47.

2 The collector was Edward Roworth, who bought *Head* (*c.* 1913, Tate) from Modigliani in 1914.

3 Epstein 1940, p. 49.

4 Epstein 1940, p. 48.

5 Epstein 1940, p. 49.

6 The secluded cottage was called Bay Point.

7 Epstein 1908.

8 Quoted by T. E. Hulme 1913.

9 Epstein is supposed to have ordered the dumping of *Mother and Child*.

10 Epstein 1940, p. 190. He finally acquired the *Brummer Head* in 1935.

11 Epstein 1940, p. 190.

12 Ezra Pound to John Quinn, 8 March 1915 (Paige 1951, p. 95).

13 Jacob Epstein to John Quinn, 28 April 1915 (paraphrased by Reid 1968, p. 203).

14 A photograph of its side view, illustrated in the *Daily Mirror*, proves that it was indeed the 'second' doves carving (photograph preserved in C. R. W. Nevinson's cuttings, vol. 1, Tate Library).

15 'Our Irreverent Critic', in his review of Frank Rutter's exhibition (C. R. W. Nevinson's cuttings, vol. 1, Tate Library).

16 Kate Lechmere, interview with Richard Cork, November 1969.

17 Pound 1914b. Epstein showed there: *Group of Birds*, the lost *Bird Pluming Itself* and *Carving in Flenite*.

18 Ezra Pound to Isabel Pound, November 1913 (Paige 1951, p. 63).

19 Pound 1915.

20 Pound 1914b.

21 Epstein's lost *Drawing* was reproduced in *BLAST*, 1, 1914, illustration xv.

22 Hulme 1924, p. 107.

23 Jacob Epstein to Bernard van Dieren, 8 March 1917 (Silber 1986, p. 34).

24 Dieren 1917.

Curtis 2003
Penelope Curtis (ed.), *Sculpture in Twentieth-Century Britain*, 2 vols, Leeds, 2003

Dieren 1917
Bernard van Dieren, *The New Age*, 7 March 1917

Dieren 1920
Bernard van Dieren, *Epstein*, London, 1920

d'Offay 1969
Anthony d'Offay, *Abstract Art in England, 1913–1915*, exh. cat., d'Offay Couper Gallery, London, 1969

Drew 1967
David Bomberg 1890–1957, Joanna Drew (ed.), exh. cat., Tate Gallery, London, 1967

Ede 1930
H. S. Ede, *A Life of Gaudier-Brzeska*, London, 1930

Ede 1931
H. S. Ede, *Savage Messiah*, London, 1931

Ede 1984
H. S. Ede, *Kettle's Yard: A Way of Life*, Cambridge, 1984

Edwards 1983
Paul Edwards, 'Wyndham Lewis: An Ego and Its Own', in *Wyndham Lewis Drawings and Watercolours 1910–1920*, exh. cat., Anthony d'Offay, London, 1983

Edwards 1992
Paul Edwards, *Wyndham Lewis: Art and War*, London, 1992

Edwards 2000
Paul Edwards, *Wyndham Lewis: Painter and Writer*, New Haven and London, 2000

Edwards 2000b
Paul Edwards (ed.), *Blast: Vorticism 1914–1918*, Aldershot, 2000

Elsen 1974
Albert E. Elsen, *Origins of Modern Sculpture: Pioneers and Premises*, London, 1974

Epstein 1908
Jacob Epstein, 'The Artist's Description of His Work', *British Medical Journal*, 4 July 1908

Epstein 1940
Jacob Epstein, *Let There Be Sculpture. The Autobiography of Jacob Epstein*, London, 1940

Epstein and Haskell 1931
Jacob Epstein and Arnold Haskell, *The Sculptor Speaks: A Series of Conversations on Art*, London, 1931

Epstein 1967
Kathleen Epstein, 'Introduction', in *The Works of Sir Jacob Epstein From the Collection of Mr Edward P. Schinman*, Farleigh Dickinson University, Rutherford, N.J., 1967

Fagg 1960
William Fagg, 'Introduction', in *The Epstein Collection of Tribal and Exotic Sculpture*, exh. cat., Arts Council, London, 1960

Farr 1978
Dennis Farr, *English Art 1870–1940*, Oxford, 1978

Farrington 1980
Jane Farrington, *Wyndham Lewis*, London, 1980

Ferguson 2002
Robert Ferguson, *The Short Sharp Life of T. E. Hulme*, London, 2002

Fisher 1957
H. A. L. Fisher, *A History of Europe*, 1936; *Complete Edition in One Volume*, London, 1957

Ford 1989
Boris Ford (ed.), *The Cambridge Guide to the Arts in Britain*, vol. 8: *The Edwardian Age and the Inter-War Years*, Cambridge, 1989

Ford 1931
Ford Madox Ford, *Return to Yesterday. Reminiscences, 1894–1914*, London, 1931

Fry 1916
Roger Fry, 'Gaudier-Brzeska', *Burlington Magazine*, XXIX, August 1916

Fussell 1975
Paul Fussell, *The Great War and Modern Memory*, Oxford, 1975

Gardiner 1992
Stephen Gardiner, *Epstein: Artist Against the Establishment*, London, 1992

Gaudier-Brzeska 1914
Henri Gaudier-Brzeska, 'Mr Gaudier-Brzeska on "The New Sculpture"', *The Egoist*, 16 March 1914

Gaudier-Brzeska 1914b
Henri Gaudier-Brzeska, *The New Age*, 19 March 1914

Gaudier-Brzeska 1914c
Henri Gaudier-Brzeska, 'Allied Artists Association Ltd', *The Egoist*, 15 June 1914

Gaudier-Brzeska 1914d
Henri Gaudier-Brzeska, 'Vortex Gaudier Brzeska', *BLAST*, 1, London 1914

Gaudier-Brzeska 1915
Henri Gaudier-Brzeska, 'VORTEX GAUDIER-BRZESKA (Written from the Trenches)', *BLAST*, 2, London, 1915

Gaudier-Brzeska 2008
Sophie Gaudier-Brzeska, *'Matka' and Other Writings*, London, 2008

Gerstein 2009
Beyond Bloomsbury: Designs of the Omega Workshops 1913–19, Alexandra Gerstein (ed.), exh. cat., Courtauld Gallery, London, 2009

Gibson 1930
Ashley Gibson, *Postscript to Adventure*, London, 1930

Gilboa 2009
Raquel Gilboa, '...And there was Sculpture': *Jacob Epstein's Formative Years 1880–1930*, London, 2009

Gill 1908
Eric Gill, Letter to the *British Medical Journal*, 4 July 1908

Gill 1915
Eric Gill, 'Mr Gill's Reply to the Critics', *Observer*, 17 October 1915

Gill 1917
Eric Gill, 'Sculpture: An Essay by Eric Gill', *The Highway*, June 1917

Gill 1929
Eric Gill, *Art-Nonsense and Other Essays*, London, 1929

Gill 1934
Eric Gill, *Art and a Changing Civilisation*, London, 1934

Gill 1937
Eric Gill, *Trousers and the Most Precious Ornament*, London, 1937

Gill 1940
Eric Gill, *Autobiography*, London, 1940

Gill 1953
Evan Gill, *A Biography of Eric Gill*, London, 1953

Gill 1930
Winifred Gill, 'Gaudier Brzeska', in *A Faggot of Verse: Poems by Five Women*, London, 1930, p. 55

Goldring 1943
Douglas Goldring, *South Lodge. Reminiscences of Violet Hunt, Ford Madox Ford and the English Review Circle*, London, 1943

Goldwater 1966
Robert Goldwater, *Primitivism in Modern Art*, New York, 1938; revised edition, 1966

Green 1987
Christopher Green, *Cubism and Its Enemies*, New Haven and London, 1987

Green 1999
Art Made Modern: Roger Fry's Vision of Art, Christopher Green (ed.), exh. cat., Courtauld Gallery, London, 1999

Greenwood 2002
Jeremy Greenwood, *The Graphic Work of Edward Wadsworth*, Woodbridge, 2002

Hamnett 1932
Nina Hamnett, *Laughing Torso: Reminiscences of Nina Hamnett*, London, 1932

Hapgood 1902
Hutchins Hapgood, *The Spirit of the Ghetto*, New York, 1902

Harrison 1981
Charles Harrison, *English Art and Modernism 1900–1939*, London, 1981

Harrison 1998
Carving Mountains: Modern Stone Sculpture in England 1907–37, Michael Harrison (ed.), exh. cat., Kettle's Yard, Cambridge, 1998

Hind 1911
C. Lewis Hind, *The Post-Impressionists*, London, 1911

Holden 1905
Charles Holden, 'Thoughts for the Strong', *Architectural Review*, July 1905

Howard 1988
Godfrey Howard, *Paris: The Essential City*, London, 1988

Howlett 1994
Jana Howlett and Rod Mengham (eds.), *The Violent Muse: Violence and the Artistic Imagination in Europe, 1910–1939*, Manchester, 1994

Hulme 1913
T. E. Hulme, 'Mr Epstein and the Critics', *The New Age*, 25 December 1913

Hulme 1924
T. E. Hulme, *Speculations: Essays on Humanism and the Philosophy of Art*, Herbert Read (ed.), London, 1924

Hulten, 1986
Futurismo & Futurismi, Pontus Hulten (ed), exh. cat., Palazzo Grassi, Venice, 1986

Humphreys 1985
Richard Humphreys, *Pound's Artists: Ezra Pound and the Visual Arts in London, Paris and Italy*, exh. cat., Tate Gallery, London, 1985

Humphreys 2004
Richard Humphreys, *Wyndham Lewis*, London, 2004

Hynes 1955
Samuel Hynes (ed.), *Further Speculations by T. E. Hulme*, Minnesota, 1955

Hynes 1990
Samuel Hynes, *A War Imagined: The First World War and English Culture*, London, 1990

John 1952
Augustus John, *Chiaroscuro. Fragments of an Autobiography: First Series*, London, 1952

Jones 1960
Alun R. Jones, *The Life and Opinions of Thomas Ernest Hulme*, London, 1960

Karol 2007
Eitan Karol, *Charles Holden*, Donington, 2007

Kessler 1971
Count Harry Kessler, *The Diaries of a Cosmopolitan, 1918–1937*, London, 1971

Keynes 1981
Geoffrey Keynes, *The Gates of Memory*, Oxford, 1981

Klein 2004
The Bone Beneath The Pulp: Drawings by Wyndham Lewis, Jacky Klein (ed.), exh. cat., Courtauld Gallery, London, 2004

Koslow 1981
F. Koslow, 'The Evolution of Henri Gaudier-Brzeska's Boston Wrestlers Relief', *Bulletin of Boston Museum of Fine Arts*, 1981

Lemny 2009
Doïna Lemny, *Brancusi & Gaudier-Brzeska, points de convergence*, Paris, 2009

Lemny 2009b
Doïna Lemny, *Henri Gaudier-Brzeska: Notes sur Liabeuf et sur Tolstoi*, Paris, 2009

Levy 1965
Mervyn Levy, *Henri Gaudier-Brzeska: Drawings and Sculpture*, New York, 1965

Lewis 1914
Wyndham Lewis (ed.), *BLAST*, 1, London, 1914

Lewis 1915
Wyndham Lewis (ed.), *BLAST*, 2, London, 1915

Lewis 1937
Wyndham Lewis, *Blasting and Bombardiering*, London, 1937

Lewis 1950
Wyndham Lewis, *Rude Assignment: A Narrative of My Career Up-to-Date*, London, 1950

Lewison 1983
Henri Gaudier-Brzeska, Sculptor 1891–1915, Jeremy Lewison (ed.), exh. cat., Kettle's Yard, Cambridge, 1983

Lipke 1967
William C. Lipke, *David Bomberg. A Critical Study of His Life and Work*, London, 1967

London 1913–14
Drawings and Sculpture by Jacob Epstein: Catalogue of Solo Exhibition at Twenty-One Gallery, exh. cat., Twenty-One Gallery, London, December 1913 – January 1914

London 1917
Catalogue of an Exhibition of the Sculpture of Jacob Epstein, exh. cat., Leicester Galleries, London, February–March 1917

London 1980
Epstein Centenary 1980: Bronzes, Drawings and Watercolours, exh. cat., Ben Uri Art Gallery, London, 1980

MacCarthy 1945
Desmond MacCarthy, 'The Art-Quake of 1910', *The Listener*, 1 February 1945

MacCarthy 1989
Fiona MacCarthy, *Eric Gill*, London, 1989

MacDougall and Dickson 2006
Sarah MacDougall and Rachel Dickson, *Embracing The Exotic: Jacob Epstein and Dora Gordine*, exh. cat., Ben Uri Gallery, London, 2006

Malvern 2004
Sue Malvern, *Modern Art, Britain and the Great War*, New Haven and London, 2004

Materer 1979
Timothy Materer, *Vortex: Pound, Eliot and Lewis*, Ithaca and London, 1979

Materer 1985
Timothy Materer (ed.), *Pound / Lewis: The Letters of Ezra Pound and Wyndham Lewis*, New York, 1985

McGuinness 1998
Patrick McGuinness (ed.), *T. E. Hulme Selected Writings*, Manchester 1998

Meyers 1980
Jeffrey Meyers, *The Enemy: A Biography of Wyndham Lewis*, London, 1980

Meyric Hughes and Van Tuyl 2002
Henry Meyric Hughes and G. Van Tuyl (eds), *Blast to Freeze: British Art in the Twentieth Century*, Wolfsburg, 2002

Michel 1971
Walter Michel, *Wyndham Lewis Paintings and Drawings*, London, 1971

Michel and Fox 1969
Walter Michel and C. J. Fox (eds), *Wyndham Lewis on Art*, London, 1969

Moody 2007
A. David Moody, *Ezra Pound: Poet*, vol. 1: *The Young Genius 1885–1920*, Oxford, 2007

Murry 1911
John Middleton Murry, 'Aims and Ideals', *Rhythm*, June 1911

Murry 1935
John Middleton Murry, *Between Two Worlds*, London, 1935

Nairne and Serota 1981
British Sculpture in the Twentieth Century, Sandy Nairne and Nicholas Serota (eds), exh. cat., Whitechapel Art Gallery, London, 1981

O'Keeffe 2000
Paul O'Keeffe, *Some Sort of Genius: A Life of Wyndham Lewis*, London, 2000

O'Keeffe 2004
Paul O'Keeffe, *Gaudier-Brzeska. An Absolute Case of Genius*, London, 2004

Orchard 1996–97
BLAST: Vortizismus – Die Erste Avantgarde in England 1914–1918, Karin Orchard (ed.), exh. cat., Sprengel Museum, Hanover, and Haus der Kunst, Munich, 1996–97

Orleans 1993
Henri Gaudier-Brzeska, exh. cat., Musée des Beaux-Arts, Orleans, 1993

Ottinger, Coen and Gale 2009
Didier Ottinger, Ester Coen and Matthew Gale, *Futurism*, London, 2009

Paige 1951
D. D. Paige (ed.), *The Letters of Ezra Pound, 1907–1941*, London, 1951

Pennington 1987
Michael Pennington, *An Angel for a Martyr: Jacob Epstein's Tomb for Oscar Wilde*, London, 1987

Physick 1963
John Physick, *Catalogue of the Engraved Work of Eric Gill*, Victoria and Albert Museum, London, 1963

Pound 1914
Ezra Pound, 'The New Sculpture', *The Egoist*, 16 February 1914

Pound 1914b
Ezra Pound, 'Exhibition at the Goupil Gallery', *The Egoist*, 16 March 1914

Pound 1914c
Ezra Pound, 'Vortex Pound', *BLAST*, 1, London, 1914

Pound 1915
Ezra Pound, 'Affirmations. III. Jacob Epstein', *The New Age*, 21 January 1915

Pound 1915b
Ezra Pound, 'Affirmations. V. Gaudier-Brzeska', *The New Age*, 4 February 1915

Pound 1916
Ezra Pound, *Gaudier-Brzeska. A Memoir*, London, 1916

Pound 1918
Ezra Pound, 'Prefatory Note', in *A Memorial Exhibition of the Work of Henri Gaudier-Brzeska*, exh. cat., Leicester Galleries, London, May–June 1918

Pound 1934
Ezra Pound, 'Gaudier: A Postscript', *Esquire*, New York, August 1934

Powell 1932
L. B. Powell, *Jacob Epstein*, London, 1932

Reid 1968
B. L. Reid, *The Man from New York: John Quinn and His Friends*, New York, 1968
Rhyne 1977
Brice Rhyne, 'Henri Gaudier-Brzeska: The Process of Discovery', *Artforum*, May 1977
Roberts 1938
Michael Roberts, *T. E. Hulme*, London, 1938
Robins 1997
Anna Gruetzner Robins, *Modern Art in Britain 1910–1914*, exh. cat., Barbican Art Gallery, London, 1997
Rose 2002
June Rose, *Daemons and Angels. A Life of Jacob Epstein*, London, 2002
Rose 1963
W. K. Rose (ed.), *The Letters of Wyndham Lewis*, London, 1963
Ross 1952
M. Ross (ed.), *Robert Ross, Friend of Friends*, London, 1952
Rothenstein 1927
John Rothenstein, *Eric Gill*, London, 1927
Rothenstein 1974
William Rothenstein, *Men and Memories*, vol. 2, London, 1974
Rother 1994
Rainer Rother (ed.) *Die Letzten Tage der Menschheit: Bilder des Ersten Weltkrieges*, Deutsches Historisches Museum, Berlin, 1994
Rubin 1984
William Rubin (ed.), *'Primitivism' in Twentieth-Century Art*, New York, 1984
Secretain 1979
Roger Secretain, *Un Sculpteur 'maudit'. Gaudier-Brzeska 1891–1915*, Paris, 1979
Shewring 1947
Walter Shewring (ed.), *Letters of Eric Gill*, London, 1947
Shone 1976
Richard Shone, *Bloomsbury Portraits. Vanessa Bell, Duncan Grant, and their Circle*, London, 1976
Shone 1977
Richard Shone, *The Century of Change. British Painting Since 1900*, London, 1977
Shone 1994
Richard Shone, 'Asheham House: An Outline History', *The Charleston Magazine*, Spring/Summer 1994
Shone 1999–2000
Richard Shone, with essays by James Beechey and Richard Morphet, *The Art of Bloomsbury, Roger Fry, Vanessa Bell and Duncan Grant*, exh. cat., Tate, London, 1999–2000
Silber 1980
Evelyn Silber, *Rebel Angel: Sculpture and Watercolours by Sir Jacob Epstein (1880–1959)*, exh. cat., Birmingham Museum and Art Gallery, 1980

Silber 1986
Evelyn Silber, *The Sculpture of Epstein with a Complete Catalogue*, Oxford, 1986
Silber and Finn 1996
Evelyn Silber and David Finn, *Gaudier-Brzeska: Life and Art*, London, 1996
Silber and Friedman 1987
Evelyn Silber and Terry Friedman (eds), *Jacob Epstein: Sculpture and Drawings*, Leeds and London, 1987
Sitwell 1948
Osbert Sitwell, *Great Morning. Being the third volume of Left Hand, Right Hand! An Autobiography*, London, 1948
Skelton 1990
Christopher Skelton, *The Engravings of Eric Gill*, London, 1990
Spalding 1986
Frances Spalding, *British Art Since 1900*, London, 1986
Speaight 1966
Robert Speaight, *The Life of Eric Gill*, London, 1966
Stephens 2008
Chris Stephens (ed.), *The History of British Art 1870–Now*, London, 2008
Stock 1969
Noel Stock, *The Life of Ezra Pound*, London, 1969
Strauss 2000
Monica Strauss, *Cruel Banquet: The Life and Loves of Frida Strindberg*, New York, San Diego and London, 2000
Sutton 1972
Denys Sutton (ed.), *The Letters of Roger Fry*, 2 vols, London, 1972
Swinburne 1866
Algernon Swinburne, *Poems and Ballads*, London, 1866
Thorp 1929
Joseph Thorp, *Eric Gill*, London, 1929
Tickner 1993
Lisa Tickner, 'Now and Then: The Hieratic Head of Ezra Pound', *Oxford Art Journal*, 2, 1993
Tickner 2000
Lisa Tickner, *Modern Life and Modern Subjects: British Art in the Early Twentieth Century*, New Haven and London, 2000
Upstone 2008
Modern Painters: The Camden Town Group, Robert Upstone (ed.), exh. cat., Tate, London, 2008
Vaughan 1959
Paul Vaughan, *Doctors' Commons: A Short History of the British Medical Association*, London, 1959
Vigurs 1976
Peter F. Vigurs, *The Garman-Ryan Collection: Illustrated Catalogue*, Walsall, 1976

Wadsworth 1989
Barbara Wadsworth, *Edward Wadsworth: A Painter's Life*, Salisbury, 1989
Wagner 2005
A. M. Wagner, *Mother Stone: The Vitality of Modern British Sculpture*, New Haven and London, 2005
Walsh 2002
Michael J. K. Walsh, *C. R. W. Nevinson. This Cult of Violence*, New Haven and London, 2002
Walsh (forthcoming 2010)
Michael J. K. Walsh (ed.), *London, Modernism, 1914*, Cambridge, (forthcoming 2010)
Wees 1972
William C. Wees, *Vorticism and the English Avant-Garde*, Manchester, 1972
Wellington 1925
Hubert Wellington, *Jacob Epstein*, London, 1925
Whitman 1938
Walt Whitman, *Complete Poetry and Selected Prose and Letters of Walt Whitman*, Emory Holloway (ed.), London, 1938
Wilenski 1932
R. H. Wilenski, *The Meaning of Modern Sculpture*, London, 1932
Williams 1963
Raymond Williams, *Culture and Society 1780–1950*, London, 1963
Wilson 1988
Andrew Wilson (ed.), *Vorticism*, ICSAC-CAHIER 8/9, Brussels, 1988
Wilson 1975
Simon Wilson, 'A Newly Discovered Sketch by Jacob Epstein for the Tomb of Oscar Wilde', *Burlington Magazine*, CXVII, 1975
Wilson 1977
Simon Wilson, '"Rom", an Early Carving by Jacob Epstein', *Burlington Magazine*, CXIX, 1977
Woolf 1940
Virginia Woolf, *Roger Fry. A Biography*, London, 1940
Yorke 1981
Malcolm Yorke, *Eric Gill: Man of Flesh and Spirit*, London, 1981
Zilczer 1978
Judith Zilczer, 'The Noble Buyer': John Quinn, Patron of the Avant-Garde, Washington DC, 1978
Zilczer 1979
Judith Zilczer, 'The Dispersal of John Quinn's Collection', *Connoisseur*, 202, 1979
Zilczer 1981
Judith Zilczer, 'The Theory of Direct Carving in Modern Sculpture', *Oxford Art Journal*, 1981
Zinnes 1980
Harriet Zinnes, *Ezra Pound and the Visual Arts*, New York, 1980

Copyright and Photographic Acknowledgements

Lenders to the Exhibition

Austin, Harry Ransom Center, The University of Texas
Kunsthalle Bielefeld
Birmingham Museum and Art Gallery
Boston, Museum of Fine Arts
Cambridge, The Fitzwilliam Museum
Cambridge, Kettle's Yard, University of Cambridge
Cambridge, King's College
Cardiff, National Museum Wales
Chichester, West Sussex Record Office
Edinburgh, Scottish National Gallery of Modern Art
University of Hull Art Collection
Jerusalem, The Israel Museum
Leeds Museums and Galleries
London, Victor and Gretha Arwas
London, Ivor Braka Ltd
London, British Museum
London, Leighton House Museum
London, Victoria and Albert Museum
Manchester City Galleries
Melbourne, National Gallery of Victoria
Minneapolis Institute of Arts
New Haven, Yale Center for British Art
New Haven, Yale University Art Gallery
New York, The Museum of Modern Art
Nottingham City Museums and Galleries
Providence, Museum of Art, Rhode Island School
 of Design
Mr and Mrs Peyton Skipwith
Southampton City Art Gallery
Tate
Toronto, Art Gallery of Ontario
Venice, Fondazione Giorgio Cini
Walsall, The New Art Gallery
Washington DC, Hirshhorn Museum and Sculpture
 Garden, Smithsonian Institution
Winchester, Hampshire County Council Museums
 and Archives Services

and others who wish to remain anonymous

Index

All references are to page numbers. Those in **bold** type indicate catalogue plates, and those in *italic* type indicate comparative illustrations.